TIME

1968

The Year That Changed the World

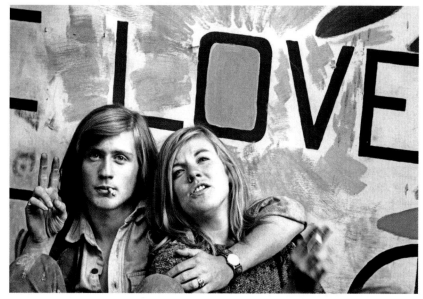

1968
The Year That Changed the World

EDITOR Kelly Knauer
DESIGNER Ellen Fanning
PICTURE EDITOR Patricia Cadley
WRITER/RESEARCH DIRECTOR Matthew McCann Fenton
COPY EDITOR Bruce Christopher Carr

TIME INC. HOME ENTERTAINMENT
PUBLISHER Richard Fraiman
GENERAL MANAGER Steven Sandonato
EXECUTIVE DIRECTOR, MARKETING SERVICES Carol Pittard
DIRECTOR, RETAIL & SPECIAL SALES Tom Mifsud
DIRECTOR, NEW PRODUCT DEVELOPMENT Peter Harper
ASSISTANT DIRECTOR, BRAND MARKETING Laura Adam
ASSOCIATE COUNSEL Helen Wan
BOOK PRODUCTION MANAGER Suzanne Janso
DESIGN AND PREPRESS MANAGER Anne-Michelle Gallero
SENIOR BRAND MANAGER Joy Butts
SENIOR BRAND MANAGER, TWRS/M Holly Oakes
ASSOCIATE BRAND MANAGER Shelley Rescober

SPECIAL THANKS
Bozena Bannett, Alexandra Bliss, Glenn Buonocore, Susan Chodakiewicz,
Margaret Hess, Robert Marasco, Dennis Marcel, Brooke Reger, Mary Sarro-Waite,
Ilene Schreider, Adriana Tierno, Alex Voznesenskiy

ISBN 10: 1-60320-017-7
ISBN 13: 978-1-60320-017-2
Library of Congress Number: 2007910093

We welcome your comments and suggestions about TIME Books. Please write to us at:
TIME Books • Attention: Book Editors • PO Box 11016 • Des Moines, IA 50336-1016

If you would like to order any of our hardcover Collector's Edition books, please call
us at 1-800-327-6388 (Monday through Friday, 7 a.m.–8 p.m., or Saturday, 7 a.m.–6 p.m.,
Central time).

PRINTED IN THE UNITED STATES OF AMERICA

Show of force *The city of Chicago became an armed camp during the Democratic
National Convention in August 1968. Here, police patrol Lincoln Park, where many
of the young people who came to the city to protest the war in Vietnam were gathering*

ART SHAY—TIME LIFE PICTURES—GETTY IMAGES

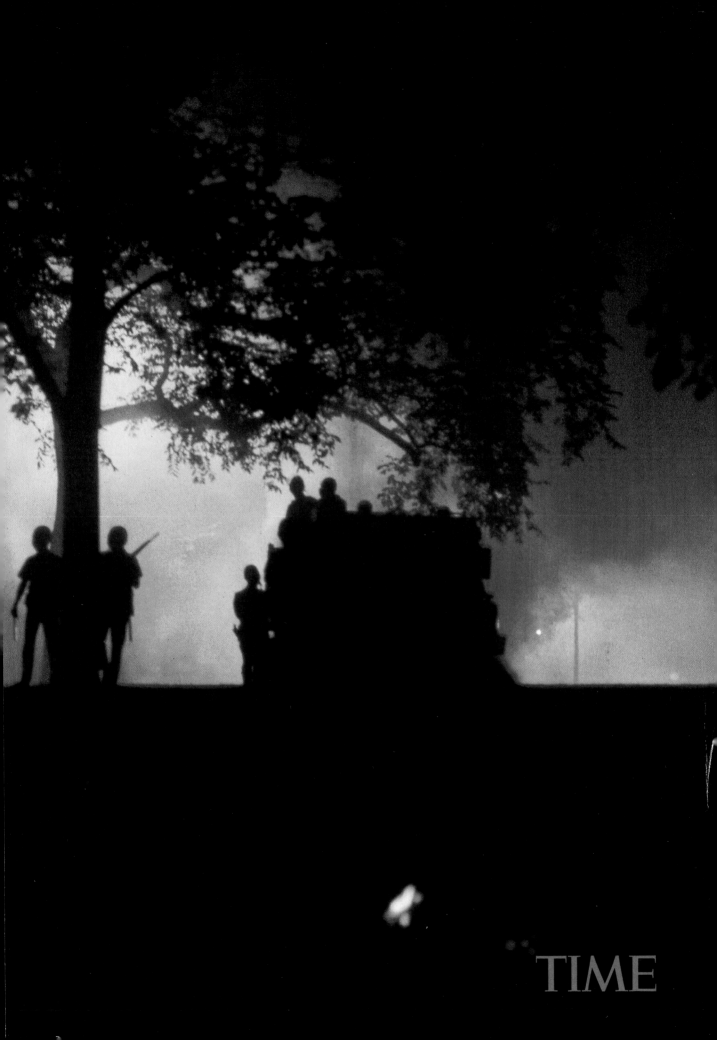

TIME

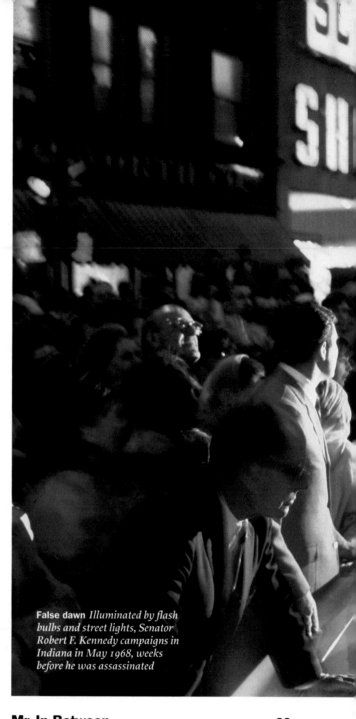

False dawn _Illuminated by flash
bulbs and street lights, Senator
Robert F. Kennedy campaigns in
Indiana in May 1968, weeks
before he was assassinated_

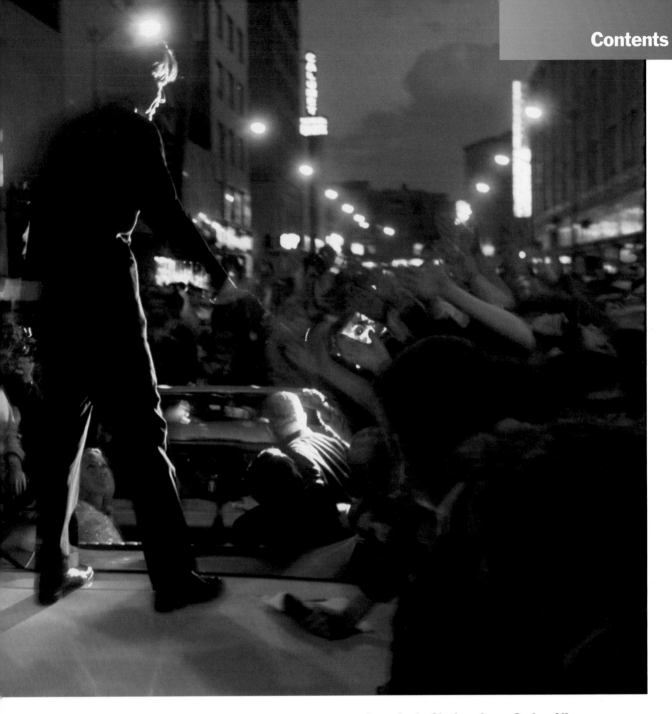

1968

Like a knife blade, the year severed past from future

By Lance Morrow

NINETEEN SIXTY-EIGHT HAD THE VIBRATIONS OF earthquake about it. America shuddered. History cracked open; bats came flapping out, dark surprises. American culture and politics ventured into dangerous and experimental regions: uplands of new enlightenments, some people thought, and quagmires of the id. The year was pivotal and messy. It produced vivid theater. It reverberates still in the American mind.

Nineteen sixty-eight was tragedy and horrific entertainment: deaths of heroes, uprisings, suppressions, the end of dreams, blood in the streets of Chicago and Paris and Saigon, and at last, at Christmastime, man for the first time floating around the moon.

One is sometimes incredulous now at 1968, not only at the astonishing sequence of events but also at the intensity, the energy in the air. People lived their lives, of course. And yet the air of public life seemed to be on fire, and that public fire singed the private self. Revolutionary bombast gusted across the wake of elegy for something in America that had got lost, some sense of national innocence and virtue. More than in ordinary times, people thought about death, about spiritual fulfillment, about transfiguration. The nation pulsed with music and proclamation, with rages and moral pretensions.

It was a perverse genius of a year, a masterpiece of shatterings. Temperaments grew addicted to apocalypse. The printer's ink from the papers that announced it all would smudge and smudge the fingers: history every day dirtied the hands.

Some of the events of the year—the seizure of the American intelligence ship U.S.S. *Pueblo*, for example—might have occurred in some other year. The events were significant but not central to the drama. For the essential 1968 was mythic. It proceeded chaotically and yet finally had the coherence and force of tragedy. And if it was the end of some things (of the civil rights movement, of Lyndon Johnson's generous social vision, of the liberals' hope to keep government on its trajectory), it prepared the way for other beginnings: the women's movement, the environmental movement, the complex reverberant life that the 1960s would have in the American mind long after the melodrama was over and those previously on fire went to tend their gardens.

Nineteen sixty-eight was a knife blade that severed past from future, Then from Now: the Then of triumphant postwar American power in the world, the Then of the nation's illusions of innocence and virtue, from the more complicated Now that began when the U.S. saw it was losing a war it should not have been fighting in the first place, when the huge tribe of the young revolted against the nation's elders and authority, and when the nation finished killing its heroes.

The old Then meant an American exceptionalism, the divine dispensation that the nation thought it enjoyed in the world. In 1968 the American exceptionalism perished, but it was reborn in a generational exceptionalism, the divine dispensation thought to be granted to the children of the great baby boom. The young were special, even sacred, in the way that America once was special and sacred. American innocence and virtue found new forms, new skins.

When time flows from father to son, from past through present into future, the generations have their orderly procession, moving vertically through time. But it was a metaphysical conceit of the baby boomers that the present expanded horizontally, into a kind of earthly eternity. No one had ever had sex before. No one had ever had the Dionysian music, the sacramental drugs, the world struggling back to its protomagical state. Complexity fell away. Deferrals of pleasure and deferences to age, the old Confucian virtues that had made their way into America through the Protestant ethic, blew away at the concussion of youth. "Don't trust anyone over 30" became the slogan of the conspiracy.

It was a moment, 1968, that mysteriously stepped outside of time, one that was forever bringing the young to dimensions of eternity and the sacred: the boy soldiers in Vietnam were connected to death, the heroes to their own cessations, cut down in the prime of their youth and work. Part of the power of the year derives from the mystery of all the possibilities that vanished into death and nothingness.

Nineteen sixty-eight was more than a densely compacted parade of events, more than the accidental alignment of planets. It was a tragedy of change, a struggle between generations, to some extent a war between the past and the future, and even, for an entire society, a violent struggle to grow up.

Anthropologists speak of the origin myths of tribes. The children of the post–World War II baby boom, 76 million of them, were—and in ways, still are—an enormous tribe. The year 1968 represents the origin myth of that tribe. After 1968, much of the drama lay ahead (Woodstock, Altamont, Kent State), and then the long dispersals of the '60s generation into the '70s. But the events of the origin myth ended sometime around the November election of Richard Nixon, when, it may be said, history seemed to have been ceded back to the fathers, and recalled from timelessness into time. ∎

—Adapted from Morrow's 1988 TIME cover story on 1968

No more war! *Youthful protesters flash the sign of the year—the peace symbol—at an antiwar rally in Chicago's Lincoln Park in August*

**"We're waist deep in the Big Muddy
And the big fool said to push on"**
—Pete Seeger, *Waist Deep in the Big Muddy*

Images of 1968

"There is division in the American house now," President
Lyndon Johnson told the nation when he announced on March 31,
1968, that he would not seek re-election. Everyone knew why: the war
in Vietnam was the toxin fouling American life, dividing hawk and
dove, parents and children. Under Johnson, a small U.S. presence in
Vietnam had grown to 525,000 troops by early 1968; some 19,000
young Americans had already died; and the Selective Service was
drafting 24,700 more kids each month—with no end in sight.

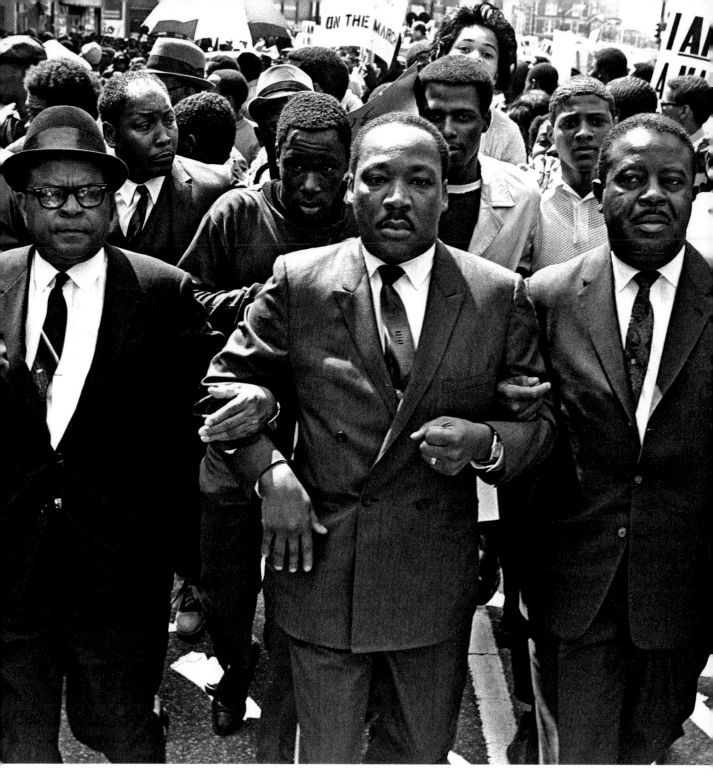

Marching for freedom and calling for unity, two outsized Americans inspired hope, not division, in 1968. When the Rev. Martin Luther King Jr. was assassinated early in April, Senator Robert F. Kennedy was preparing to make a speech in a largely black neighborhood in Indianapolis. Aides begged him to cancel his address, but he insisted on speaking. Here is what he said: "Those of you who are black can be filled with hatred, with

"Didn't you love the things they stood for? Didn't they try to

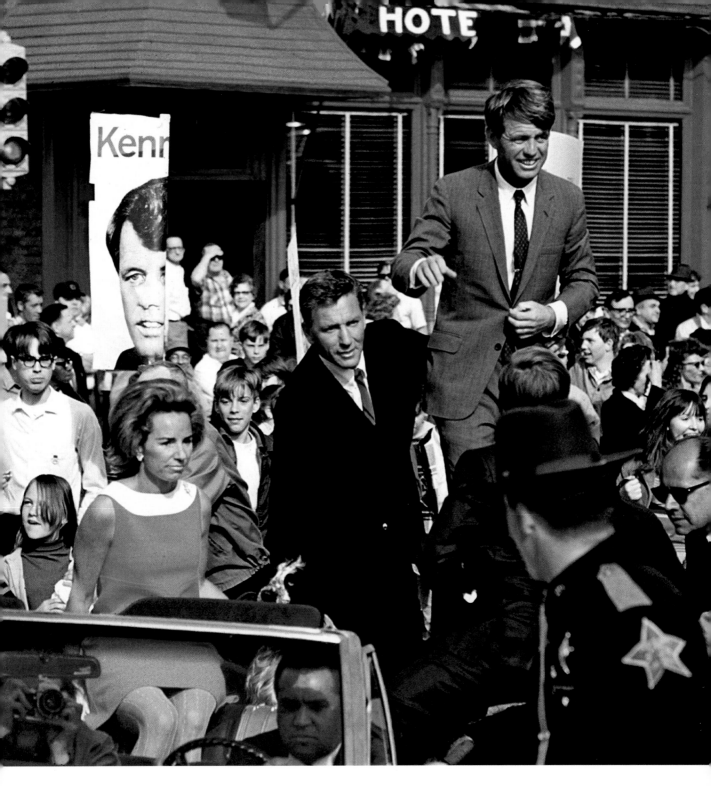

bitterness and a desire for revenge. We can move toward further polarization. Or we can make an effort, as Dr. King did, to understand, to reconcile ourselves and to love ... Violence breeds violence, repression brings retaliation, and only a cleansing of our whole society can remove this sickness from our soul." Nine weeks later, Kennedy was shot dead in Los Angeles. It's possible, Americans learned, to assassinate the future.

find some good for you and me?" —Dick Holler, *Abraham, Martin and John*

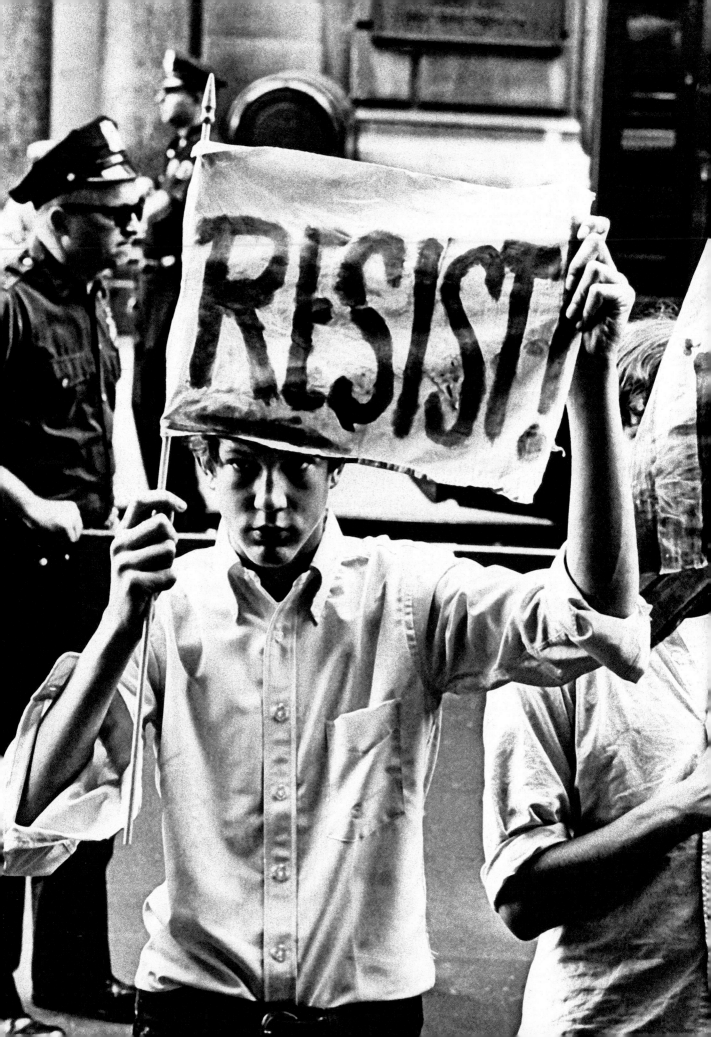

"Everywhere I hear the sound of marching,
charging feet, boy
'Cause summer's here and the time is right
for fighting in the street, boy"
—Jagger/Richards, *Street Fightin' Man*

"Violence is as American as cherry pie," Black Power advocate H. Rap Brown declared in 1967—and his remark, designed to provoke, appeared more like a prophecy in 1968. Urban ghettos had begun to burn earlier in the 1960s, but after the murder of the Rev. Martin Luther King Jr., America was struck by the most widespread rioting in its history; above, fires flare on the south side of Chicago. Later in the year the streets of Chicago were spattered with blood, as cops and protesting kids, left, battled in the streets, live on television.

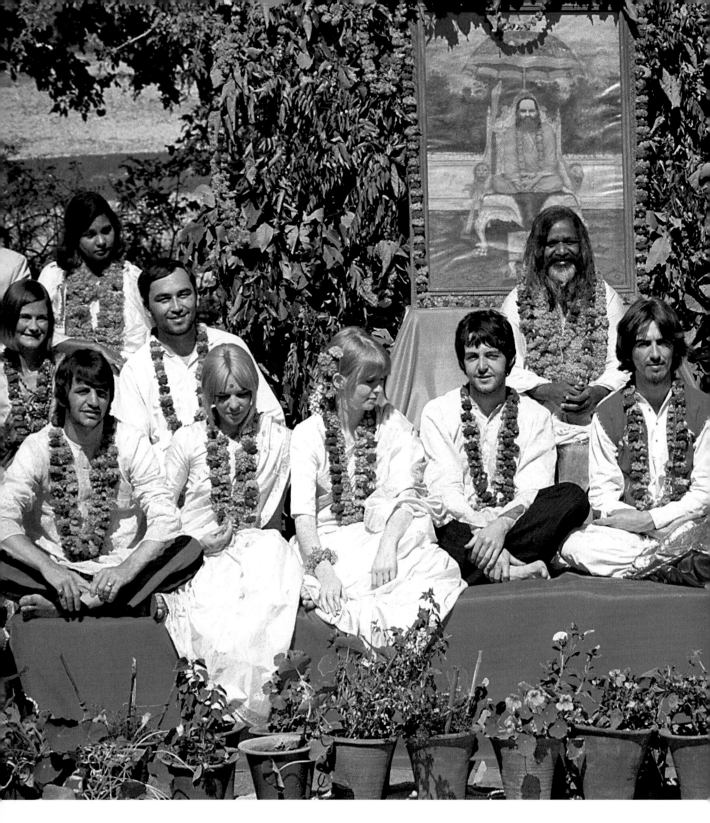

The Beatles reigned over popular culture in 1968, and John Lennon confronted the year's most compelling issues on the song *Revolution*. More artist than activist, he sang, "But when you want money for people with minds that hate/ All I can tell you is brother, you have to wait." Seeking to change their own minds, the Beatles flew to India early in the year for an anticipated escape into Transcendental Meditation that failed. Meanwhile, hippies like the members of the Hog Farm commune, right, continued to follow Timothy Leary's advice: "Turn on, tune in, drop out."

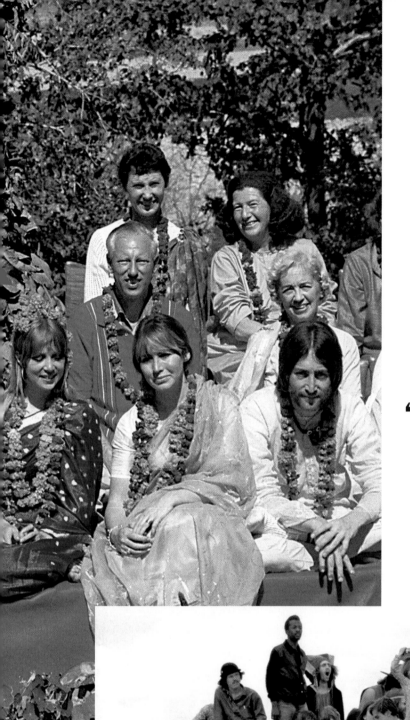

> **"You say you'll change the constitution**
>
> **Well, you know**
>
> **We all want to change your head"**
>
> —Lennon/McCartney, *Revolution*

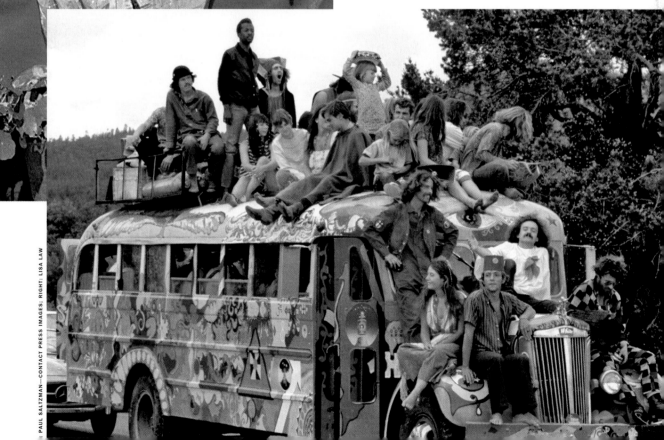

"O say can you see/ My eyes, if you can/ Then my hair's too short"
—Rado/Ragni, *Hair*

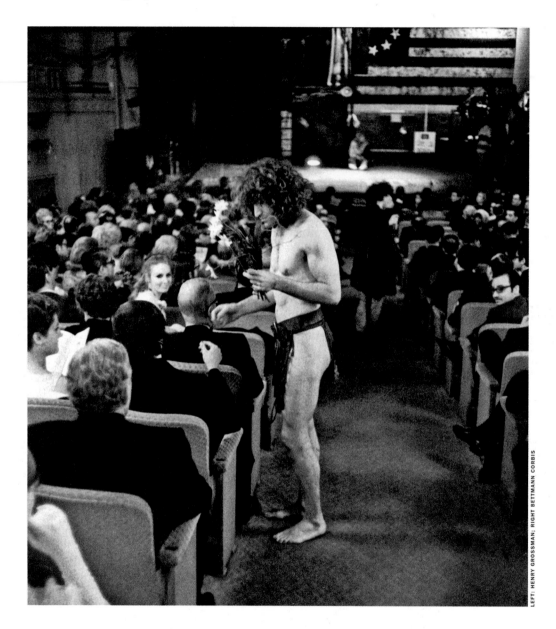

Whether it was a half-naked actor handing out flowers before a performance of *Hair* on Broadway or student protesters taking over the halls of Columbia University, a great "youthquake" rocked American culture in a war of shock waves. Hairstyles, TV shows, music, fashion—every aspect of life became the signifier of an entire worldview. You were either a hawk or a dove, a "freak" or a "straight." But you couldn't be in the center, for in 1968 the center did not hold.

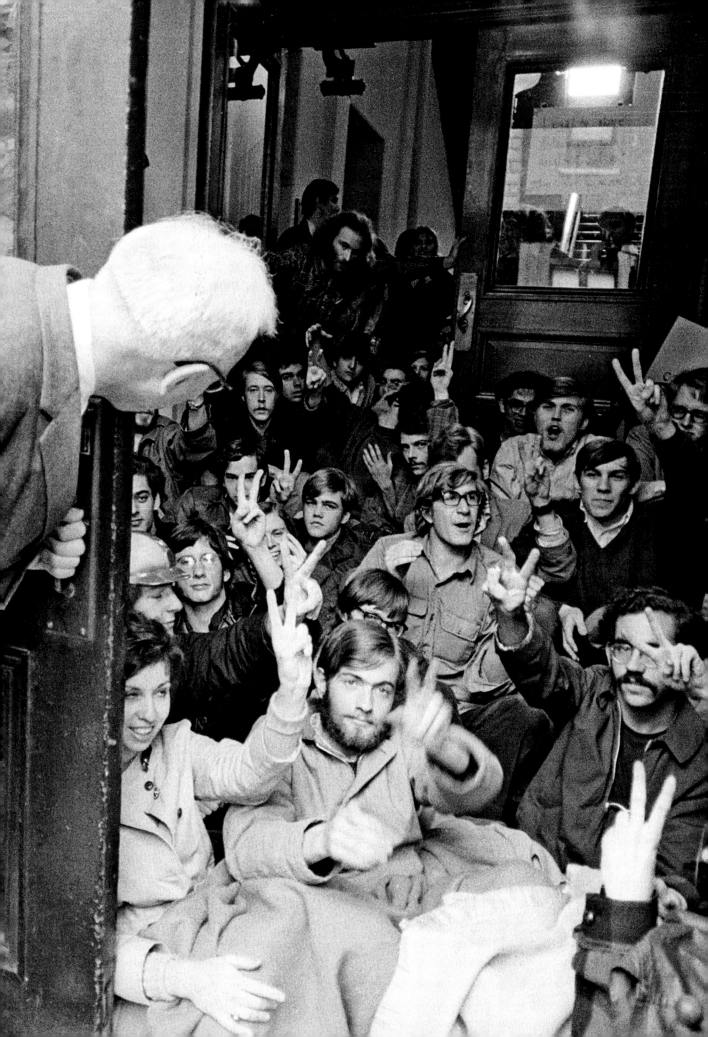

"But if you love him you'll forgivehim/
Even though he's hard to understand/
… Stand by your man"
—Wynette/Sherrill, *Stand by Your Man*

Law and order: above all, law and order. By November 1968,
Americans were desperate for shelter from the year's howling storms.
Republican candidate Richard M. Nixon, whose career once seemed over,
engineered one of the great resurrections in U.S. political history by
divining the mood of millions of Americans who were outraged by
violence and disorder. He won the presidency not so much by promising
cures for the nation's ills as simply by cataloging and decrying them.

Out of this world: that's where many people longed to be late in 1968. Worn down by protest and politics, distressed by division, sick of the violence that flared in the streets and had robbed the nation of two strong voices of healing, Americans needed few excuses to look to the heavens. And there they found an affirmation of a different America—the pioneering nation that had prospered by putting its faith in the future. As three brave men read from the Book of Genesis on Christmas Eve, 1968, for one moment the cares of the year were forgotten, and the vision of a world united in peace prevailed.

"Good night, good night, everybody/ Everybody everywhere,

good night" — *Good Night,* Lennon/McCartney

Waiting For the Light

In the Tet Offensive the U.S. wins a battle—but loses the more critical war of perception

LATE ON THE NIGHT OF JAN. 30, 1968, A TINY, beat-up, blue-and-white taxi turned a corner on Saigon's Thong Nhut Boulevard. Followed closely by a truck running with its lights out, the taxi pulled up in front of a fortress-like building. The handful of U.S. Marine guards manning the gates of the U.S. embassy didn't take much notice at first, because residents in South Vietnam's capital were busy celebrating the most important holiday in the nation's calendar: the lunar New Year, or Tet.

A few miles away, U.S. Army radio operator Norm Taillon sat relaxing on the roof of a hotel with buddies from his unit. "We were having a couple of beers and watching the fireworks off toward the Chinese district of Saigon," he recalls. U.S. and South Vietnamese forces were in a relaxed posture because, for several years, their adversaries, Viet Cong (V.C.) guerrillas and the North Vietnamese Army (NVA), had observed a truce during Tet. Indeed, a month earlier, the Viet Cong had passed out leaflets around South Vietnam that promised U.S. and South Vietnamese troops would be "free to attend celebrations in churches and amusements during the Christmas, solar New Year and lunar New Year days."

The U.S. troops' confidence also came from a new sense that the war in Vietnam was, if not being won, at least winnable. General William Westmoreland, commander of U.S. forces in Vietnam, had summed up this perception 10 weeks earlier, on a visit to Washington, when he had assured the American people that "we have reached an important point, when the end begins to come into view." Days later, he used the words "light at the end of the tunnel" to describe the improving military situation. Few noticed at the time that he was borrowing a phrase from General Henri Navarre, the

Help! *A U.S. paratrooper guides a medical-evacuation helicopter into the jungle to pick up casualties outside Hue on April 1, 1968, only weeks after the U.S. regained control of the city*

ART GREENSPON—AP IMAGES

16

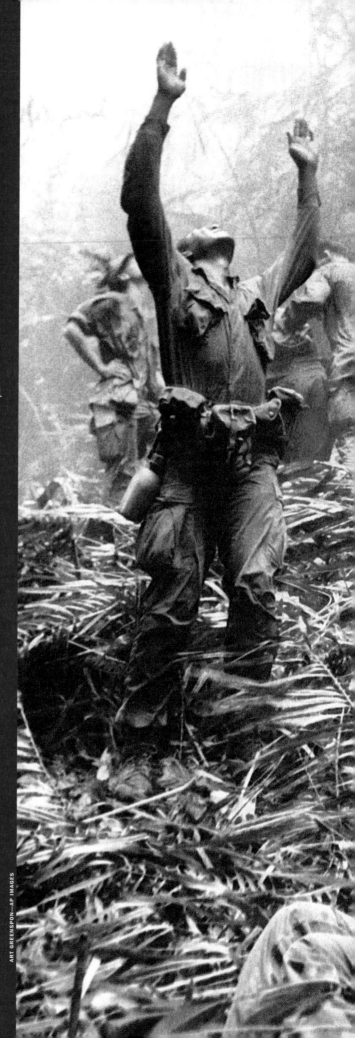

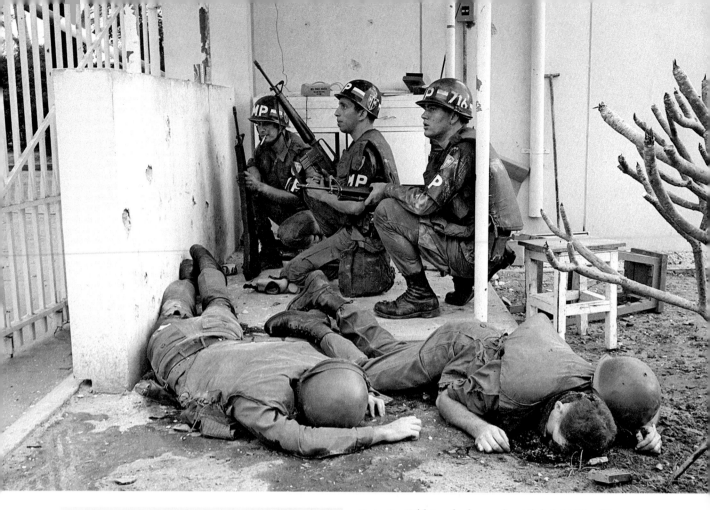

Under fire *With two dead comrades at their feet, U.S. military police return fire inside the U.S. embassy compound in Saigon on Jan. 31, 1968. The compound was breached, but it was not overrun*

Welcome to Vietnam!

Just after midnight on Jan. 30, 1968, a leased commercial jetliner bringing combat engineer Dean Dietrich, 21, and more than 100 other young U.S. soldiers into Vietnam for their first tour of duty was making its final approach to a runway at the large U.S. base at Cam Ranh Bay. "They [the enemy] were blowing up the runways," Dietrich told TIME in 2007, recalling that several planes parked on the ground were already on fire. Dietrich and company had landed in Vietnam as the Tet Offensive began.

Hours after arriving, Dietrich was still trying, amid chaos, to connect with the unit he had been assigned to, without much luck. Just when he located his outfit's truck, he looked up to see a helicopter descend beside him. An officer jumped out and asked for volunteers to conduct a high-risk reconnaissance mission nearby. Hearing no response, he pointed at Dietrich and another soldier: "You and you!" "But that's my truck," Dietrich protested. "Past tense," said the commander. "It was your truck." "But I'm an engineer," Dietrich argued. "Past tense," said the commander. "You were an engineer."

For the next several weeks, Dietrich's new unit carried out reconnaissance missions, laid land mines and came to the rescue of other units besieged in the jungle. Eventually, Dietrich was given command of a 12-man squad and had his kneecap shot off in a firefight. He had been in Vietnam for some 20 weeks. Seriously wounded, he was shipped home—to a baby daughter he had barely seen yet. He never managed to hook up with the unit to which he had originally been assigned.

former commander of French forces in Vietnam, who had used the words before the disastrous 1954 battle of Dien Bien Phu. The general's optimism was shared by President Lyndon Johnson, who flew to South Vietnam for a surprise Christmas Eve visit with the troops late in 1967 and boasted, "The communists cannot win now."

Privately, however, Westmoreland was less upbeat. On his watch, the number of Americans fighting in South Vietnam had risen from 15,000 in 1964 to some 500,000 by the end of 1967. During the same period, more than 15,000 Americans had died. (By year's end, this number would almost double.) More than 2 million tons of bombs had been dropped on the enemy. Yet on his visit to Washington, Westmoreland had told his superiors that he would need another 200,000 troops to finish off the communist insurgency.

That prediction inflamed the growing number of Americans who were calling the war a disaster. In recent years, antiwar sentiment in the U.S. had grown steadily, spreading from college campuses to Congress. Even as Westmoreland was visiting the U.S., Minnesota Senator Eugene McCarthy was launching a campaign to unseat Johnson, a fellow Democrat. McCarthy's single issue: to end U.S. involvement in Vietnam. By early 1968, the war in Southeast Asia was a poison in America's bloodstream, splitting the nation into deeply opposed camps—children against parents, brother against brother—that had begun to demonize each other.

In North Vietnam, military leaders had been working for more than a year on a radical strategy that called for simultaneous, surprise attacks on more than 100 targets across South Vietnam. The campaign would mark a new chapter in the long war in two ways. A force that had previously fought mainly in the countryside would now attack primarily in South Vietnam's urban centers. And guerrilla units accustomed to fighting in small numbers under cover of darkness would now openly assemble in large formations during daylight hours to stage frontal attacks. Hanoi hoped these risks would spark a popular uprising among South Vietnam's population, which might both topple the Saigon government and drive the Americans from the country. As the plan took final shape in late 1967, it was named for the holiday with which it was now timed to coincide: Tet Mau Than, or the New Year of the Monkey.

AS THE TET TRUCE DREW NEAR, A FEW AMERICANS noticed an unusual uptick in the number of funeral processions, as caskets were hand-carried to freshly dug graves all over Saigon. Nobody thought to investigate this, but anyone curious enough to open one of the coffins would have found inside not victims of war but weapons of war. As more than 10,000 Viet Cong guerrillas filtered into Saigon in the days before Tet, they stashed rifles, grenades, mortars and artillery into hundreds of make-believe graves.

Those graves were being dug up just as the taxi halted in front of the U.S. embassy on the evening of Jan. 30. In an instant, a squad of 19 guerrillas jumped from the car and the truck that followed it and began firing antitank rockets into the walls of the embassy compound. Then they sprinted through the breached wall and began firing wildly at the Marine guards and MPs inside. Within seconds, a machine gun secretly mounted in a window across Thong Nhut Boulevard also began firing into the embassy compound.

The explosion knocked Allan Wendt, a young U.S. diplomat who was the duty officer that night, out of bed. "It shook the entire building," he recalls. Ordered by Marines and MPs to stay inside the embassy, Wendt and eight other civilians were pinned down for six hours. Unable to communicate with anyone in Saigon, he managed to reach a State Department official in Washington. "He said, 'What the hell is going on out there?' And I said, 'Listen.' And just as I held up the phone, you could hear another rocket thudding into the building."

Watching from the roof across town, Taillon recalls, "All of a sudden the fireworks were replaced with artillery rounds coming in." In Saigon, communist guerrillas laid siege to the headquarters buildings of South Vietnam's army and navy, its presidential palace and the national radio station. The struggles raged across the nation, as some 70,000 communist insurgents attacked capitals in 36 of South Vietnam's 44 provinces, along with

On the run *Under fire in Da Nang on Jan. 30, South Vietnamese kids dodge bullets—and bodies*

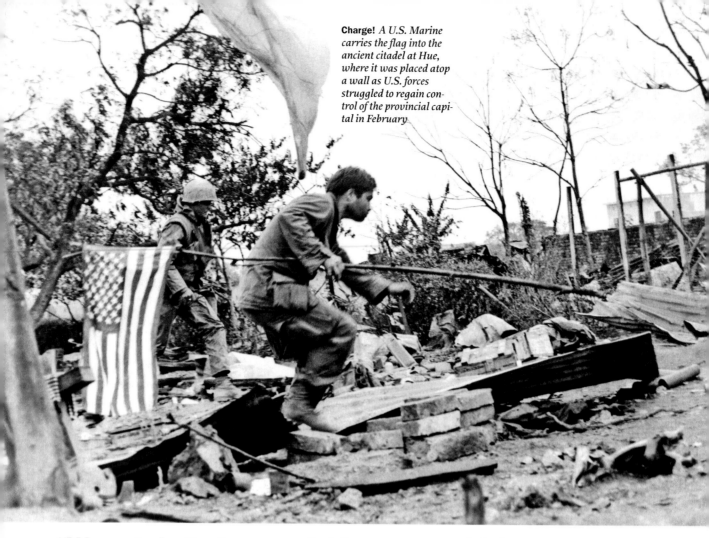

Charge! *A U.S. Marine carries the flag into the ancient citadel at Hue, where it was placed atop a wall as U.S. forces struggled to regain control of the provincial capital in February*

"We got shelled every night ... we couldn't get gunships or support because it was happening everywhere"

—Lou Millslagle, Vietnam veteran, 2007

more than 100 other cities, towns and military bases.

One of these was a mooring facility for container ships, laden with ammunition, in the Dong Nai River. Lou Millslagle, a 19-year-old sergeant in the 199th Light Infantry Brigade, had just dropped off members of his squad to guard the ships as they offloaded their explosive cargo to barges tied alongside. "At the stroke of midnight, shells started hitting the ship," he recalled to TIME in 2007. "I could see flames coming from the barge. I don't know why, but I jumped down and started throwing off burning ammunition crates. The guy on the fantail opened up with an M-60. I felt a white-hot burn on my leg but didn't think much of it." He later realized he had been hit by several bullets. "We got shelled every night for the next week. We couldn't get gunships or support because it was happening everywhere."

Stunning in its audacity, the Tet Offensive exploded across South Vietnam, catching U.S. and South Vietnamese commanders utterly unprepared. The North Vietnamese made the most progress in the provincial capital of Hue, where they managed to capture and occupy much of the city within a few hours. They used the

opportunity to round up and massacre more than 1,000 civilians who were deemed to be sympathetic to the South Vietnamese government.

Within the city, Richard Pelham, a 17-year-old private first class in the First Marine Division, remembers, "It was house-to-house fighting, and we weren't trained for that. It was just rifles and grenades. No heavy weapons or tanks. They had a whole company of NVA dug into the old Coca-Cola building. We walked by, and all hell broke loose. We lost 21 men in an hour and a half. I lost some very good friends there."

On the same day, 19-year-old Lance Corporal Al Shaw, assigned to Marine Recon, instinctively moved his men to the top of a hill outside of Hue. Though he was assigned to call in artillery fire on North Vietnamese troop concentrations, he says, "I had to call in 'Open fire' from two of our own batteries," he recalled in 2007 of his decision to direct U.S. fire against his own position, "because they were overrunning us. There were 13 of us on the hill. Only five of us, all wounded, came off. And two helicopters went down coming to get us. But we brought out our dead." (Shaw was later awarded the Navy Commendation Medal for valor.)

THE BATTLE FOR HUE WOULD RAGE FOR WEEKS, BUT many of the Tet attacks were subdued within a matter of days, even hours. The raid on the U.S. embassy claimed five American lives, but the insurgents never gained a foothold within the compound: in a six-hour firefight, all 19 guerrillas were killed. Nearby, the 14-man team that briefly captured the Saigon military radio station barricaded itself inside and held off U.S. and South Vietnamese forces for several hours before they ran out of ammo and blew themselves up.

Within 24 hours, Tet Offensive operations in Saigon had collapsed. But in one crucial respect, the damage was done. American TV news cameras had captured footage of the Viet Cong guerrillas firing machine guns and running wild inside the walls of the U.S. embassy. The images shocked a nation that had been told for years that the North Vietnamese were close to giving up. "When I walked out of the embassy," Wendt recalls, "and saw the compound littered with mangled dead bodies, I just couldn't believe it. This was the American embassy, the seat of American power."

Ambivalence on the home front was further amplified only days later, when newspapers ran the historic photo of a South Vietnamese general executing a suspected Viet Cong at point-blank range. Justly or not, the new images left Americans deeply shaken, a fact that still angers veterans of Tet. "We creamed them," says Jack Rickman, who was a 28-year-old U.S. Army captain in January 1968. "We were knocking them over and stacking them up. The Viet Cong were finished as a fighting force after that. There was no way you could see it as anything but a victory for our side."

"We were at first startled, then unbelieving and finally almost ecstatic," remembers retired Army Colo-

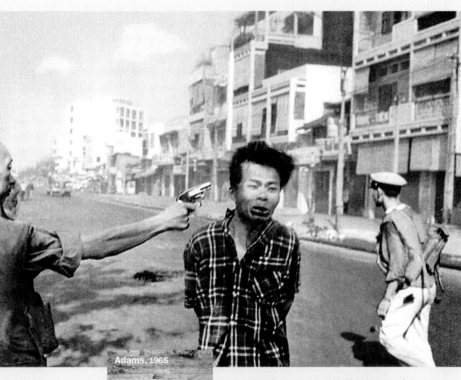

EDDIE ADAMS—AP IMAGES

Adams, 1965

AP IMAGES

The Shot Seen Round the World

On Feb. 1, 1968, two days into the Tet Offensive, as U.S. and South Vietnamese forces were mopping up the pieces of the campaign in Saigon, a bound young prisoner suspected of being a Viet Cong officer was brought before General Nguyen Ngoc Loan, the chief of South Vietnam's national police force. Only moments earlier, Loan had learned of the murder, by Viet Cong guerrillas, of one of his senior officers, along with that man's wife and six children. Even as Associated Press photographer Eddie Adams and an NBC News crew filmed him, Loan drew a pistol, raised it to the prisoner's temple and fired a single shot into his head, killing the man instantly.

The photograph of the summary execution shocked the world,

becoming for many an indelible image of the savagery bred by the conflict and of the harshness of South Vietnam's regime. General Loan's action drew a swift rebuke from U.S. military officials.

Adams, who was a close friend of Loan's, won a Pulitzer Prize for the photo but for the rest of his life regretted taking it. After Loan's death, he wrote in TIME, "The general killed the Viet Cong; I killed the general with my camera. Still photographs are the most powerful weapon in the world. People believe them, but photographs do lie, even without manipulation. They are only half-truths." General Loan was severely wounded three months after the execution; he escaped from South Vietnam when it fell to North Vietnam in 1975 and ended up in Virginia, where he operated a pizza parlor in Dale City until 1991. He died in 1998.

"The Viet Cong were finished as a fighting force after that. There was no way you could see it as anything but a victory for our side"
—Jack Rickman, Vietnam veteran, 2007

No place like home *South Vietnamese civilians return to the battered streets of Hue after the long fight to control the city. Veteran Jack Rickman's quote at left captures the irony of the situation: the U.S. had won a victory, but at what cost?*

nel Robert Simpson, "that our enemy was playing so directly to our strength. We slapped each other on the back and rejoiced that the war was suddenly going very much in our favor. 'If they keep this up,' we told each other, 'we can wrap this thing up in a few months and go home.'" But when Simpson went on leave in Hawaii a few weeks later, he was shocked the first time he saw a civilian newspaper: "I learned, to my utter astonishment, that Tet was considered a major defeat."

There is considerable evidence to back up Simpson's point of view. Of the 70,000 fighters North Vietnam sent into combat during Tet, more than 60% were killed. Many of the Viet Cong's most experienced leaders were wiped out. So grievous were North Vietnam's losses that the communists were unable to mount another major campaign until the spring of 1972. Moreover, Hanoi's primary goal of Tet, to unleash a popular uprising that would cause the South Vietnamese government to implode, turned out to be wishful thinking.

YET HANOI'S SECOND GOAL, TO SHAKE AMERICANS' confidence in the prospects for victory, succeeded. Upon hearing the first bulletins of the start of Tet, CBS News anchor Walter Cronkite bellowed to his staff, "What the hell is going on over there? I thought we were winning this war." Determined to find out, the veteran journalist traveled to Vietnam in February to make a documentary about the war. "To say that we are mired in stalemate seems the only realistic, yet unsatisfactory, conclusion," he observed at its end. "It is increasingly clear to this reporter that the only rational way out, then, will be to negotiate, not as victors but as an honorable people who lived up to their pledge to defend democracy, and did the best they could."

In the White House, a dejected Johnson told aides that if he had lost Cronkite, he had lost the war. In a note the President scribbled to himself at the time (but was not made public until 1983), Johnson wrote, "Change of sentiment in this country. Clear-cut statement. Can no longer do job we set out to do. Adjust our course. Move to disengage."

Within a week, most of the major combat of Tet was over, although "mopping up" operations in some areas continued for two months. With only a handful of exceptions, American and South Vietnamese troops had prevailed in every major engagement. But even if the military results were encouraging, the political landscape had been remade. Before the final shots of the campaign were fired, Johnson announced that he would not run for another term as President, Robert Kennedy and Richard Nixon declared that they would seek their parties' nominations, and America's antiwar movement had become bolder and more militant than ever before. At the same time, Hanoi seemed to abandon its hopes for a quick victory in South Vietnam, a shift signaled by its decision to take part in peace talks for the first time since the war began. Even so, the conflict would drag on for seven more bloody years, the light in the tunnel constantly receding. ∎

CENTRAL PRESS—GETTY IMAGES

Walter Cronkite, TV Newsman

CRONKITE HAS CONSTRUCTED AN ONSCREEN personality that makes him the single most convincing and authoritative figure in TV news," TIME wrote in 1966. Two years later, "the most trusted man in America" would call upon that credibility to say things that no other broadcast journalist of the era could get away with saying. His documentary on the war in Vietnam, produced in the wake of the Tet Offensive, concluded with the dire observation that America was "mired in stalemate." Of President Lyndon Johnson's legendary reaction that the war was lost if Cronkite was no longer for it, the CBS News anchor wrote simply in his 1996 memoir, *A Reporter's Life:* "I think it is possible that the President shared my opinion, and that, in effect, I had confirmed it for him."

Six months later, Cronkite narrated the bitter fallout from Vietnam, the meltdown that took place in the streets of Chicago. Early on, he told viewers that "the Democratic Convention is about to begin in a police state ... there just doesn't seem to be any other way to say it." Later, when a CBS correspondent was assaulted on live television, he observed bitterly, "I think we've got a bunch of thugs here." But Cronkite's year ended on a note of rhapsody, not regret. On Dec. 21, the longtime booster of NASA's exploits in space delighted in telling viewers, "This morning three Americans ... are on the verge of making man's first journey to the moon." ■

Colin Powell, U.S. Army Officer

MAJOR COLIN POWELL, 31, RETURNED TO VIETNAM IN July of 1968 for a second tour of duty. (His first had been in 1962-63.) Soon after he arrived, Powell was handed a potentially explosive assignment: he was ordered to look into vague rumors that war crimes might have been committed by U.S. soldiers near the tiny hamlet of My Lai in March 1968. Unable to substantiate the claims, Powell let the matter drop, unresolved. In fact, the reports proved true, but they did not become public until late in 1969, when they became a major news story around the world.

Decades later, Powell's involvement in the My Lai scandal provoked embarrassing questions when he was named Chairman of the Joint Chiefs of Staff and U.S. Secretary of State. But the lessons of a war gone wrong were not lost on the young officer. Determined never again to let his country stumble into an ill-conceived conflict, he formulated the "the Powell Doctrine," which states that the U.S. must only commit its troops to a conflict that will win broad public support, and that the U.S. must also have an achievable objective, muster decisive superiority in arms and create a clear exit strategy. As Powell wrote in his 1995 book, *My American Journey,* "Many of my generation vowed that when our turn came to call the shots, we would not quietly acquiesce in half-hearted warfare for half-baked reasons that the American people could not understand." ■

24

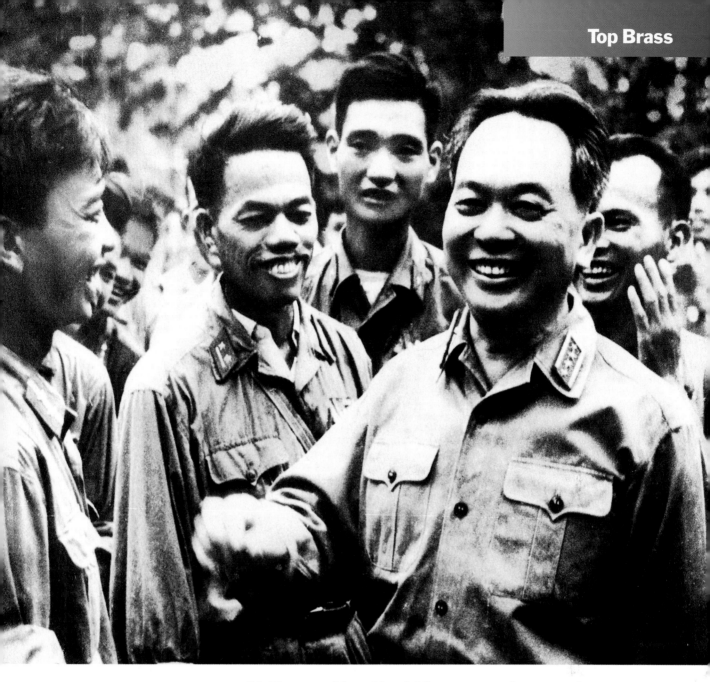

Vo Nguyen Giap, North Vietnamese Commander

Warrior *Giap's 1954 victory at Dien Bien Phu over the French was the first by an Asian resistance group battling a colonial army in a conventional fight. Giap, above in 1968, proved a master strategist of guerrilla warfare in the 1960s*

New focus *At top left, Cronkite , 52 in 1968, reports from Vietnam in his March 1968 documentary, which helped shift U.S. public opinion against the war*

Rising *Bottom left, Powell was 31 in 1968 and a young star in the Army. After investigating unconfirmed tales of war crimes, he described relations between U.S. soldiers and the Vietnamese people as "excellent"*

AS GENERAL VO NGUYEN GIAP'S LARGEST GAMBLE OF THE VIETNAM WAR, the Tet Offensive, raged in February 1968, TIME noted, "It is one of those little ironies of fate that General Giap's name contains the Vietnamese words for force (Vo) and armor (Giap)." Calling the commander of North Vietnam's armed forces and the mastermind of the Viet Cong "a dangerous and wily foe," TIME quoted him as describing his U.S. adversary as an "impotent colossus." Giap, 56 in 1968, was just the opposite. A top Pentagon official told TIME, "You know when he's in charge. You can feel him there."

The summer 1967 death of Nguyen Chi Thanh, a rival with whom he had previously shared authority, gave Giap sole control of North Vietnam's military, making him second only to Ho Chi Minh in the nation's hierarchy. Giap used his new power to mount both the siege at Khe Sanh and the Tet Offensive. The battles cost North Vietnam dearly, but Giap was unfazed: he routinely told his senior officers, "Every minute, thousands of men die all over the world. The life and death of human beings mean nothing." This brilliant practitioner of guerrilla warfare had no formal training as a soldier. "The only military academy I have been to," he boasted after his signature 1954 victory over the French at Dien Bien Phu, "is that of the bush." ∎

25

Getting into The Groove

Pop art waves goodbye, psychedelic styles take over, and hippies light out for the territories as American trends keep vibrating to the pulses of the counterculture

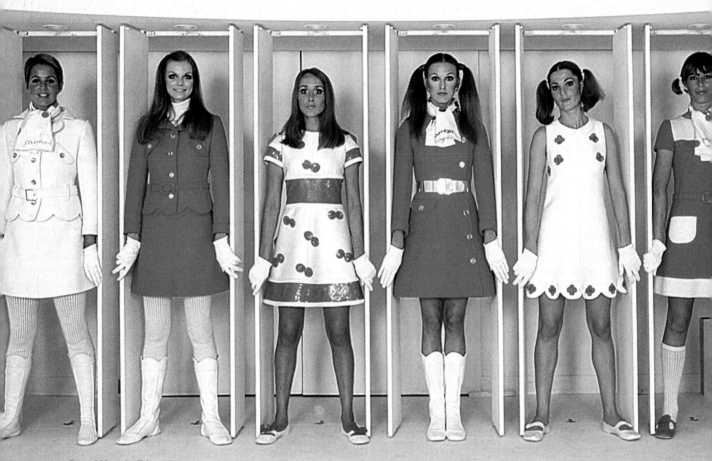

One Word: Plastics

Paging Austin Powers! The Pop art look of the early '60s was still alive and well in 1968, as these models wearing the work of French designer André Courrèges—looking like so many lollipops arranged in a drawer—demonstrate. Courrèges was among those who helped introduce the miniskirt earlier in the decade; another of his signature looks is the white go-go boots worn by several of these models. This was the last gasp of the colorful, plasticky look of the early and mid-'60s; in the years to come, the Pop style shown here would fall from favor, as designers took their inspiration from hippie culture and began turning to layered looks that featured long, flowing skirts, Indian prints, Gypsy and Native American regalia and Victorian bric-a-brac.

Peter Max, Starring Peter Max

Why separate art from life? Peter Max plastered a self-portrait across the bottom of the work above. TIME *described Max, 28, in 1968, as "the grooviest thing going … a walrus-mustached native of Berlin who likes to explain that his flair for star-crossed psychedelic patterns was instilled during his boyhood in Shanghai, where he watched Buddhist monks painting at a nearby pagoda." No hippie, Max licensed his work to half a dozen companies, including General Electric; his work was ubiquitous in the late '60s, emblazoned on posters, cups, plates, decals and medallions. Max,* TIME *reported, "zaps about Manhattan with his blonde, beret-crowned wife in a decal-covered 1952 Rolls-Royce with a liveried chauffeur." It beats a garret.*

Hallucinations in Print

Visual art doesn't get much more psychedelic than the brilliantly colored posters created to promote rock concerts in the '60s, most notably in the navel of the hippie movement, San Francisco. The work of such gifted graphic artists as Wes Wilson, Stanley ("Mouse") Miller, Rick Griffin, Victor Moscoso, Alton Kelley and many others is instantly identifiable as emerging from the mind-bending ferment of the LSD scene. The unique calligraphy that is a hallmark of the style is often said to have originated with Wilson, who says he based the flowing, deformed characters on his own drug experiences and on his study of Vienna Secessionist lettering.

The poster scene predated 1968, but it was going strong during that year, as seen on this page. Today there is a thriving market in the original works created in this era; small handbills can run into the hundreds of dollars, and some posters bring more than $10,000 at auction.

In addition to poster art, underground comics emerged as a cultural force in the late '60s. Leading the graphic parade was Zap Comix, catnip for stoned hippies; the first issue, labeled "For Adult Intellectuals Only," was published in San Francisco early in 1968. Zap artists included Griffin, Robert Crumb and S. Clay Wilson.

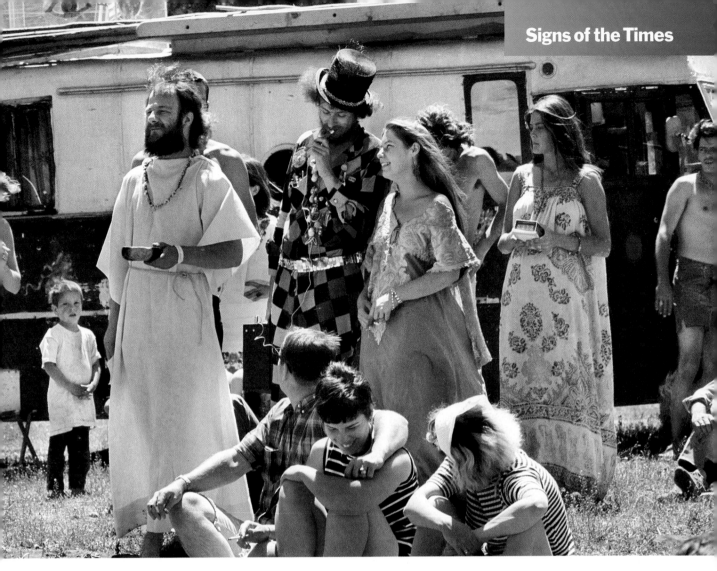

Sunshine Daydream

In the fall of 1967, San Francisco hippies held a mock burial for the much ballyhooed Summer of Love, demonstrating their contempt for the commercialization of their peace-love-and-pot lifestyle (a word that came into use about this time). But reports of the hippies' demise were exaggerated: in 1968 the tie-dye ethos was still spreading its good vibes across wide swaths of mainstream America. The Wood-stock Music Festival, often called the apex of the movement, took place in August 1969. Above, hippies (and spectators) at a commune in New Mexico gather to groove and celebrate a wedding.

Your Heart on Your Sleeve

In the late 1960s the concept of the T shirt as a billboard for one's tastes and political leanings had yet to be invented. And while some cars sported bumper stickers, the vogue for such messages didn't really take off until the 1970s. So ... how to telegraph your opinions to random strangers? The answer was lifted from political campaigns, as buttons with slogans of all sorts—cute, catchy, rude—began showing up on America's shirts.

STUDENT POWER

DON'T TRUST ANYONE OVER 30

BLACK IS BEAUTIFUL

BAN THE BRA

moratorium

SILENT MAJORITY

SUPPORT OUR BOYS IN VIETNAM

MAKE LOVE NOT WAR

GOD IS ON A TRIP

this button is just an attempt to communicate.

BLACK POWER

I AM A HUMAN BEING: DO NOT FOLD, SPINDLE OR MUTILATE

HIPPY POWER

STOP YOU'RE BLOWING MY MIND!

HANDS OFF TIM LEARY

Legalize Spiritual Discovery

PEACE

Poor People's Campaign 1968

"KEEP THE FAITH BABY"

SUPPOSE THEY GAVE A WAR AND NOBODY CAME

J. EDGAR HOOVER SLEEPS WITH A NIGHT LIGHT

WARNING: YOUR LOCAL POLICE ARE ARMED AND DANGEROUS

YOU FIGHT & DIE BUT CAN'T DRINK AT 18

GO NAKED

BOOKS MUST GO!

GREAT SOCIETY ABOMINABLE SNOW JOB

Effete Snobs For Peace

WE SHALL OVER KILL

STONED

GOD IS DEAD

TURN ON TUNE IN DROP OUT

APATHY

WE SHALL OVERCOME

FLOWER POWER

HELP I'm having an identity crisis

MY BUTTON LOVES YOUR BUTTON

Stirrings of Feminism

Many of the most powerful social movements of the past 40 years began to take shape in the late 1960s. The feminist movement was in its early phases on Sept. 8, 1968, when members of the Women's Liberation Front staged a protest at the Miss America beauty pageant in Atlantic City, N.J. The "women's libbers" lampooned the event as a cattle auction, much to the annoyance of mainstream Americans.

The Krishna Connection

Americans called them by the chant they sang as they paraded through airports and down city streets: Hare Krishnas. Interest in the exotic religions of the East spiked in the '60s and was given a huge boost in 1967-68 when the Beatles signed on as followers of Maharishi Mahesh Yogi's Transcendental Meditation. The ecstatic celebrants at left are at the Society for Krishna Consciousness in New York City.

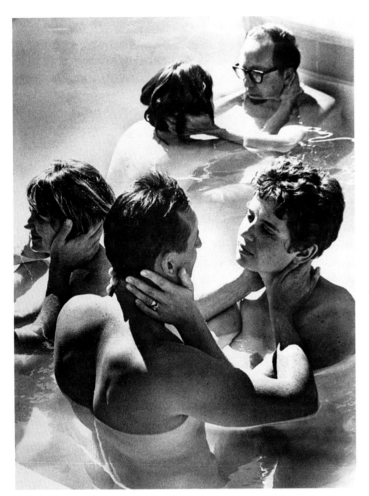

Close Encounters

We know what you're thinking, but the couples at left are not engaging in an orgy. No, indeed! Rather, they are riding the tide of one of the enduring forces spawned by the 1960s, the self-help movement. Specifically, these seekers are engaging in an "eyeballing" encounter at psychologist Paul Bindrim's human potential movement resort in Palm Springs, Calif.

California was the epicenter of the self-help community; the Esalen Institute in Big Sur, founded in 1962 by Michael Murphy and Dick Price, devoted itself to "the harmonious development of the whole person." Serving as a laboratory for the investigation of human-potential philosophies, Eastern religious practices, occult theories and the like, it was both ridiculed and venerated, a barometer of the times.

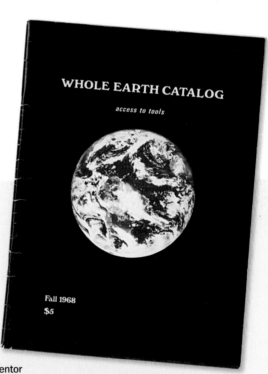

WHOLE EARTH CATALOG

access to tools

Fall 1968
$5

Back to the Garden

One of the most influential social movements of the late 1960s was the hippie-driven flight away from the cities and "back to the land." The celebration of all things natural—and the resulting demonization of cities and other man-made creations—was one of the driving influences of the counterculture ethos.

Those seeking gardens of Eden—and fields in which to plant pot—found their Bible in the *Whole Earth Catalog.* This oversized, psychedelicized tribute to the Sears & Roebuck catalog was the brainchild of Stewart Brand, a visionary writer who had taken part in early government-sponsored tests of LSD, then signed on as one of novelist Ken Kesey's "Merry Pranksters." In 1968 Brand began wondering, as he put it, why NASA had never published a picture of the entire earth as seen from space, though such photos were rumored to exist. The campaign to publish such an image brought Brand into contact with another visionary, the architect and inventor R. Buckminster Fuller, the gadfly author of the 1963 groundbreaking work of social criticism, *Operating Manual for Spaceship Earth.*

In the fall of 1968, Brand published the first edition of the *Whole Earth Catalog,* a unique volume that anticipated the World Wide Web in print, featuring links to products and books that were a mixture of counterculture fads, "back to the land" how-to manuals and Brand's personal enthusiasms. The volume's rudimentary production values were part of its down-home charm, and it was an instant hit. Readers of the catalog often built the geodesic domes pioneered by Fuller for their frontier lifestyles; at left is a 1968 settlement in Drop City, Calif. As for Brand's request of NASA, it was brilliantly fulfilled late in 1968, when Apollo 8 astronaut Bill Anders took the famed photograph of the whole Earth rising across the bleak surface of the moon.

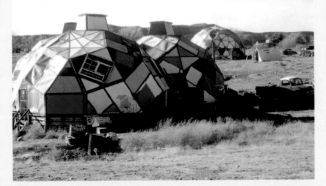

31

Listen Up!

"This is the dawning o'

"Get Clean for Gene!"
—COLLEGE STUDENTS *who cut their hair to support Senator Eugene McCarthy's campaign for President*

"As we look at America, we see cities enveloped in smoke and flame. We hear sirens in the night. We see Americans hating each other; killing each other at home. And as we see and hear these things, millions of Americans cry out in anger: Did we come all this way for this?"
—RICHARD NIXON, *accepting the GOP nomination for President*

"Socialism with a human face."
—ALEXANDER DUBCEK, *President of Czechoslovakia, describing his goal of combining communism and freedom*

"My brother need not be idealized or enlarged in death beyond what he was in life—to be remembered simply as a good and decent man, who saw wrong and tried to right it, saw suffering and tried to heal it, saw war and tried to stop it."
—SENATOR EDWARD KENNEDY, *eulogy for his brother Robert F. Kennedy*

"Where have you gone, Joe DiMaggio? A nation turns its lonely eyes to you"
—PAUL SIMON, *lyrics*, Mrs. Robinson

"It became necessary to destroy the town in order to save it."
—U.S. OFFICER, *to AP reporter Peter Arnett about Ben Tre in South Vietnam. Critics say the quote was fabricated*

"Our nation is moving toward two societies, one black, one white—separate and unequal."
—NATIONAL ADVISORY COMMISSION ON CIVIL DISORDERS *(the Kerner Commission), summary report*

"The whole world is watching!"
—ANTIWAR PROTESTERS, *chanting to police during street riots at the Democratic National Convention in Chicago*

Vibrant times make for vibrant words, and the quotes of 1968 are a verbal Xray of a hectic year

he Age of Aquarius"

—JAMES RADO AND JEROME RAGNI, lyrics *from* Hair

"What the hell is going on over there? I thought we were winning this war."

—WALTER CRONKITE, *CBS News anchorman, to his staff, after the launch of the Tet Offensive*

"Senator Kennedy has been shot. Is that possible? Is that possible? Is it possible, ladies and gentlemen? It is possible ... Oh, my God. Senator Kennedy has been shot."

—ANDREW WEST, *a reporter for KRKD radio in Los Angeles*

"The Earth from here is a grand ovation to the vastness of space."

—JIM LOVELL, *astronaut, broadcasting from lunar orbit, Dec. 23*

"How many of you sick people are from the Students for a Democratic Society?"

—SPIRO AGNEW, *Republican vice-presidential candidate, to hecklers at a campaign appearance*

"Sock it to me!"

—RICHARD NIXON, *appearing on* Rowan & Martin's Laugh-In

"What we're saying today is that you're either part of the solution or you're part of the problem."

—ELDRIDGE CLEAVER, *Black Panther leader, in a speech in San Francisco*

"The youth rebellion is a worldwide phenomenon that has not been seen before in history. I do not believe they will calm down and be ad execs at 30, as the Establishment would like us to believe."

—WILLIAM S. BURROUGHS, *writer*

"That's it, baby! When you got it, flaunt it."

—MEL BROOKS, *The Producers*

Trends of the Year

July

July 17 *Coup in Iraq puts Saddam Hussein on the nation's Command Council*

July 25 *Pope Paul VI issues encyclical* Humanae Vitae, *condemning birth control*

August

Aug. 8 *Richard Nixon nominated at the Republican National Convention*

Aug. 20 *Soviet and Warsaw Pact tanks roll into Czecho-slovakia, ending Prague Spring*

Aug. 26 *Beatles release* Hey, Jude

Aug. 26-29 *Rioting between protesters and police at the Democratic National Convention in Chicago*

Aug. 29 *Hubert Humphrey nominated at the Democratic Convention*

September

Sept. 16 *Candidate Richard Nixon appears on* Laugh-In

October

Oct. 2 *Students riot in Mexico City; some 200 believed killed*

Oct. 10 *Detroit Tigers beat St. Louis Cardinals in World Series in seven games*

Oct. 12 *Olympic Games open in Mexico City*

Oct. 20 *Jacqueline Kennedy marries Aristotle Onassis*

Oct. 31 *L.B.J. announces U.S. bombing halt in Vietnam*

November

Nov. 5 *Nixon elected President*

Nov. 22 *Beatles release double record,* The White Album

December

Dec. 3 *Elvis (a.k.a. "the come-back special") airs on NBC*

Dec. 22 *David Eisenhower and Julie Nixon wed*

Dec. 23 Pueblo *crew set free*

Dec. 23-25 *Apollo 8 astronauts circle the moon and broadcast live TV images back to Earth*

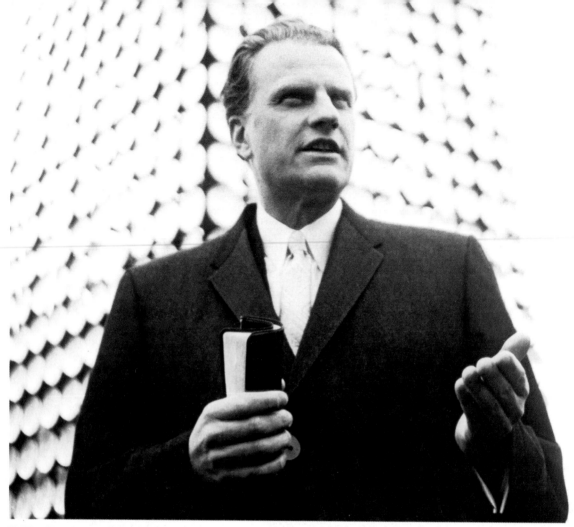

Billy Graham, Preacher

BY 1968, THE REV. BILLY GRAHAM HAD been "America's preacher" for some 20 years; he first won fame in the late 1940s. TIME spoke with Graham just before the November election, noting that he had served as an unofficial spiritual adviser to every President since Truman. Without making an official endorsement— "The moment I start getting involved in partisan politics, it would greatly diminish my ministry"—Graham made clear that he favored Richard Nixon for the office. The preacher had offered the closing benediction at the Republican Convention and even sat in on a session to vet running mates for Nixon. In September Graham introduced Nixon at a Pittsburgh crusade and praised him for his "generosity" and "tremendous constraint of temper."

Graham, 49 in 1968, also weighed in on the roiling currents of the year, telling TIME that the Supreme Court had "gone too far" in favoring criminals. The North Carolinian, noted for rejecting racial segregation in his ministry, said he supported Black Power but only when it fostered "a feeling of self-respect," rather than violence or civil disobedience. ∎

Hugh Hefner, Playboy

THE YEAR 1968 WAS A GOOD ONE FOR the man TIME described in a May 1967 cover story as "alive, American, modern, trustworthy, clean, respectful, and the country's leading impresario of spectator sex." In founding *Playboy* in 1953, Hugh Hefner had taken the old-fashioned, shame-thumbed girlie magazine, stripped off the plain wrapper, added gloss, class and culture—and hit the jackpot. By 1968 some 4 million copies of *Playboy* rolled off the printing presses each month, 16 Playboy clubs dotted the globe, and a Hef-hosted Playboy TV show made its debut.

The prophet of pop hedonism had instinctively realized what sociologists had been saying for years—that the Puritan ethic was dying in the U.S. and that pleasure and leisure were becoming positive, universally desired values. He had brilliantly linked sexual license with upward mobility, as his magazine glorified the trappings of the "swinging" lifestyle: sleek cars and stereo sets, fine wines and foods. Four decades later, Hefner is still playing the roué on TV, though his stable of playmates is smaller: in 1968 he shared his Chicago mansion with 24 girlfriends. ∎

Looked up to *In a 1968 Gallup poll of the most admired people in the world, Graham, above, placed third, after Dwight Eisenhower and Lyndon Johnson, but ahead of Robert F. Kennedy (4), Pope Paul VI (5) and George Wallace (8)*

All work, no play? *Hefner, right, seemed to be living a hedonist's dream in 1968: his mansion boasted a swimming pool with private grotto and a bar reached by a fire pole. In fact, TIME declared in 1967, "he has succumbed to the work ethic"*

34

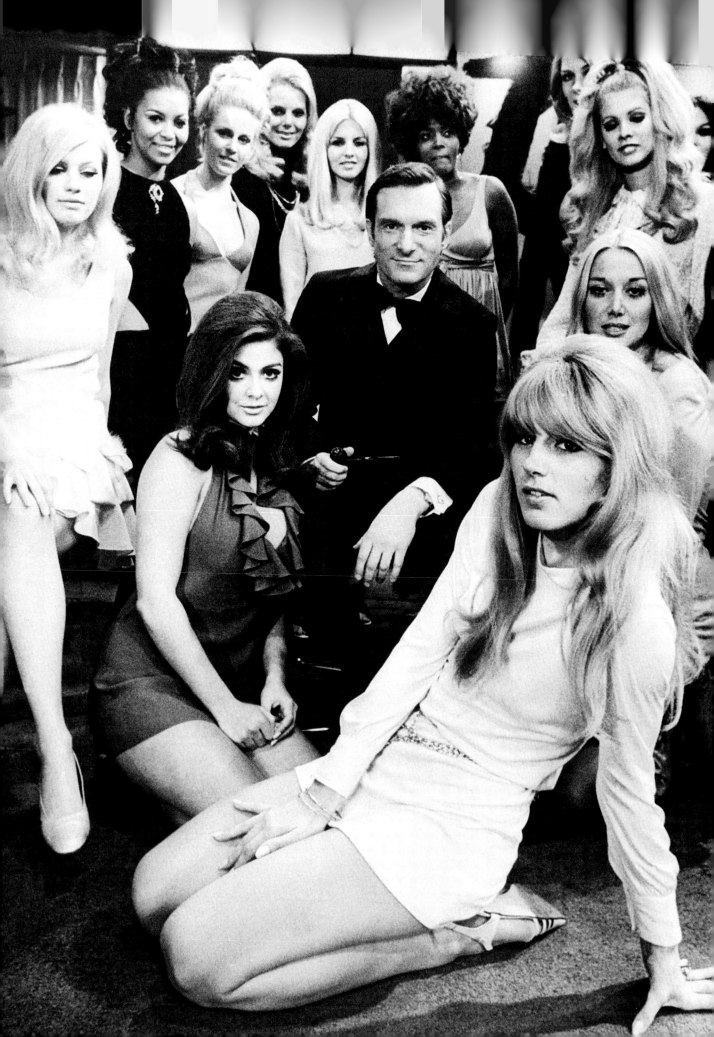

Worn down *Lyndon Johnson, a strong man, was shattered by his inability to control events in Vietnam. Below, in July 1968, he slumps in dejection upon listening to tape recordings on which his son-in-law, Captain Charles Robb, told of his heartbreak at losing young soldiers under his command in Vietnam*

Exit Strategy

Two months after the Tet Offensive begins, President Lyndon B. Johnson stuns Americans—and puts the Oval Office in play—by declaring he will not run for re-election

WHEN TIME DESIGNATED PRESIDENT LYNDON B. Johnson the Person of the Year 1967, the editors called on brilliant caricaturist David Levine to create a memorable cover image: Johnson as King Lear, beset by two renegade legislators, Senator Robert F. Kennedy and Congressman Wilbur Mills, as Goneril and Regan, with Vice President Hubert Humphrey as a loyal Cordelia. The portrait registered L.B.J.'s monumental fall from grace with the American people. After becoming President upon John F. Kennedy's assassination in 1963, Johnson won election in his own right in 1964 by one of the greatest margins in U.S. electoral history, beating Republican Barry Goldwater 61% to 38%. L.B.J. had gone on to pass two major civil-rights bills and to launch the Great Society, the historic social plan that brought the nation Medicare, Head Start and many more programs long advocated by liberal Democrats.

Yet by early 1968, everything had soured for Johnson, as the nation watched its young men drafted to serve in a controversial war and disaffected blacks burn down their own neighborhoods. Rarely had the voices of dissent been raised so loud or trained on so many issues. The nation was so divided over Vietnam that it was no longer possible for the President or many of his Cabinet members to travel without the danger of a rowdy demonstration. Outside the White House gates, protesters chanted, "Hey, hey, L.B.J./ How many kids did you kill today?" Johnson's own party was in open rebellion: Senators Kennedy and Eugene McCarthy were strongly challenging his renomination. Surveys taken before the Wisconsin primary gave L.B.J. a humiliating 12% of the vote.

On March 31, Johnson stunned Americans by declaring he would not seek re-election. He delivered the news at the end of a national TV broadcast in which he announced an about-face in his Vietnam policy: the U.S. would temporarily halt its massive bombings of North Vietnam in hopes of starting peace talks with Hanoi.

The President's decision would play a critical role in the jittery vibe that rattled America in 1968: by making himself a lame duck nine months before the November election, he left a glaring vacancy at the helm of the ship of state. With his authority deeply compromised, L.B.J. could only watch as the nation spun ever more swiftly into a spiral of assassinations, riots and recriminations: a house divided against itself, barely standing. ∎

The Unforeseen Eugene

The highly unusual political events of 1968 had their origin thousands of miles from the U.S., in the jungles of Vietnam, where some 500,000 young Americans were engaged in a deadly struggle against communist North Vietnam on behalf of U.S. ally South Vietnam. As President Lyndon Johnson continued to ramp up the U.S. commitment, critics at home, in ever great numbers, began questioning not only the conduct of the war but also its very necessity.

The forces opposed to the war cheered on Nov. 30, 1967, when a little-known Democratic Senator from Minnesota, Eugene McCarthy, 51, declared he would run against Johnson for the party's nomination. "McCarthy's entry into the primaries against an incumbent President was unforeseen," TIME said. "His appeal on the stump, despite a low-key approach, was unforeseen." Most unforeseen of all: McCarthy rallied the hopes of young people opposed to the war. College students, vowing to get "clean for Gene," trimmed their hair and shaved off their beards, then marched the streets of New Hampshire to support McCarthy, who ended up in a near tie with L.B.J. in the first Democratic primary of 1968. Johnson declared he would not run for re-election 19 days later.

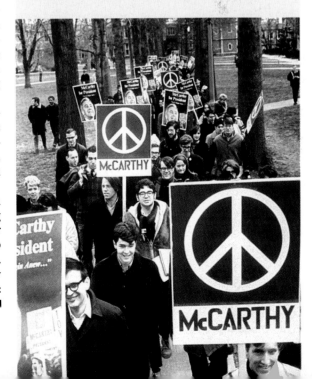

"… I've seen the Promised Land. I may not get there with you. But I want you to know tonight, that we, as a people, will get to the Promised Land"

—The Rev. Martin Luther King Jr.,
 April 3, 1968, Memphis

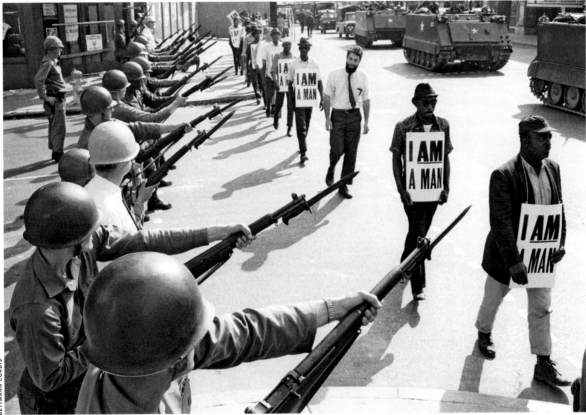

BETTMANN CORBIS

A Dreamer Dies

Rev. Martin Luther King Jr. is assassinated in Memphis, silencing the civil rights movement's most eloquent voice

THE ASSASSINATION OF THE REV. MARTIN LUTHER King Jr. not only robbed America of one of its greatest moral leaders; it also was the signal event that kick-started the careering, out-of-control trajectory of 1968. Coming only eight weeks after the Tet Offensive revealed the fragility of the U.S. position in Vietnam—and only days after unpopular President Lyndon B. Johnson stunned Americans by stating he would not stand for re-election—King's death magnified the sickening sense among many Americans that their nation was a runaway train with the passengers at odds, violence in the air and a lame-duck leader at the throttle.

King had been propelled to fame in his late 20s by his leadership of the successful boycott of the Montgomery, Ala., public transit system in 1956. Soon the young preacher, a graduate of all-black Morehouse College and Boston University, became the acknowledged leader of the burgeoning movement for civil rights for American blacks. King did not invent that movement, but he galvanized it with his soaring oratory, gave it momentum and steered it toward nonviolence. His mis-

sion reached its peak in the March on Washington of August 1963, when King challenged the nation with his famed peroration at the Lincoln Memorial. "I have a dream!" he cried, and it seemed his dream was becoming reality. TIME named King its Person of the Year 1963, and the next year he received the Nobel Peace Prize. Yet though 1965 marked the enactment of the Voting Rights Law and King's successful campaign to register black voters in Selma, Ala., it also saw rioting break out in the Watts ghetto in Los Angeles. In 1966 and '67, riots erupted in other major cities—Detroit, Newark, Cleveland.

To many blacks, the pace of gain was too slow and the rewards too meager. By the spring of 1968 the cause King served with such eloquence and zeal was beginning to pass him by. To a new generation of black militants, his strategy of nonviolence, moderation and partnership with white political leaders in Washington had come to seem naive, outmoded, even suicidal.

Black militants would use his murder to cry, "The civil rights movement is dead!" But they had said it long before his assassination. For many African Americans,

BETTMANN CORBIS

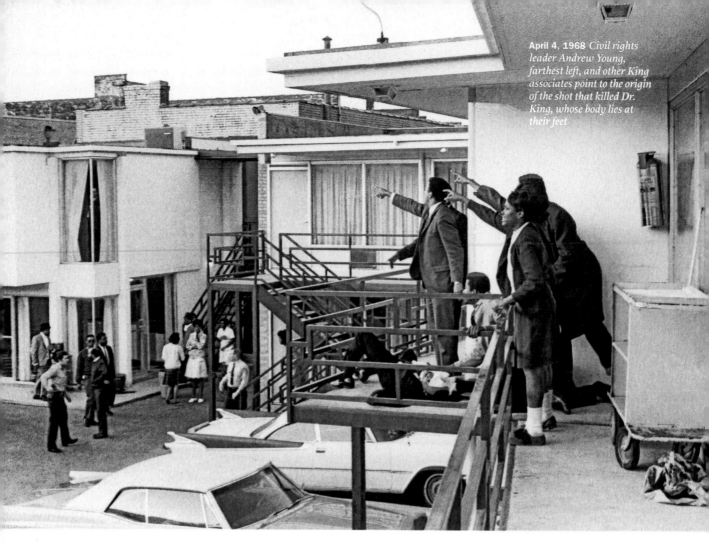

April 4, 1968 *Civil rights leader Andrew Young, farthest left, and other King associates point to the origin of the shot that killed Dr. King, whose body lies at their feet*

King was dangerously close to slipping from prophet to patsy. For years, behind his back, his black denigrators had called him "de Lawd." Lately he had heard himself publicly called an Uncle Tom by radicals out to steal both headlines and black support.

Yet if ever there was a transcendent symbol of American ideals and brotherhood, it was Martin Luther King. Bridging the void between black despair and white unconcern, he spoke so powerfully about the unjust condition of U.S. blacks that he became the moral symbol of civil rights not only to America but also the world beyond. With his assassination, the heroic age of the civil rights movement came to an end, and America entered a confusing period when no single figure could claim to speak on behalf of the entire black community and both King's detractors and presumptive heirs jousted to win the allegiance of their fellow African Americans.

THE PROXIMATE CAUSE OF KING'S DEATH WAS, IRONically, a small-time labor dispute: the month-old strike of 1,300 mostly black sanitation workers in Memphis, where the white city leadership was refusing their appeals for modest pay hikes. King had initially hesitated to lend his authority to this relatively minor cause, but in late March he went to Memphis to inspire the striking workers, and now, on April 3, he returned.

The Eastern Airlines jet that carried King from Atlanta to Memphis was delayed 15 minutes before takeoff while crewmen checked its baggage for bombs that anonymous callers had warned were aboard. That was not particularly unusual: back in Montgomery, a 12-stick dynamite bomb had been thrown on his porch but failed to explode. In Harlem in 1958, a deranged black woman stabbed him dangerously near the heart. He had been pummeled and punished by white bullies in many parts of the South. He was hit in the head by a rock thrown in Chicago.

But when King arrived in Memphis, he met a different challenge. Some newspapers had emphasized during the previous week that the antipoverty activist had been staying at the luxurious Rivermont, a Holiday Inn hostelry on the Mississippi's east bank, which charged $29 a night for a suite. To repair his image, King checked into the black-owned Lorraine, a nondescript, two-story cinderblock structure near Memphis' renowned Beale Street. At the Lorraine, King and his entourage paid $13 a night for their green-walled, rust-spotted rooms.

Across Mulberry Street from the Lorraine, on a slight rise, stood a nameless rooming house adorned only with a metal awning whose red, green and yellow stripes shaded an equally nameless clientele. Into that dwelling—actually two buildings, one for whites, the other for blacks, and connected by a dank, umbilical hallway—walked a young, dark-haired white man in a neat business suit. "He had a silly little smile that I'll never forget," said Bessie Brewer, manager of the rooming house. The man, who called himself John Willard, chose Room 5, with a view of the Lorraine, and paid his

Stricken *King's body is taken from the balcony of the Lorraine Motel to a waiting ambulance*

$8.50 for the week with a crisp $20 bill—another rarity that stuck in Mrs. Brewer's mind.

Back at the Lorraine, King and his aides were finishing a long, hot day of tactical planning for a march the next week. During the session, King had assured his colleagues that, despite death threats, he was not afraid. "Maybe I've got the advantage over most people," he mused. "I've conquered the fear of death."

Just the night before, King had anticipated his death in the conclusion of an exultant speech to the striking Memphis workers. "We've got some difficult days ahead," he declared. "But it doesn't matter with me now. Because I've been to the mountaintop. And I don't mind. Like anybody, I would like to live a long life. Longevity has its place. But I'm not concerned about that now. I just want to do God's will. And he's allowed me to go up to the mountain. And I've looked over. And I've seen the promised land. I may not get there with you. But I want you to know tonight, that we, as a people, will get to the Promised Land. And I'm happy tonight. I'm not worried about anything. I'm not fearing any man. Mine eyes have seen the glory of the coming of the Lord."

After the strategy session, King washed, dressed for dinner and chatted with his aides, including his close associate, Andrew Young, and a rising star of the civil rights movement, the young Chicago minister Jesse Jackson, only 27. Then King walked out of Room 306 onto the second-floor balcony of the Lorraine to take the evening air. Leaning casually on the green iron railing,

King's Assassin

James Earl Ray, the confessed killer of Martin Luther King Jr., was captured at London's Heathrow Airport on June 8, 1968, two months after King's murder. Ray, an escapee from a Missouri state penitentiary, confessed in March 1969 to having murdered King, only to perform one of criminology's most famous about-faces, protesting his innocence for the remainder of his 99-year sentence. In June 1977 Ray and six other convicts escaped from Tennessee's Brushy Mountain State Penitentiary, but they were recaptured three days later.

Ray died in prison on April 23, 1998, at age 70. In the years preceding his death, he found support for his contention that he had been set up as the fall guy in King's assassination from a most unlikely source: the King family. In response to the charges leveled by the family and Ray attorney William Pepper, President Bill Clinton ordered a formal investigation by the U.S. Department of Justice into King's murder and Ray's conviction. The commission's report, issued in 2000, found no credible evidence that Ray was innocent and recommended that no further investigation be undertaken.

Veteran TIME reporter Jack White, who followed the case for years, wrote at the time: "... the King family has offered not a shred of credible evidence to support their charges of a wide-ranging government conspiracy ... What they serve up instead is a murky brew of truths, quarter-truths and outright lies assembled by the latest in a long string of Ray defense lawyers."

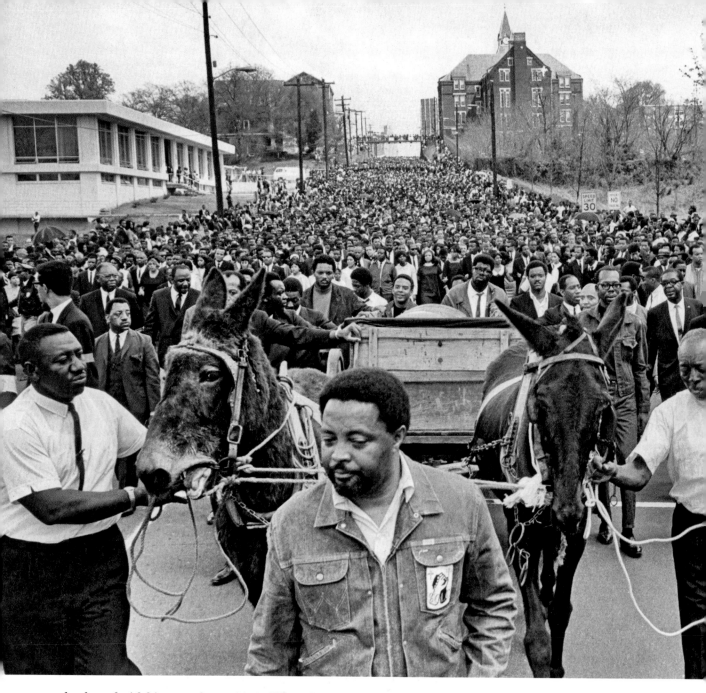

he chatted with his co-workers as his Cadillac sedan was readied in the dusk below.

Then, from a window of the rooming house across the way, came a single shot. "It was like a stick of dynamite," recalled an aide. As those on the balcony hit the deck, the heavy-caliber bullet smashed through King's neck, severing his spinal cord and slamming him away from the rail, up against the wall, with hands drawn tautly toward his head. "Oh, Lord!" moaned one of his lieutenants as he saw the blood flowing over King's white button-down shirt.

His aides tenderly laid towels over the gaping wound; some 30 hard-hatted Memphis police swiftly converged on the motel in response to the shot. In doing so, they missed the assassin, whose weapon (a scope-sighted 30.06-cal. Remington pump rifle), binoculars and suitcase were found near the rooming house. A spent cartridge casing was left in the grimy lavatory. The range from window to balcony: an easy 205 ft.

An ambulance came quickly, then raced to St. Joseph's Hospital, two miles away. Moribund as he entered the emergency ward, Martin Luther King Jr., 39, was pronounced dead within an hour of the shooting. His death was the 12th major assassination in the American civil rights struggle since 1963; in response, riots broke out in black districts across the land (*see following story*).

FIVE DAYS LATER, AMERICANS CAME TOGETHER TO pay their final respects to King. Not since the funeral of John F. Kennedy five years before had the nation so deeply involved itself in mourning. Streets customarily thronged with busy city traffic echoed eerily and emptily under sunny skies; banks and department stores, their windows unlit, were closed all or most of the day; schools in many cities were shuttered in tribute, as Americans turned to their TV sets. An estimated 120 million watched a funeral procession and service that lasted more than three hours.

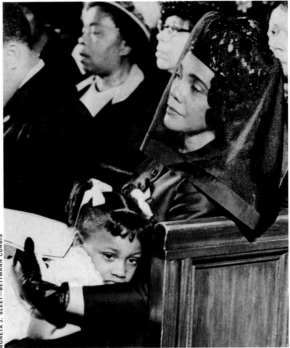

MONETA J. SLEET—BETTMANN CORBIS

Solemnities *At left, King's mule-born cart passes through the streets of Atlanta on April 9. Above, widow Coretta Scott King comforts youngest daughter Bernice, 5, during the funeral*

The march King led in death through Atlanta proved grander—both in attendance and dedication to his ideals—than any he had led in life. Fully 200,000 Americans, black and white, walked Atlanta's sun-beaten streets, as temperatures reached 82°F. By 10:30 a.m., the nominal starting time, more than 35,000 people had packed the side streets around the red brick Ebenezer Baptist Church on Auburn Avenue, where King had served as co-pastor for eight years.

It was a humbling experience for some of the 60 U.S. Congressmen who found themselves forced to wait outside, including Illinois' Senator Charles Percy, Maine's Edmund Muskie and Texas' Ralph Yarborough. No such indignities beset Harry Belafonte, who sat in a front row, as did comedian Dick Gregory. Before the service, Richard Nixon leaned over to whisper hello to Jacqueline Kennedy, black-draped in the pew ahead; he received an icy stare in return.

After the service, Black Power advocate Stokely Car-

michael, wearing a black suit, dark blue Mao shirt, shades and zippered suede boots, darted over to Coretta Scott King and began a whispered conversation. Mrs. King listened for several minutes, then dismissed him. Vice President Hubert Humphrey, on hand as the President's special representative, stared tight-lipped from his seat a coffin-length away.

Then followed a four-mile march to the campus of Morehouse College, one of countless processions that Americans undertook that week in King's honor. On a sharecropper's cart drawn by a brace of mules, King's coffin, followed by his Atlanta mourners, passed the helmeted, machine-gun-armed cops of Governor Lester Maddox at the Georgia Statehouse. Maddox, elected because of his strong stand against racial integration in Georgia, had refused to close schools on the funeral day and later protested the lowering of the flag to half-staff. The procession terminated at the college where King had graduated at age 19.

There, on a quadrangle crowded with 100,000 mourners, Morehouse president emeritus Benjamin E. Mays, 72, eulogized the man whose eloquence he had hoped would ease his own passage. The two ministers had agreed that the one who survived would deliver the other's eulogy. "Too bad, you say, Martin Luther King Jr. died so young," preached Mays. "Jesus died at 33, Joan of Arc at 19, Byron and Burns at 36. And Martin Luther King Jr. at 39. It isn't how long but how well." The magnetic voice of the civil rights movement had been silenced. But the demands for equality it so memorably expressed would only gather force in the years to come. ■

Funeral Pyres

The nation's ghettos erupt in flames as
blacks vent their fury over Martin Luther King's murder, but in a final tribute to his message, peace soon prevails

AFTER AMERICA'S MOST ELOQUENT PROPONENT OF civil rights and racial harmony was murdered, a shock wave of looting, arson and outrage swept the nation's black ghettos. In their geographical range, the riots exceeded anything in the American experience: by week's end, 168 towns and cities had been shaken by rioting. The outbursts touched off by the assassination of the Rev. Martin Luther King Jr. were intense, but in welcome contrast to the long, deadly racial riots of recent summers in many U.S. cities—Los Angeles in 1965, Detroit and Newark in 1967—they were relatively brief. Order was soon restored in most cities, and they remained calm for the rest of the year.

The restraint resulted in part from the inchoate sense of guilt the vast majority of U.S. whites felt over King's death. The unprecedented cooperation of many black leaders—both moderate and militant—also helped pacify angry slum dwellers. Tensions were also reduced by the lessons learned from three years of urban upheaval. Following the deadly riots of 1967, President Lyndon Johnson convened a committee led by Ohio Governor Otto Kerner to address the causes of urban violence. Its report was released on Feb. 29, 1968—only five weeks before King's assassination. When cities erupted after King's death, many lawmen heeded the report's findings, which warned that "the use of excessive force— even the inappropriate display of weapons—may be inflammatory and lead to worse disorder."

Across the country, police refrained from using guns, and magistrates quickly processed those arrested for rioting, setting low bail, as the commission urged. Police and National Guardsmen kept their weapons holstered or unloaded except in cases of extreme provocation. "Police have shown remarkable restraint," said former Committee on Racial Equality (CORE) leader James Farmer. In

all, 43 deaths nationwide were attributed directly to the riots, fewer than in Detroit's 1967 uprising alone.

In Newark, where 23 people lost their lives in days of rioting in the summer of 1967, there were no casualties, and only one shot was fired—by a policeman, as a warning into the air. Some 200 young blacks from the United Community Corp., Newark's antipoverty organization, patrolled the ghetto, keeping the peace. The kids made an impressive contribution to cool; so did a courageous "Walk for Understanding" by 25,000 people, predominantly white suburbanites, who hiked through the city's smoldering Central Ward to show solidarity with blacks.

Washington, afflicted for the first time since 1962 by racial turmoil, endured three days of severe pillaging and burning that brought a force of 15,246 regular troops to its defense. Total damage to the capital's buildings and property: $13.3 million, highest in the U.S. The 711 fires around the city were a reminder of an earlier

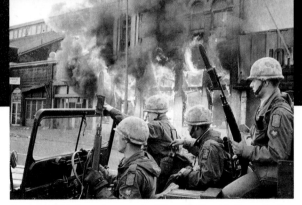

On guard *U.S. Army troops patrol Seventh Street in the nation's capital on April 6, two days after King's assassination. Above, firefighters battle blazes set by arsonists in Chicago*

era, when British troops burned the capital in 1814.

Many major cities remained relatively quiet: New York City, Detroit, Cleveland, Los Angeles and Milwaukee, among others. In all of them, black militants were among the most influential peacemakers, as the majority of African Americans rejected the call of activist Stokely Carmichael to "get your gun." Even in death, Martin Luther King Jr.'s message of progress through nonviolence still resounded across the land. ∎

Back to the Roots

Not all revolutions are political: as African Americans began raising their voices and taking more pride in their heritage and culture in the 1960s, their newfound confidence was expressed in a fresh embrace of all things African and black. Afro hairdos were one of the most visible symbols of black pride; others included the wearing of brightly colored dashikis and African jewelry

Say It Loud!

We're black, and we're proud!

African Americans embrace their heritage, even as militant blacks call for revolution in the streets

POWER TO THE PEOPLE

A Bedraggled March on Washington

In the months before his death, the Rev. Martin Luther King Jr. was working on a major national protest campaign intended to highlight his new agenda: he was hoping to move beyond his crusade for racial justice and begin a broader-based movement for economic justice in America. The plan was dubbed "The Poor People's Campaign"; its centerpiece was intended to be a march on Washington by a "multiracial army of the poor" that would put pressure on Congress to pass a proposed Poor People's Bill of Rights. But King's murder robbed the effort of its driving wheel, and though his successor as head of the Southern Christian Leadership Conference, the Rev. Ralph Abernathy, did his best to keep the momentum of the campaign going, he lacked King's galvanizing presence.

In May, with the approval of the government, protesters set up a tent city along the National Mall. But "Resurrection City" soon became a swamp of mud and a magnet for violence that had the perverse effect of diminishing support for King's cause and marring his legacy. Lyndon Johnson's White House responded with a few minor initiatives, but after a tepid final rally on June 19, the campaign was abandoned. TIME's verdict: "The marchers can leave with some claim to victory, though, sad to say, it is mostly illusory."

A New Brand of Militant Leaders

Martin Luther King Jr.'s last book was titled *Where Do We Go from Here?* The question wasn't rhetorical. Well before King's murder in Memphis, the civil rights movement was divided, with no clear direction, no certain answers and dozens of would-be leaders vying for the allegiance of African Americans. With King's death, the question became urgently compelling. Even as black leaders long regarded as radical worked with white authorities in cities across America to keep neighborhoods from burning—Mau Mau chieftain Charles Kenyatta in New York City, Black Nationalist Ron Karenga in Los Angeles, playwright LeRoi Jones (Amiri Baraka) in Newark, N.J.—more and more blacks were attracted to the rising generation of militant leaders who advocated aggressive tactics to counter what they viewed as a deeply racist and unjust society. As with so many of the clashes of 1968, the result was bloodshed, demonization and division.

Leading the new black militants was the Black Panther Party, founded in 1966 in Oakland, Calif., by Bobby Seale and Huey P. Newton. The Panther uniform of black jackets, black berets and tight black trousers gave the group a military air that scared the pants off many white Americans.

As the Panther train picked up steam, longtime activists Stokely Carmichael, right, and H. Rap Brown, behind him, defected from the Student Nonviolent Coordinating Committee to join the group. Another potent new Panther was Eldridge Cleaver, left. A former convict whose 1968 book *Soul on Ice* became a classic, prophetic work of black rage and empowerment, Cleaver "knew how to grab the imagination of the people!" Seale recalled for TIME after Cleaver's death in 1998.

The authorities cracked down hard on the militants. Cleaver,

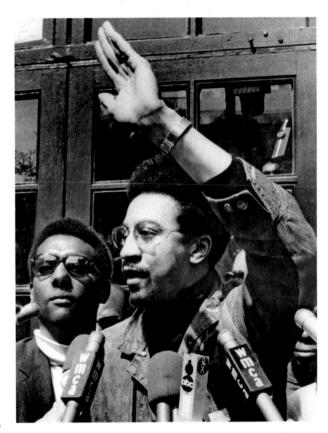

the Panthers' Minister of Information, ended the year a fugitive from justice; after he was wounded in a firefight with Oakland police in April, his parole was revoked and he went into hiding. In October, Newton was convicted of manslaughter in the killing of a policeman in 1967 (the charges were later dropped). Also in October, a New Orleans jury found Brown guilty of violating a seldom-used federal law that banned the carrying of a firearm across a state line while under indictment. As of early 2008, Brown was serving a life term in prison for his role in the killing of two police officers.

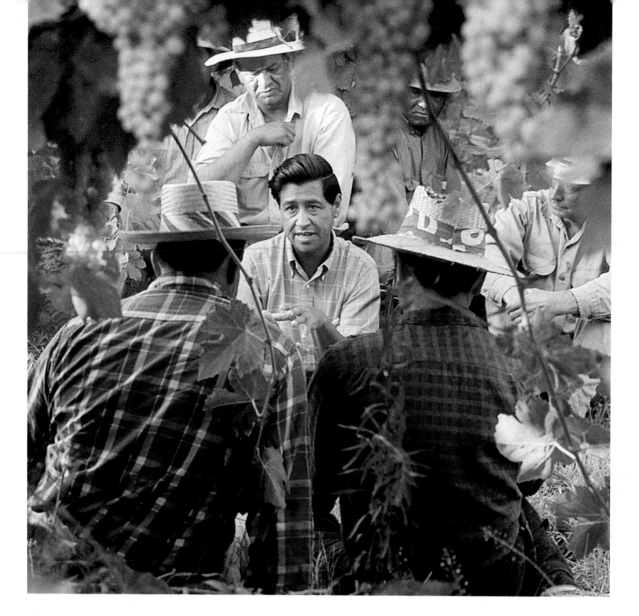

Cesar Chavez, Labor Leader

THREE WEEKS AND FOUR DAYS IN THE EARLY SPRING OF 1968 TRANSformed Cesar Chavez from an obscure regional labor leader into a working man's hero. At the start of the year, Chavez, the Mexican-American co-founder and leader of the United Farm Workers, was caught between Scylla and Charybdis. The California grape growers against whom he was leading a 35-month-old strike were increasingly resorting to the use of physical force against their underpaid workers. Chavez's constituents, many of them Mexicans, were seething with frustration and becoming more inclined to meet violence with violence. Chavez, a devout Roman Catholic, embarked on a 25-day fast, subsisting only on water and daily Communion wafers. Deeply committed to nonviolence, he intended to shame the growers into making concessions while also leading his followers, by example, away from the use of force and into the embrace of passive confrontation.

When Chavez's fast ended on March 10, five of nine major growers had signed contracts with the United Farm Workers, and his followers were newly inspired to peaceful resistance. With Senator Robert F. Kennedy (who called Chavez "one of the heroic figures of our time") at his side, Chavez attended Mass and then spoke to more than 8,000 assembled admirers. "I am convinced that the truest act of courage, the strongest act of manliness, is to sacrifice ourselves for others in a totally nonviolent struggle for justice," said the man who had lost 30 lbs. and was too weak to walk without assistance. "To be a man is to suffer for others. God help us to be men!" ■

In the arena *Chavez, above, led a long fight for dignity for his fellow Chicanos before his death in 1997.* TIME *was among those needing instruction; it referred to Chavez's followers as "wetbacks" several times in 1968*

Appetite for power *Jackson, top right, speaks at the Poor People's Campaign camp in Washington, where he and several hundred followers lunched at a Department of Agriculture cafeteria but refused to pay. Jackson argued the meal was owed "for all the lunch programs we didn't get"*

Pioneer *Chisholm, right, ran for the Democratic nomination for President in 1972, the first black person to do so; she won 162 delegates. She died in 2005 at 80*

48

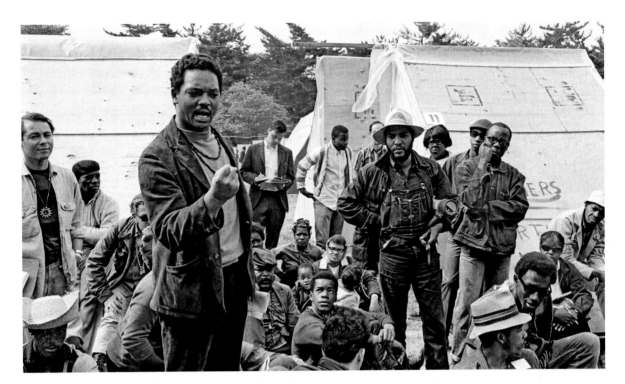

Jesse Jackson, Civil Rights Leader

THE EVENTS OF A TUMULTUOUS YEAR TRANSFORMED JESSE JACKSON, 26, INTO A NATIONAL FIGURE, SHOW-casing all facets of the outsized figure Americans know today: ambitious, sometimes grandstanding, but also a leader of undeniable passion, energy and eloquence. He was ordained a Baptist minister, even though he hadn't quite completed the required coursework at Chicago Theological Seminary. He watched his mentor, Martin Luther King Jr., perish in front of his eyes, then, whether justly or not, was accused by King's acolytes of trying to claim the fallen leader's mantle by telling exaggerated tales of how King had whispered his last words to Jackson. He used King's Operation Breadbasket to bring much needed money and jobs into Chicago's black neighborhoods, even as he was accused by the white business estab-lishment of demagoguery and blackmail. TIME described him in March 1968 as "a burly, apothegmatizing King lieutenant who praises the Lord and believes in the might of economics," who had "wrested work from ghetto businessmen for 3,000 of his flock and boosted South Side Negroes' annual income by $22 million." ∎

Shirley Chisholm, Representative

UNBOUGHT AND UNBOSSED" WAS THE CAMPAIGN SLOGAN 43-year-old Shirley Chisholm chose for her 1968 run for Congress. The Democrat meant it literally: though victory for a black was virtually ensured in her Brooklyn district, she was dismissed by the African-American political establishment, which favored the Republican national civil rights leader James Farmer. He soon declared "women have been in the driver's seat" in black communities for too long, forgetting not only that the district was overwhelmingly black but also that most of its voters were female.

Chisholm, the first black woman ever elected to the U.S. House of Representatives, bucked tradition by balking at an assignment to the Agriculture Committee—irrelevant to her urban district—quipping, "Apparently all they know here in Washington about Brooklyn is that a tree grew there." She was soon reassigned to another committee, and Washington's male power brokers learned what Brooklyn's had before them: don't trifle with Shirley Chisholm. ∎

When Rock Ruled

New sounds, new stars
and a new political edge make 1968's music vital

ARETHA FRANKLIN AND JIM MORRISON OF the Doors may not have had much in common as artists, but they both topped the charts in 1968. Their success is emblematic of a period of bubbling musical ferment, when audiences were open to a wide range of different styles: among the year's hitmakers were country star Johnny Cash; psychedelic San Francisco groups; dance-oriented Motown acts; veteran "British Invasion" bands; and even Louis Armstrong, 67, who scored a late-career hit with (*What a*)*Wonderful World.* Reigning over this yeasty scene were the two forces that had led the transformation of pop music from a minor adjunct of adolescence into the most vital artistic force of the era: England's Beatles and the shape-shifting American songwriter Bob Dylan.

In 1968 rockers were looking beyond the allure of psychedelia and using their music to explore the cultural and political divides of the era. Rock 'n' roll stopped rolling; it became, simply, rock: a louder, angrier force that, like its listeners, had grown up. Music, once no more than a lark, turned dark, giving voice to all the fury and frenzy of a society that seemed to be in the middle of an accelerated nervous breakdown. ∎

Aretha Franklin

The daughter of Detroit Baptist preacher the Rev. C.L. Franklin graced TIME's *cover in June 1968. "She flexes her rich, cutting voice like a whip," the magazine said. "She does not seem to be performing so much as bearing witness to a reality so simple and compelling that she could not possibly fake it." Franklin, then 26, had become a star in 1967 with her gender-switching cover of Otis Redding's song* Respect. *Atlantic Records producer Jerry Wexler struck gold by pairing "Lady Soul" with a Memphis rhythm section.*

The Doors

TIME *first reported on the Doors
and their magnetic lead singer, Ji
Morrison (then only 23), late in 1
noting, "[Their music] takes them
only past such familiar landmark
the youthful odyssey as alienation
sex, but into the symbolic realism
the unconscious—eerie night wor
filled with throbbing rhythms, sh
metallic tones, unsettling images.
In 1968 the band confronted the
crisis in Vietnam on its third albu*
Waiting for the Sun, *in the bitte
antiwar song* The Unknown
Soldier. *The group told* TIME *they
hoped to create music "with the
structure of poetic drama." Morri
died only three years later, in 197*

Jimi Hendrix

The year after he soared at fame at the Monterey Pop Festival by dousing his instrument with lighter fluid and setting it on fire, Jimi Hendrix, 25, was at the peak of his all-too-brief career as rock's greatest guitar shaman. TIME caught his show in Cleveland in April, and reported, "[Jimi] hopped, twisted and rolled over sideways without missing a twang or a moan. He hung the guitar low over swiveling hips, or raised it to pick the strings with his teeth; he thrust it between his legs and did a bump and grind, crooning, "Oh, baby, come on now, sock it to me!" Later in 1968, Hendrix released the album Electric Ladyland, featuring his classic version of Bob Dylan's All Along the Watchtower. Only two years later, Hendrix would die in London; like Janis Joplin and Jim Morrison, he was a victim of success—and excess.

Big Brother and the Holding Company with Janis Joplin

Like Jimi Hendrix, San Francisco band Big Brother and the Holding Company found fame at the 1967 Monterey Pop Festival, as their Texas-born lead singer, Janis Joplin, 25, infused their psychedelic blues sound with sheer lung power and raw charisma. In this picture, the group is playing at promoter Bill Graham's famed New York City venue the Fillmore East, against a hallucinatory backdrop provided by the Joshua Light Show. 1968 was the band's high point; their best album, Cheap Thrills, was released in August. Featuring the hit single Piece of My Heart and delightfully loony cover art by underground comics guru Robert Crumb, the record was No. 1 on the charts for weeks. TIME's reviewer noted, "[Joplin's] big raw voice is an instrument in the process of being destroyed by the passion with which she plays it." The statement might also have applied to her spirit: Joplin would be dead within two years of her 1968 heyday.

JBA CAMERA PRESS—RETNA

The Rolling Stones

Britain's bad-boy purveyors of retooled U.S. rhythm-and-blues took an unusual career detour late in 1967, following the Beatles into pop psychedelia with the wannabe Sgt. Pepper *album* Their Satanic Majesties Request. *But the Stones weren't cut out to be wizards of the studio; as a great live act, their specialty was exciting libidos rather than expanding minds. Said guitarist Keith Richards: "I'd grown sick to death of the whole Maharishi guru s___ and the beads and bells."*

In 1968 the Stones got back to their roots with a vengeance, releasing the potent single Jumpin' Jack Flash *and the zeitgeist-defining anthem* Street Fightin' Man. *Their late 1968 album* Beggars Banquet *was a strong return to form. In December 1968 they staged a concert-cum-promotional stunt, "The Rock and Roll Circus," in which ringmaster Mick Jagger cracked the whip over such stars as John Lennon, Yoko Ono, Eric Clapton and the Who. But production snafus resulted in poor performances, and the film was not released until 1996.*

James Brown

"Say it loud—I'm black and I'm proud!" That was the title boast of James Brown's hit 1968 single—and as the leader of music's tightest band and the progenitor of the bubbling soul-on-overdrive sound that would become known as funk, Brown had every right to make it. When the swivel-hipped, sweating, groove machine proclaimed himself "the hardest-working man in show business," no one argued. In embracing the new Black Power movement, Brown became a powerful voice for the aspirations of African Americans. Above, he performs for U.S. troops in Vietnam.

Led Zeppelin

These baby-faced British rockers came together in 1968; within a few years the sound they helped pioneer, heavy metal, was rock's default format. Jimmy Page, center, was a respected studio guitarist who had played with top blues act the Yardbirds since 1966; bassist John Paul Jones, top, was a well-known multi-instrumentalist. The pair enlisted two unknowns—Birmingham singer Robert Plant, right, and his pal, drummer John Bonham, left—to join them. Taking a name coined by Who drummer Keith Moon, the new group played its first gig on Oct. 15, 1968, and made its U.S. debut in December.

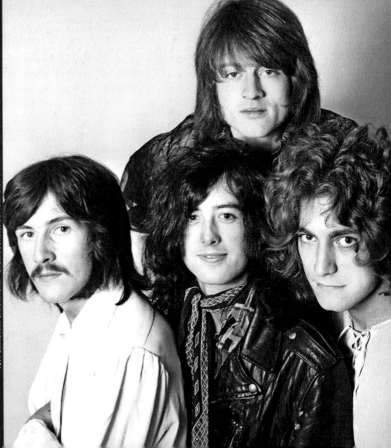

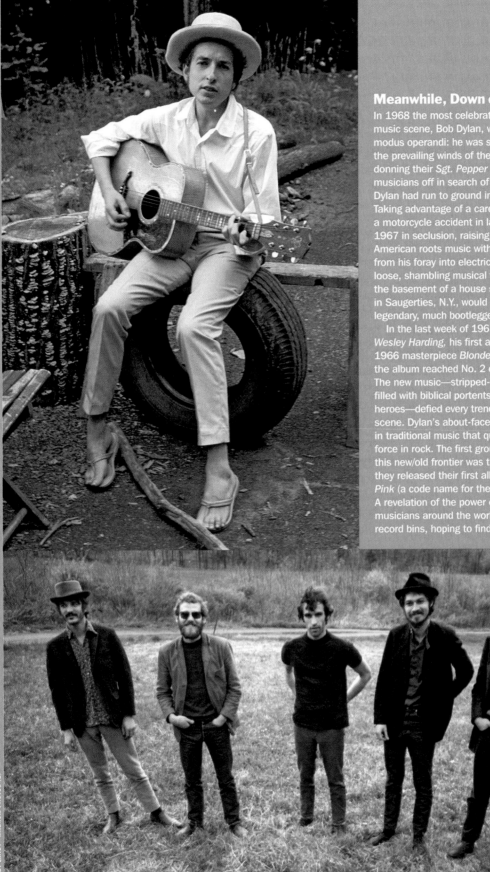

Meanwhile, Down on the Farm …

In 1968 the most celebrated contrarian of the '60s music scene, Bob Dylan, was following his standard modus operandi: he was sailing full speed against the prevailing winds of the era. As the Beatles were donning their *Sgt. Pepper* outfits and sending other musicians off in search of psychedelic frontiers, Dylan had run to ground in Woodstock, N.Y. Taking advantage of a career hiatus offered by a motorcycle accident in late July 1966, he spent 1967 in seclusion, raising a family and exploring American roots music with the backup musicians from his foray into electric rock, the Band. The loose, shambling musical tall tales they recorded in the basement of a house shared by Band members in Saugerties, N.Y., would later become the legendary, much bootlegged "Basement Tapes."

In the last week of 1967, Dylan released *John Wesley Harding,* his first album since his mercurial 1966 masterpiece *Blonde on Blonde.* In 1968 the album reached No. 2 on the U.S. music charts. The new music—stripped-down acoustic songs filled with biblical portents and American folk heroes—defied every trend on the current pop scene. Dylan's about-face sparked a new interest in traditional music that quickly became a defining force in rock. The first group to stake a claim on this new/old frontier was the Band, below. In 1968 they released their first album, *Music from Big Pink* (a code name for the Saugerties house). A revelation of the power of roots rock, it sent musicians around the world panning for gold in old record bins, hoping to find the future in the past.

Deus ex machina *A 1st Air Cavalry Skycrane helicopter delivers supplies to some 6,000 U.S. Marines who weathered a 77-day siege at the forward outpost of Khe Sanh while surrounded by some 40,000 North Vietnamese troops*

The Siege Of Khe Sanh

Surrounded and outnumbered, tough U.S. troops stand fast in an isolated citadel

FORMER U.S. MARINE CLIFFORD TREESE VIVIDLY REMEMBERS HIS WELCOME to the besieged outpost of Khe Sanh in northwest South Vietnam in January 1968. Surrounded by North Vietnamese Army (NVA) troops, the combat base was accessible only by air. As he approached the U.S. citadel in a C-130 cargo plane, Treese recalls, "I noticed several holes in our plane. One of the crew members said we were being shot at. Then he said that as we touched down, we wouldn't be stopping because the NVA was shelling the runway." Instead, Treese, part of an artillery crew, was told to get behind the wheel of the 2½-ton truck in the giant plane's rear compartment. As the aircraft touched down on the runway, its back door was lowered, and, Treese says, "with the C-130 moving down the airstrip about 55 m.p.h., I drove out the open back." Seconds after the truck was out the door, the plane lifted off again, while Treese, following instructions from the aircrew, drove immediately for the side of the runway, jumped out and dove for cover. Within seconds, the area around his truck was enveloped in machine-gun and small-artillery fire.

Treese was aboard one of the last C-130s to make the descent into Khe Sanh. Within days, as the amount and tempo of enemy fire increased, these large, slow-moving cargo planes began to take unacceptable losses. "Every inch of the runway was zeroed in," recalls retired Marine pilot David L. Althoff. "If an airplane tried to land, they just walked artillery rounds right up the center line." For this reason, fixed-wing aircraft were replaced by smaller, more agile helicopters, which had a better chance of dodging incoming rounds.

The siege of Khe Sanh was a battle that both sides wanted but for very different reasons. The Americans were itching for a fight at the combat base, in the South Vietnamese highlands near both the Laotian border and the demilitarized

LARRY BURROWS—TIME-LIFE PICTURES

Exposed *These Marines, stranded on a hillside at a forward position, dig into the terrain as they await the arrival of relief troops and support helicopters. Apparently, "the smoking lamp is lit"*

zone (DMZ) that separated America's ally South Vietnam from communist North Vietnam, because they felt sure to prevail in any decisive engagement between conventional forces. They also wanted to exorcise the ghosts of a similar battle 14 years earlier: French hopes of prevailing over the anticolonial rebels led by Ho Chi Minh in Vietnam had died in 1954 at Dien Bien Phu, another mountain engagement in which regular armies faced one another head on. The Americans hoped that a clear win in a reprise of that confrontation would be the precursor to a wider victory in the war as a whole. Finally, General William Westmoreland, the commander of U.S. forces in Vietnam, wanted to keep hold of Khe Sanh because he hoped one day to use it as a jumping-off point to invade Laos and sever the Ho Chi Minh Trail, the lifeline along which supplies from North Vietnam were ferried into South Vietnam.

The North Vietnamese had a different agenda. First, they wanted to draw U.S. forces into the remote northwestern corner of South Vietnam, the better to improve the army's chances of scoring a knockout blow in the upcoming Tet Offensive, set to explode at the end of January. Second, they hoped, if against the odds, for a replay of their 1954 triumph at Dien Bien Phu. A victory in either campaign would be significant: success in both, they hoped, might tip the war decisively in their favor and drive the Americans out of Indochina entirely.

Hunkered down *A Marine takes a reading break in a well-upholstered bunker inside the Khe Sanh citadel*

BY THE LAST WEEKS OF 1967, elements from four NVA divisions were slowly filtering into the jungle around Khe Sanh. In mid-January, an estimated 40,000 enemy troops surrounded fewer than 6,000 U.S. Marines inside the combat base. Yet even with such lopsided odds, this was the sort of opportunity that U.S. military commanders always were seeking in Vietnam but seldom got: the matchup of U.S. troops against uniformed enemy soldiers (rather than guerrillas) played directly to America's strengths in the struggle.

In Saigon, General Westmoreland laid out his plan: lure the North Vietnamese into a trap, then use air power to eviscerate them. In Washington, an approving President Lyndon Johnson had a scale model of Khe Sanh, complete with actual sand and clay, set up in the White House Situation Room, and the Texan began comparing the coming battle with the famed 1836 siege of the Alamo. "I don't want any damn Dinbinphoo," Johnson warned his generals; at one point he demanded that the Joint Chiefs of Staff sign a personal pledge that Khe Sanh would not fall to the enemy.

Meanwhile, in North Vietnam's capital, Hanoi, NVA chief General Vo Nguyen Giap publicly declared his intention to kill or capture every Marine in and around Khe Sanh. "When we heard about this," recalls Treese, "it infuriated us." Although many Marine commanders privately disagreed with Westmoreland about Khe Sanh's strategic importance, nobody had any intention of retreating—or of being massacred.

The NVA attack began on Jan. 20. From that point onward, "Khe Sanh was being shelled continually," Althoff says. "Anywhere from one to 1,300 rounds a day of incoming artillery, rockets and mortars. There were snipers within 25 meters all the way around the fence, and anyone who moved aboveground would get shot at." Successive waves of NVA troops charged the perimeter of the camp, only to be beaten back by machine-gun and mortar fire, even as a long-distance artillery battle raged in the hills around the surrounded outpost.

General Westmoreland fired back, unleashing his massive air campaign, Operation Niagara, on Jan. 21, as U.S. planes dropped more bombs into a smaller area over a shorter period of time than had any other air campaign in the history of warfare. In the next 77 days, U.S. Air Force, Navy and Marine pilots flew more than 24,000 separate missions over Khe Sanh. "At times," Marine Corps historian Kurt Wheeler wrote later, "the amount of air support on station was so extensive that the limiting factor was the airspace over the targets, with planes stacked up to 35,000 ft. waiting to engage the NVA."

While U.S. bombers helped keep the NVA from overrunning Khe Sanh, the men on the ground needed thousands of tons of supplies each day. With fixed-wing aircraft no longer able to survive the approach to Khe Sanh, helicopter pilots like Althoff began flying into the combat base to evacuate Marines wounded in the fighting. The North Vietnamese had the approach path used by the choppers "zeroed in with .50-cal. machine guns, and they knew exactly where to shoot to hit you," recalls Althoff. Even in heavy cloud cover, "they'd just listen for you and start laying fire down the glide slope. If you were on it, you were drilled."

Retired Marine Colonel William Dabney, who commanded a satellite outpost atop Hill 881 South, a few miles from the Khe Sanh base, recalls, "We figured out that the NVA tended to leave mortar tubes registered wherever they'd fired their last rounds, so we'd fake that zone with smoke, bring the helo to hover over it, and listen for the tube to 'pop.' Once we knew that a mortar

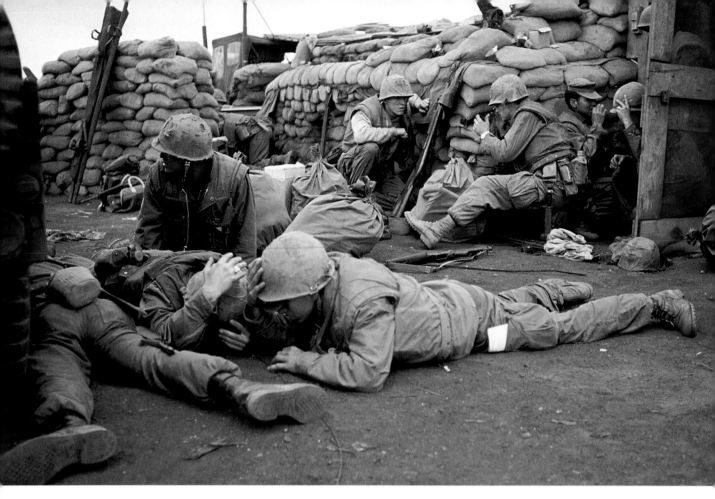

round was on the way, we'd shift to another zone and bring the bird in, usually getting away with it, because it took the NVA about 10 seconds to shift a tube to a new target, and time of flight for the round was about 20 to 25 seconds. This gave us time to get casualties aboard, replacements offloaded, bird gone and troops covered before the next round came in."

H ILL 881 SOUTH WAS A KEY STRATEGIC POSITION BEcause it occupied higher ground than Khe Sanh itself. By holding this promontory, the Marines prevented the enemy from using it as a post to direct artillery fire into the main base. It also allowed U.S. troops to track NVA movements and direct fire from both Khe Sanh's heavy artillery and the bombers circling overhead onto their targets, with a devastating effect on the enemy. But the price was steep: Dabney's men were confined for the entire 11-week siege to an area roughly 150 yds. long and 50 yds. wide, where they found themselves surrounded and under constant enemy fire.

"Heroism was routine," Dabney remembers. "The landing zones were always hot, and the medical-evacuation missions were the most dangerous. It took time to carry badly wounded men from cover to the helicopter and then return to cover, and the mortar rounds were often announced as being 'on the way.' Yet there was no occasion when men had to be ordered to carry stretchers. To the contrary, it was often necessary to restrain too many from lending a hand and exposing themselves unnecessarily."

Because incoming helicopters were being shot down at a prodigious rate, every kind of supply grew scarce.

Incoming! *Marines in Khe Sanh hit the dirt as a round of artillery fire arrives. Like their predecessors in the battles of World War I, these troops lived under constant fire in small areas surrounded by sandbags, using deep trenches to move safely through the fortress*

Water was like gold: Ray Stubbe, a Marine chaplain at Khe Sanh, recalls seeing men spread plastic tarps on the ground at night, then lick the dew off in the morning.

As the battle dragged into its third week and then passed one month, Khe Sanh's Marines were holding their own. But policymakers in both the White House and the Pentagon were becoming unnerved by the lack of a quick victory. The Joint Chiefs of Staff briefly raised with Westmoreland the prospect of using tactical nuclear weapons to destroy NVA forces in the area; the plan was ruled out, as the two armies were so close together.

Meanwhile, General Giap, whom U.S. intelligence officials believed had set up a field headquarters in caves near Khe Sanh, faced a dilemma. The force he had assembled in the area was theoretically large enough to overrun the combat base and its outlying satellite posts. But to do this, he had to bring his troops together for a massive frontal assault, and each time he began to do so, U.S. artillery and air power would shred the NVA columns, forcing him to scatter the units once again.

U.S. forces used a secret, experimental program called Operation Igloo White at Khe Sanh, in which warplanes dropped networks of acoustic, seismic and infrared sensors into the jungle. The probes radioed back indications of NVA troop formations, triggering new aerial onslaughts. In February, sensors along Route 9 (the major east-west road in the area of Khe Sanh) showed a

concentration forming. Within minutes, U.S. bombs and artillery barrages devastated the NVA formations.

At the combat base, Marines resorted to less scientific warfare, using empty gunpowder canisters as commodes. The last man to use the improvised toilet would place a grenade (with the pin pulled, but the lever held down) inside the canister, screw the top back on, and roll the metal cylinder down the steep hillside around the base. Enemy soldiers who opened the top in hopes of retrieving valuable U.S. supplies would be killed by a grenade blast that also covered them in excrement.

During the second week in March, as U.S. losses mounted, Clifford Treese was helping unload ammunition from a truck inside the Khe Sanh Marine base when he heard a shout: "Incoming!" Before he could react, "the first rocket hit my truck. I was blown through the air like a rag doll and landed about 50 ft. away. I saw my truck and everything around me exploding. I had to get out of there. But as I went to move, I saw my right arm was blown off at the elbow."

"I grabbed what was left of my arm," he continues, "to stop or slow down the bleeding. I figured this was the end. I prayed more in the seconds that followed than most people pray in a lifetime. A few minutes later, a medical corpsman reached Treese and bore him away to a field hospital. Yet so many others were also suffering that Treese's severed arm didn't earn him a space on an evacuation helicopter until two days later.

EVEN AS THE AMERICANS WERE TAKING GRIEVOUS losses from enemy artillery, it was becoming clear to Giap that his goal of overrunning the U.S. base was unachievable. His own losses were enormous, and by late March, he also needed to deploy troops to support the flagging Tet Offensive, which he had launched 10 days after laying siege to Khe Sanh. In retrospect, some historians also believe Giap was worried that the large number of NVA troops in the area might provide too tempting a target for U.S. nuclear weapons (Pentagon discussions of this option had by this time leaked to the press). This prospect horrified Hanoi's allies in Moscow and Beijing, who may have pressured the North Vietnamese to begin withdrawing from Khe Sanh.

At almost the same moment, U.S. commanders were planning to launch a relief force of ground troops, who would open Route 9 to reach Khe Sanh. This spearhead, called Operation Pegasus, was also tasked with finding and destroying the main body of Giap's troops. The NVA general faced a decision: either withdraw—or subject his army to the continuing meat grinder of air power (which might soon include nuclear weapons) while being mauled on the ground by fresh contingents of U.S. soldiers. He decided to quit the field. By the first week in April, when the U.S. column began rolling down Route 9, NVA strength in the area had been reduced to fewer than 10,000 troops, and they had lost their appetite for further direct assaults against the fortified compound.

The siege was lifted on April 8. As the first elements of the Pegasus salient arrived at Khe Sanh, the outpost was no longer surrounded. The Marines' 77-day ordeal was the longest single battle of the Vietnam War and one of the longest in U.S. military history. The price: more than 700 Americans dead; 10-15,000 North Vietnamese dead.

In the end, neither side achieved its goal. The U.S. avoided the kind of loss the French had suffered in 1954 but did not inflict a crushing blow that would turn the war in its favor. Giap failed to repeat his triumph at Dien Bien Phu, yet he did create a serious diversion to support the more significant Tet Offensive. Within two months, Westmoreland had left Vietnam for a new post in Washington. His successor, General Creighton Abrams, waited exactly one week into his tenure before declaring that Khe Sanh was no longer strategically significant. He had the base destroyed and abandoned.

Today the land around the former Marine stronghold at Khe Sanh is a coffee plantation. When clearing the land, its new owners found that the trees were still so pitted with shrapnel 40 years after the battle that they could only be used as firewood. But for the men who fought there, the memories endure. Dabney, who was belatedly awarded a Navy Cross in 2005 for his actions at the outpost, recalls Marines on Hill 881 South who concealed wounds, because they already had two Purple Hearts and being awarded a third meant being shipped home. "They didn't want to leave," he recalls. "It was their sense of duty. I wish I could convey to the young Marines of today, and to our fellow countrymen, how magnificent those men really were." ∎

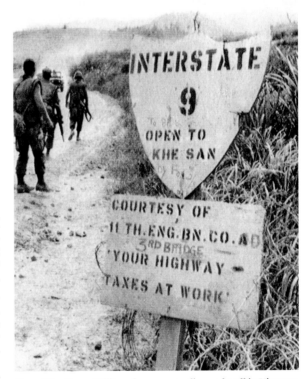

Sign of the times *Military humor was alive and well in Vietnam, as this sign saluting the opening of the road to Khe Sanh indicates*

Morning stars *The original Broadway cast of* Hair *included Melba Moore, on shoulder at center left, and Diane Keaton, sitting at center. Keaton was the one cast member who never took part in the show's brief nude scene. She told* Esquire *magazine, "There isn't enough meaning in it for me. And I don't have the nerve; it's such a personal thing"*

Good *Hair* Day

Broadway gets hip—more or less—as the "American tribal love-rock musical" lands on the Great White Way

O N APRIL 29, 1968, THEATERGOERS WITNESSED A marriage that had been brewing for the four years since the Beatles' American debut, when the first rock musical, *Hair,* opened on Broadway. And sure enough, one critic fumed at the volume levels in the show: "The musical problem would be solved by some attention to allowing the audience to hear the music instead of being submerged in it," groused Leigh Carney—of *Rolling Stone* magazine.

Carney proved to be in the minority: critics and audiences swooned for *Hair,* which arrived on Broadway in its third incarnation. The musical was first produced at New York City's renowned theater laboratory, the Public Theater, in October 1967. The staging was a success, and producer Michael Butler, then 40, a Chicago businessman, briefly mounted a second production at Manhattan's Cheetah discothèque. After another success, Butler brought the show to Broadway (where several theater owners turned down the production owing to its content). Under new director Michael O'Horgan, a specialist in guerrilla theater tactics, the show was substantially retooled for the Broadway production.

Following one of the principal tenets of the hippie ethos, the creators of *Hair* were above all determined to shock audiences, and New York *Times* critic Clive Barnes helpfully enumerated its arsenal of outrages: "Frequent approving references are made to the expanding benefits of drugs. Homosexuality is not frowned upon ... The American flag is not desecrated ... but it is used in a manner that not everyone would call respectful. Christian ritual also comes in for a bad time, the authors approve enthusiastically of miscegenation, and one enterprising lyric catalogues somewhat arcane sexual practices more familiar to the pages of the *Kama Sutra* than the New York *Times.* So there—you have been warned. Oh, yes, they also hand out flowers."

Barnes left out the kicker: some of the cast members briefly appeared—gasp!—in the nude. The creators of *Hair* saw their wish fulfilled in January 1969, when the show debuted in Mexico City: the government shut it down after one performance and deported the cast. For, truth to tell, perhaps the most shocking thing about *Hair* wasn't its prefab jabs at the American way of life but that it was an energetic, enjoyable show with a batch of memorable songs. "What holds *Hair* together is the score, which pulses with an insistent, primitive beat," TIME's

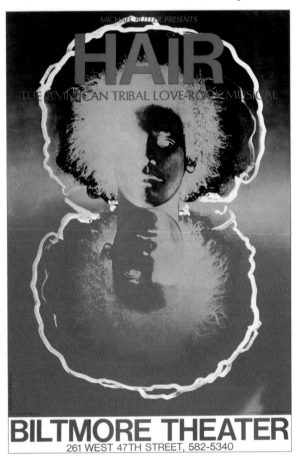

BILTMORE THEATER
261 WEST 47TH STREET, 582-5340

civilized critic opined. Composer Galt MacDermott, 39, and lyricists Gerome Ragni, 25, and James Rado, 36, who conceived the show and appeared in the cast, came up with melodic, rock-flavored tunes with clever lyrics, as in the title song, an enthusiastic ode to all things hirsute. In the next few months, three of the songs from *Hair* became Top 40 radio hits: *Aquarius/Let the Sunshine In, Hair* and *Good Morning Starshine.*

We'll let another cranky critic from *Rolling Stone,* Tom Phillips, have the last word. "The big problem," he declared, "is that the ... hippies in *Hair* bear only the most superficial resemblance to any people ... in America today ... They look like the hippies we read about in TIME magazine, and they do, or claim to do, all the dirty things that TIME hints such people do." Shocking! ■

Skirmishes On the Quadrangle

Student rebels take charge at Columbia University, and other campuses feel the heat

WHEN TIME NAMED THE "GENERATION UNDER 25" as its Person of the Year 1966, it put its finger on the pulse of the great youthquake that would drive so much of the ferment of the 1960s. Two years later, the members of that generation were taking a long look at the societies they were about to join—and rejecting them. Taking to the streets to engage in bloody combat with police, students marched in protest around the globe. In the U.S., the "children's crusade" of college kids helped make Senator Eugene McCarthy a serious candidate for the Democratic presidential nomination—and convinced President Lyndon Johnson not to seek re-election.

The French have glorified the fall of the Bastille since 1789, but what turned America's middle-class kids into fledgling revolutionaries? Consider the college graduating class of 1968. They were high school seniors on the day that John Kennedy, a politician who had gained their trust and inspired their dreams, was shot to death in Dallas. They were college seniors in the year that Martin Luther King, who had tapped their idealism and drawn them into social protest, was murdered. Throughout their college careers, the War in Vietnam tormented their consciences. When the U.S. government lifted the deferments that sheltered graduate students from the draft in the mid-'60s, male graduates of the Class of '68 no longer faced the war as an ethical issue but as an immediate, wrenching reality. The war was starting to come home: Was it any wonder the campuses erupted?

The major campus battle of 1968 took place at Manhattan's prestigious Columbia University, where student rebels stormed the office of president Grayson Kirk, held three officials hostage for 26 hours, took over five university buildings and forced the 17,000-student university to suspend all classes—until the university called in New York City police to restore order.

Meet the new boss *This photo of student David Shapiro relaxing in Columbia president Grayson Kirk's office became one of the iconic images of student protest in the 1960s*

Situated in Morningside Heights at the edge of Harlem, Columbia at the time was an academic enclave surrounded by the poverty and decay of the Harlem ghetto. In 1959 the university leased part of nearby Morningside Park as a site for a gymnasium, though some local black leaders objected that the project would deprive them of parkland. A later objection arose over the architectural plans. Columbia intended to make part of the gym exclusively available to neighborhood kids, but it blundered by providing for a rather grand entrance facing the campus and a separate, smaller one, facing Harlem. When blacks damned the facility as a symbol of back-door paternalism and branded it a case

of "Gym Crow," Columbia students took up their cause.

On March 27 a group led by the most radical of the era's leftist campus groups, Students for a Democratic Society (SDS), marched into Columbia's Low Library to protest a university ban on indoor demonstrations. When Kirk began disciplinary action against six of the group's leaders, the SDS organized a demonstration on April 23 to demand that the charges be dropped. Students seized the occasion to protest the construction of the gymnasium, as well as the university's recently discovered work with the Institute for Defense Analysis, a Washington think tank with close ties to the Pentagon.

The university quickly proposed discussions, but the students shouted down the offer and marched to Morningside Park, where they tore down a fence at the gymnasium excavation site. Led by SDS chair Mark Rudd, they returned to campus and stormed ivy-covered Hamilton Hall, where they roosted in front of the office of acting dean Henry S. Coleman, pasted up photos of Vladimir Lenin and Che Guevara and chanted "Racist gym must go!" As night fell, they stayed put, while Coleman and a few friends casually played cards in the office.

As Lenin might have predicted, the revolutionary vanguard soon split. Arguing that the white SDS insurgents in front of Coleman's office were not sufficiently militant, a group of 60-odd black students asked them to

leave—and at 6 o'clock the next morning they did. (The blacks later released their three hostages, 26 hours after first taking them captive.) Some white students now stormed president Kirk's vacant office in nearby Low Library. One group broke down a side door to get into the office; others clambered through a window. They hurled his papers onto the floor, fired up his cigars and pasted a sign on the window: LIBERATED AREA. BE FREE TO JOIN US.

Over the next 48 hours, students seized three more campus buildings. A coordinated command post was set up; mimeograph machines churned out bulletins and manifestos. Spotlight-seeking Black Power advocates Stokely Carmichael and H. Rap Brown showed up to counsel the students occupying Hamilton Hall.

Some students denounced the protests. Outside Low Library, some 200 counterdemonstrators cried, "Get 'em out!" A fight broke out between some 40 of the burly "jocks," who had set up a blockade to starve out the occupants of the building, and 40 youths, mainly blacks, bearing food. The attackers were thrown back, causing one of the school's football fans to note that "it's probably the first time Columbia has ever held a line."

Nor did all faculty members support the administration. A number of professors, mainly younger ones, were sympathetic to the students' cause. When the administration called in police to eject the demonstrators inside Low Library, 30 professors blocked their way.

Soon, at the urging of New York City mayor John Lindsay, the university announced it would temporarily suspend construction of the disputed gymnasium. Too little, too late: the students refused to budge.

The lines are drawn *Student factions square off in front of a Columbia building, as occupiers roost in the windows. At right, antiwar demonstrators march in New York City on April 27*

THE UPRISING AT COLUMBIA PROVED CONTAGIOUS, as minirevolutions broke out on campuses across the nation. At Princeton, more than 500 students demonstrated to support turning trustee powers over to faculty and students. At the Stony Brook campus of the State University of New York, 50 students staged a 17-hour sit-in at the school's business office in sympathy with Columbia's protesters. At Northwestern, 60 members of the Afro-American Student Union took over the school's main business office, and 15 sympathetic white students occupied the dean of students' office.

At Columbia, the impasse couldn't last. On April 30, just before dawn—when, explained a Manhattan cop, "Harlem is asleep"—1,000 New York City police, armed with warrants signed by Columbia University trustees, marched on the campus and ousted the rebels, after almost six days of occupation. In the melee, more than 130 people—including 12 police officers—were injured; 698 people, mostly students, were arrested and charged with criminal trespass, resisting arrest or both.

On May 17 the campus erupted once more, after the university suspended four SDS leaders, including Rudd. In protest, Rudd and his followers seized Hamilton Hall again, but they were quickly arrested. As news of the arrests spread, students began jeering at police, hurling bricks through windows and constructing barricades at campus entrances. President Kirk gave the order for police to clear the campus, and after a brick slammed into

the face of a patrolman, 1,000 outraged police charged through the crowd, night sticks swinging. When peace was restored, 68 people—including 17 policemen—had been injured, and 177 persons were under arrest.

Looking back on those chaotic events for this book, Mark Rudd told TIME he wasn't surprised that the university sent in the police: "They had been threatening a bust since the beginning, but what surprised me was the extent of violence the police employed and the administration condoned. Then they did it a second time, three weeks later. This shocked everybody on campus."

That summer, after Columbia cooled down, noted anthropologist and longtime Columbia professor Margaret Mead told TIME that the crisis marked "the end of an epoch" in the way universities are governed. While blaming the students in part, she accused the administration of failing to recognize the right of students to share in campus authority and of being unresponsive to community needs. She also faulted the trustees, saying, "We can no longer have privately endowed universities governed by boards of trustees that are not responsive to anyone but themselves."

The questions raised at Columbia rippled across U.S. campuses in the years that followed. As Mead hoped, they sparked an overdue examination of America's universities, and a new understanding of their mission. In this view, universities are not diploma mills; they are living communities in which a host of constituents—students and neighbors, faculties and administrators, trustees and alumni—have a role to play. ∎

The Face of Rebellion: Chapter 2

GERALD S. UPHAM

When TIME profiled eight U.S. students for its cover story on "The Graduate, 1968," one person was a natural choice: Columbia's David Shapiro, who had become the poster boy for student rebellion when he was photographed smoking a cigar in the chair of university president Grayson Kirk.

The son of a Newark physician, Shapiro played violin under Leopold Stokowski at 16 and had his first book of poems (*January*) published as a college freshman. The trouble with Columbia, Shapiro told TIME in 1968, was that "instead of [being] a place where creativity was admired, it was a place where clarity and discursiveness were admired. It was a place that stilled your voice. I felt I was in a prison in which the bars only receded, never dissolved. I could almost physically feel it, here in this university with its iron gates keeping the community out."

Shapiro's voice hasn't been still in the four decades that followed: he has published numerous volumes of poetry and art criticism, has been nominated for the National Book Award, has won grants from the National Endowment for the Humanities and National Endowment for the Arts and has taught at Cooper Union, Princeton, Bard College—and Columbia University.

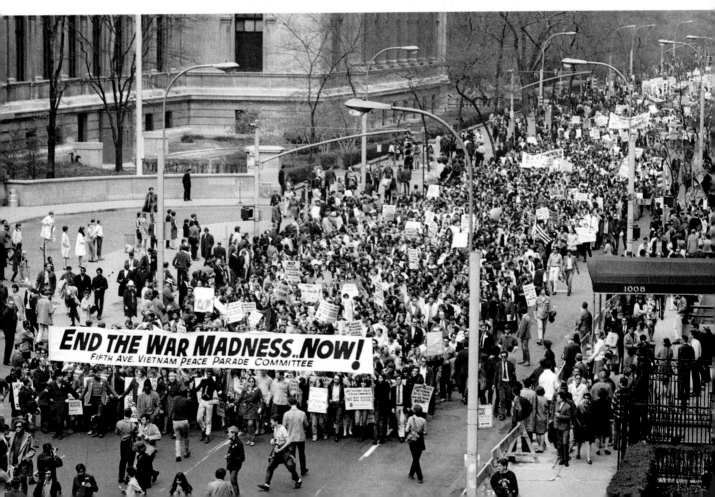

Seeing Red

Revolution is in the air as anger over the war
in Vietnam, racism and other social ills turns
young Americans into left-leaning radicals

ERNESTO 'CHE' GUEVARA LYNCH
JIM FITZPATRICK · 1968

HULTON ARCHIVE/GETTY IMAGES

1960s Radical Groups

Students for a Democratic Society (SDS) Founded in 1960, the largest group that organized opposition to the war in Vietnam dissolved amid internal dissension in 1969.

Weather Underground Emerging after 1968 from the breakup of SDS, this radical splinter faction endorsed acts of violence to foment a revolution.

National Mobilization Committee to End the War in Vietnam (the "MOBE") Founded in 1967 and the force behind that year's march on the Pentagon, MOBE was a key planner of protests at the 1968 Democratic Convention in Chicago.

Student Nonviolent Coordinating Committee (SNCC) This black student network led civil rights protests; it dissolved after many of its leaders left to join the Black Panther Party.

Mark Rudd: Columbia's Rebel Reflects

Mark Rudd, center, the 20-year-old student who was the most prominent leader of the 1968 protests at Columbia University, looked back on those days for TIME in 2008.

Going into the protests, we had no plan at all: this was absolute improvisation, for better or worse. If ever there was a moment of historical determinacy, that was it. There were certain principles we were following: that we would be confronting the liberal Columbia administration for its complicity with the war and with racism; that we would enter into a coalition with the black students and the community; that we wanted to demonstrate our militancy through aggressive action. Everything else was improvised. What surprised me was the extent of the violence the police employed and the administration condoned [in ending student occupation of campus buildings]. Then they did it a second time, three weeks later. This shocked everybody on campus.

The goal of the Students for a Democratic Society (SDS) always was the radicalization of many more students on campus. By this standard, our protest was an amazing success. It also succeeded in becoming a model for other students around the country and the world. We saw photos of demonstrators in France carrying signs saying, COLUMBIA, PARIS. National SDS adopted the slogan "Create Two, Three, Many Columbias." The gym project was stopped, and many more people became aware of Columbia's support for imperialism and its institutional racism. If I had to do it again, I'd try to adopt totally nonviolent strategy and tactics. There wasn't that much violence or vandalism on the part of the students, but I would have tried to make it even clearer that it was the administration and the cops who were violent, not us.

The Leftist's Bookshelf

Newly radicalized college students in the late 1960s embraced rebels and leftist thinkers as heroes. Most prominent was Ernesto (Che) Guevara, the Argentine who helped lead the Cuban revolution and was killed in 1967 while fomenting revolution in Bolivia. The late Malcolm X was also lionized, and works by Frantz Fanon, the anticolonialist writer from Martinique, and German sociologist Herbert Marcuse were popular. Paul Krassner's magazine *The Realist* was a low-budget pamphlet that combined incisive political commentary with outrageous, often vulgar satire.

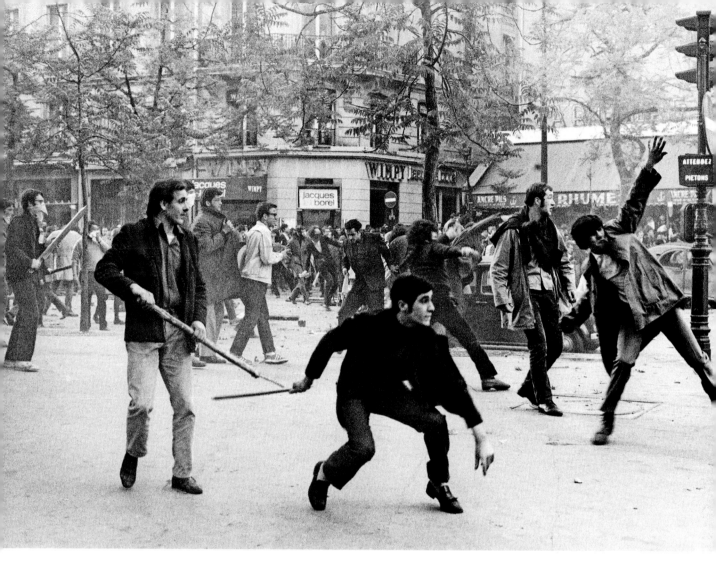

L'Etat? C'est Nous!

Challenging the 10-year reign of Charles de Gaulle, the students of France take to the streets—and when the Ancien Régime blinks, workers join them on the barricades

THE GREAT YOUTHQUAKE OF 1968 RATTLED THE ENtire planet. Even as U.S. students were occupying Columbia University buildings, young people in France were taking over the Sorbonne and setting up barricades in the streets. However, the French students enjoyed one advantage over their American counterparts: their rage could be directed against a singular symbol of age and authority, the grandiose 77-year-old autocrat who shared Louis XIV's inability to distinguish himself from the state he ruled, Charles de Gaulle.

It was General De Gaulle who inspired the French Resistance in World War II, then helped France recover from the shame of its Vichy collaboration with Hitler. It was De Gaulle who had taken control of a drifting France in 1958 and charted its new course after the lost colonial wars in Algeria and Vietnam. For 10 years, despite an occasional flicker of trouble, De Gaulle had ruled a serene,

stable nation. The aspirations of France and the dictates of its man on horseback appeared to be inseparable—a tribute to both his undeniable greatness and his penchant for saying it so often that people believed it.

But in the first days of May 1968, the myth that France and De Gaulle were one lay shattered forever amid the garbage festering in the streets of Paris, the litter of uprooted paving stones, the splinters of chestnut trees hacked down to make barricades, the blood spilled on the capital's boulevards. France was a nation in angry rebellion—at times, it seemed, on the verge of civil war.

Everywhere, France writhed in revolt and dishevelment. More than half of the nation's 16 million workers were on strike, and most of the rest were idled by a massive transportation shutdown. The country's students barricaded themselves in their universities. Farmers defiantly parked their tractors across the nation's high-

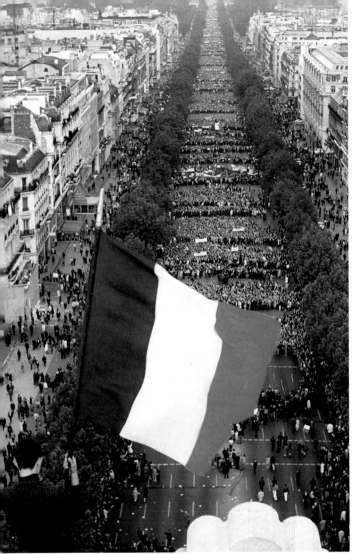

got tough, firing tear gas and concussion grenades and slashing any head within range of their long, hard-rubber truncheons. Some 30 fierce battles erupted throughout Paris. All told, 130 policemen and 447 civilians were injured, and 795 rioters were arrested. Fighting also broke out in other large French cities.

The chaos earned the students the overnight sympathy of much of France. Alarmed, Premier Georges Pompidou, acting as De Gaulle's regent while the general was off on an ill-timed state visit to Romania, called off the police and let the students roam freely through the Left Bank's Latin Quarter, long a bastion of the young.

A realization soon dawned on the leadership of France's workers: a few thousand students had forced the Gaullist regime to back down. Within hours, a spontaneous reaction swept across France as workers by the thousands occupied factories, shut down assembly lines and raised the red flag of revolt above plant gates. What a handful of students had begun was now a vast movement of civil and economic disobedience embracing some 10 million Frenchmen. Soccer players forced the cancellation of all matches. Leggy strippers took over the Folies Bergère, locking out customers. Sewage workers staged a sewerside sit-in. Buses, trains, taxis and all French commercial aircraft came to a halt.

L IKE THE STUDENTS, THE WORKERS WERE RISING UP against a society smothering in hierarchy. Nearly 200 years after the French Revolution, blue-collar workers remained tightly fettered near the bottom of a rigid social system, with little hope of escape. The room at the top of French life was restricted largely to those who were born there; social mobility was unknown.

When the government negotiated an increase in the minimum wage with union leaders, militant workers refused to endorse it. De Gaulle, shaken, flew to a French air base in Baden Baden, Germany, to confer with military brass. Secure in his belief he could maintain martial law in France if necessary, he returned to Paris and delivered a radio address on May 30 in which he dissolved the National Assembly, called for new elections on June 23 and ordered workers to return to their jobs.

As would also happen in the U.S. in 1968, the "silent majority" of French voters now weighed in. After De Gaulle's speech, 1 million people paraded through the streets of Paris to support him. Most workers returned to their posts; the police took control of the Sorbonne on June 16; and the Gaullist party won a large majority of seats in the new Assembly. Yet in the long run, the general was a survivor, not the victor, of the disorders of 1968. Charles de Gaulle would cling to power for 10 more months—but after he stepped down, a deluge of reforms would course through the arteries of his sclerotic domain, as students won the academic freedoms they demanded, laborers forced changes in the workplace and fresh breezes blew through the calcified halls of government buildings. And to the French, "May 1968" has taken a place next to the year 1789 as a cherished emblem of liberty, equality and fraternity. ∎

Left, right, march! *At left, students battle with police on the streets of Paris; the two sides waged running battles for weeks. Above, an orderly procession of citizens marches down the Champs Elysées on May 30 in support of General De Gaulle*

ways. Protesters surged through Paris streets by the thousands each night, battling police and riot troopers.

The nation's travails began in the spring, led by student militants who felt ignored, ill tutored by their schools and dismayed by the rigidity of their society. Amid a swirl of flags—red flags, black anarchist flags, Cuban flags and Viet Cong flags—radical scholars seized the Sorbonne's quadrangle, began holding revolutionary teach-ins and chalked graffiti on sidewalks and walls. Sample of one highly effective recruiting slogan: THE MORE I MAKE REVOLUTION, THE MORE I WANT TO MAKE LOVE. Soon self-styled anarchist Daniel Cohn-Bendit, 23, a.k.a. "Danny the Red," took the protests nationwide.

After three weeks of increasingly larger protests that spread to schools across the country, students in Paris mounted their largest march on May 10. "We don't give a damn about the General," chanted some 10,000 rebels as they marched through Paris toward the waiting cordons of helmeted riot police. Some broke into France's stock market, the Bourse, ripped down quotation boards and built a fire inside the building. Others erected barricades at the Place de la Bastille, a symbol dear to every would-be revolutionary's heart. In response, the police

A Symbol of Hope,

As a second major leader is assassinated in a two-month span, Americans question the nation's tragic trajectory

ROBERT F. KENNEDY ENTERED THE RACE FOR THE 1968 Democratic presidential nomination as he did so many things: impulsively. Indeed, the entry of the Senator from New York initially seemed ignominious to some Democrats; he was seen as a late-comer, piggybacking on Senator Eugene McCarthy's courage in challenging Lyndon B. Johnson, a sitting President of his own party. Even before McCarthy declared he would run against Johnson in November 1967, Kennedy had seriously considered making a run for the nomination but decided against it. Then, after the Tet Offensive, R.F.K.'s friend and confidant, writer Pete Hamill, sent him an impassioned letter, noting that many Americans kept a portrait of John F. Kennedy on their walls and arguing that his younger brother had an "obligation of staying true to whatever it was that put those pictures on the walls."

The message resonated with Kennedy, who was both a bitter personal rival of Johnson's and a long-standing critic of his conduct of the war in Vietnam. On March 16 he declared he would run for the presidency. The news electrified the nation, for Kennedy was a deeply polarizing figure who generated great love and great hatred, but never indifference. To many, he was the vindictive former aide to Joe McCarthy; Jack Kennedy's cocksure, unscrupulous hatchet man; a carpetbagger who had resigned as Attorney General in Johnson's cabinet to make an opportunistic 1964 run for a Senate seat in New York.

To many others, though, Kennedy came across as a man of infinite compassion, a leader with unique empathy for the poor, the hungry, the minorities and all those whom he termed the "suffering children of the world." And to all, he was the bearer of the legacy of Camelot, the inheritor of the grand dreams of Joe Kennedy, paterfamilias of America's foremost political dynasty. And R.F.K. was a family man himself: his Virginia home, Hickory Hill, was crowded with 10 children, and No. 11 was on the way in the spring of 1968.

As a campaigner, Kennedy, 42 in 1968, rapidly developed his own style, blending hard proposals, double-edged wit and a tough platform manner. In the shop-

Man of the hour *Senator Robert Kennedy campaigns in Philadelphia, where the crowd greets him with typical frenzy*

Taken in His Prime

"I think we can end the divisions within America ... the violence"
—Senator Robert F. Kennedy, June 5, 1968

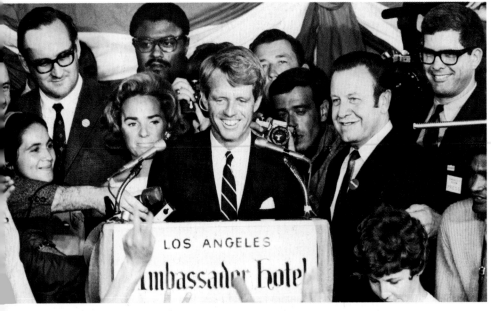

The winner *Moments before he was shot, Kennedy celebrates his victory in California's primary, which made him the clear leader in the race for the Democratic nomination for the presidency*

ping centers, on city street corners, in village squares, at campus rallies, with the wind whipping his hair and admirers plucking at his clothes, R.F.K. exuded charisma.

Longtime broadcast journalist Jeff Greenfield, who was a young speechwriter for R.F.K. in 1968, told TIME in 2007 that Kennedy was "the most extraordinary public figure I've ever met." One reason: he had the guts to tell audiences what they didn't want to hear. On campuses he called for draft reform and an end to student deferments. When medical students asked who would pay for his proposed increases in social services for the poor, he shot back, "You!" On April 4, in one of his finest hours, Kennedy informed a mainly black crowd at a rally in Indianapolis that Martin Luther King had been shot. Eloquently calling for reconciliation between the races in America, he urged his listeners to react peacefully. There was no riot in Indianapolis.

Before long, Kennedy was dominating the Democratic race, winning primaries in Indiana and Washington. On May 14, he took the Nebraska primary with 51% of the vote, against 31% for McCarthy. The Kennedy landslide carried every one of Omaha's 14 wards; R.F.K. ran ahead in 88 of the state's 93 counties.

YET ONE SHADOW HUNG OVER ROBERT KENNEDY'S campaign: the murder of his older brother Jack, gunned down in 1963. More than anyone else, R.F.K. had long felt the possibility that some day people would no longer be able to mention "the Kennedy assassination" without specifying which one. Yet he made a point of declining police protection when it was offered, and his unofficial bodyguard went unarmed.

On June 5, Kennedy faced the biggest day of balloting yet, as primaries were held in California and South Dakota. During the day he romped on the beach at Mal-

ibu with Ethel and six of their children. He had to rescue son David, 12, from a strong undertow—but what Kennedy day would be complete without a little danger?

That night it was on to the Ambassador Hotel, near downtown Los Angeles, to wait out the vote count. Spirits, already high, rose with the favorable totals. In South Dakota, R.F.K. won 50% of the vote, vs. 30% for a slate favorable to native son Hubert Humphrey and 20% for McCarthy; in the far more crucial California primary, the result was 46% for Kennedy, 42% for McCarthy and 12% for an uncommitted delegate group. The two victories gave Kennedy 198 precious delegate votes.

Next, R.F.K had formalities and fun to attend to: a midnight appearance before loyal campaign workers (and a national TV audience) in the hotel's Embassy Room, a quiet chat with reporters, then a large, private celebration at a fashionable nightspot.

Taking the lectern in the Embassy Room, Kennedy greeted his supporters with a characteristic mixture of serious talk, cracks about his dog Freckles and sincere musings about his ruptured country. Among his last words from the rostrum: "I think we can end the divisions within the United States ... the violence."

The next stop was to be the pressroom. For once, Kennedy did not plunge through the crush to reach the room's main door. Bill Barry, his bodyguard, did not like the idea of using a back passageway. Said R.F.K.: "It's all right." So they went directly behind the speaker's platform toward a serving kitchen that led to the pressroom. The Senator walked amid a clutch of aides, hotel employees and newsmen, with Ethel a few yards behind. The route took him through a swinging door and into the hot, malodorous, corridorlike chamber that was to be his place of execution.

On his left were stainless-steel warming counters, on his right a large icemaking machine. At the far end of the kitchen stood a man with a concealed gun. Later, a witness was to say that the young man had been there for some time, asking if Senator Kennedy would come that way. It was no trick getting in; there was no serious security screening by either the hotel or the Kennedy staff.

Kennedy paused to shake hands with a dishwasher, turning slightly to his left as he did so. Before he released the hand of Jesus Perez, the gunman managed to get across the room, prop his right elbow on the serving counter and, from behind two assistant maîtres d'hôtel, fire at his victim from just 4 ft. away. Kennedy fell.

The hotel men grappled with the assassin but could not reach his gun hand. Author George Plimpton and

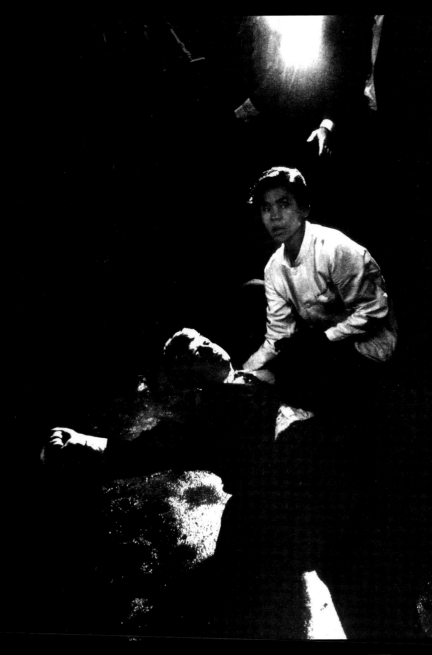

Pietà in a hotel kitchen LIFE *magazine photographer Bill Eppridge took the iconic photo at left of Ambassador Hotel busboy Juan Romero kneeling at the side of the wounded Robert Kennedy. Less familiar are Eppridge's other photos of the events, below. From left, a crowd gathers around Romero and the Senator; Ethel Kennedy asks spectators to move back to provide breathing room for her wounded husband; at right, the uproar continues. Ethel Kennedy remained very calm in the moments after the shooting, reported* TIME *correspondent Hays Gorey, who was following the campaign. Wrote Gorey of the scene: "[Kennedy's] lips were slightly parted, the lower one curled downwards, as it often was. Bobby seemed aware. There was no questioning in his expression. He didn't ask, 'What happened?' They seemed almost to say, 'So this is it.'"*

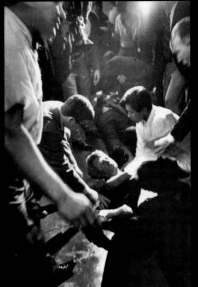

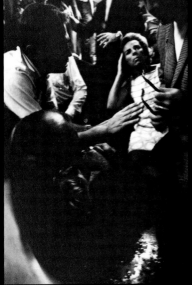

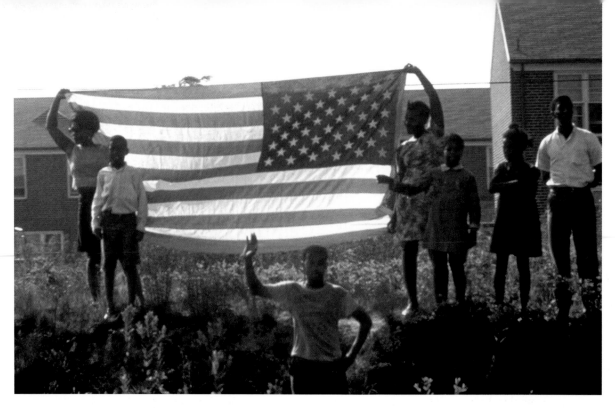

Kennedy aide Jack Gallivan joined the wrestling match. The gun, waving wildly, kept pumping bullets and found five other human targets. Eight men in all, including R.F.K. pals Rafer Johnson, an Olympic champion, and Roosevelt Grier, a 300-lb. Los Angeles Rams football lineman, fought with the slight but lithe assailant.

Johnson finally knocked the pistol out of the stubborn hand. "Why did you do it?" he screamed. "I can explain! Let me explain!" cried the short, dark-complected man. Several R.F.K. supporters tried to kill the man with their hands. Johnson and Grier held him and fended them off. Someone had the presence of mind to shout, "Let's not have another Oswald!" Johnson pocketed the gun.

Scores of people now pressed into the area. A priest appeared, thrust a rosary into Kennedy's hands. Someone cried, "He doesn't need a priest, for God's sake, he needs a doctor!" A hatless young policeman rushed in with a shotgun. "We don't need guns! We need a doctor!"

Ethel Kennedy, shoved back to safety by a hotel employee at the first sound of gunfire, appeared moments later, kneeling to kiss the cheek of Erwin Stroll, 17, a campaign worker who had been wounded in the left shin. Finally she got to Bobby. She knelt over him, whispering. His lips moved. She rose and tried to wave back the crush. Someone clamped an ice pack to Kennedy's bleeding head, and someone else made a pillow of a suit jacket. His tie was off, his shirt open, the rosary clutched to his hairy chest. An aide took off his shoes.

Within a few minutes, physicians were found. More policemen arrived; Johnson and Grier turned over their prisoner and the gun. The cops hustled the man out, carrying him part of the way past threatening spectators. California Assembly Speaker and R.F.K. supporter Jesse Unruh bellowed, "I want him alive! I want him alive!"

With Ethel by his side, Kennedy was taken first to nearby Central Receiving Hospital, where doctors could only keep him alive by cardiac massage and an injection of adrenaline; they alerted the better-equipped Good Samaritan Hospital to prepare for delicate brain surgery. Kennedy had been hit three times. One bullet just grazed him, and another of the .22-cal. slugs had entered the right armpit and worked its way up to the neck; it was relatively harmless. The third had penetrated his skull and passed into the brain, scattering fragments of lead and bone. It was these that the surgeons had to probe for in their 3-hr. 40-min. operation.

In the intensive-care unit after the operation, Ethel rested on a cot beside her husband, held his unfeeling hand, whispered into his now-deaf ear. Sisters Jean Smith and Pat Lawford hovered nearby. Ted Kennedy, his shirttail flapping, strode back and forth. His older brother lingered in a deep coma before dying at 1:44 a.m. on June 6, 25 hours and 27 minutes after the shooting.

Kennedy's assassin, Sirhan Bishara Sirhan, 24, was a Palestinian, a Maronite Christian Arab whose parents had come to America from Jordan. Registered as a resident alien rather than a U.S. citizen., Sirhan was apparently inflamed to the point of murder by Kennedy's strong support of the state of Israel. He was convicted of R.F.K.'s murder in April 1969 and sentenced to death; the sentence was later commuted to life in prison. Early in 2008 Sirhan remained incarcerated in the California State Prison at Corcoran, but as in the cases of John F. Kennedy and Martin Luther King, conspiracy theories continue to swirl around R.F.K.'s murder.

The assassination of two major leaders within a period of nine weeks further convinced many Americans that the nation was in free-fall. The events, TIME reported, "prompted, at home and abroad, deep doubts about the stability of America. Many saw the unleashing of a dark, latent psychosis in the national character, a stain that had its start with the first settlement of a hostile

continent. For the young people, in particular, who had been persuaded by the new politics of Robert Kennedy and Eugene McCarthy to recommit themselves to the American electoral system, the assassination seemed to confirm all their lingering suspicions that society could not be reformed by democratic means."

THE DAYS THAT FOLLOWED SEEMED LIKE A DREAM TO many Americans, a surrealistic mirror image of two other all-too-recent periods of national mourning. Once again, the nation watched the grim logistics of carrying the coffin of a Kennedy home in a presidential Boeing 707. This time the craft carried three widows: Ethel Kennedy, Jackie Kennedy and Coretta Scott King.

The party arrived in New York City at 9 p.m. on Thursday, June 6; already the crowd was beginning to form outside St. Patrick's Cathedral on Fifth Avenue. The black, the young and the poor were heavily represented: Bobby Kennedy's special constituents. Lyndon Johnson attended Friday's funeral. He had started his presidency by giving condolences to the Kennedys; now, near the end of his power, he came to mourn the man who had helped shorten his reign. Ted Kennedy concluded his eulogy with the lines adapted from George Bernard Shaw that Bobby used to end many of his own speeches: "Some men see things as they are and say 'Why?' I dream things that never were and say 'Why not?'"

During the afternoon a special 21-car train bore the Senator's coffin and his family and friends south to Washington. From the rear platform, Ted Kennedy, with short, sad gestures, thanked the people for coming out. Jeff Greenfield recalls: "The train ride was so striking because inside, it was an Irish wake. Ethel and Bobby's oldest son walked through the entire train thanking everybody for coming. Outside, the whole country was grieving: wounded war veterans, African-Americans, the poor. All of Bobby's natural constituents were lining the tracks, grief-stricken."

Long after nightfall, the train arrived in Washington. Along the lamplit streets, past a luminescence of sad and silent faces, the cavalcade wound through the federal city and across the Potomac, where in a green grove up the hill in Arlington National Cemetery, John Kennedy's grave looked out over the city and the river. The moon, the slender candles, the eternal flame at John's memorial, 47 ft. away, and the floodlights laved Robert Kennedy's resting place beneath a magnolia tree. It was 11 o'clock, the first nighttime burial at Arlington in memory. There was no playing of taps, no rifle volley. After a brief and simple service, the coffin flag was folded into a triangle for presentation to Ethel as the band played *America the Beautiful*. And across the nation in the weeks that followed, thousands of bereaved Americans hung another portrait on their walls. ■

Burial *Senator Kennedy's casket is interred after 11 p.m. Son Robert F. Kennedy Jr. leads the pallbearers*

Visionary *Warhol in 1968. After being released from prison in 1971 for her crime, Solanas continued to stalk Warhol and was arrested again*

"In the future, everyone will be world-famous for 15 minutes"

Shooting Stars

Reality intrudes on the synthetic domain of Andy Warhol, as a crazed acquaintance shoots the pioneering Pop artist

H E CALLED HIS STUDIO, A LOFT ON UNION SQUARE in Manhattan, the Factory, and like so many of his gestures, Andy Warhol's deadpan moniker worked on many levels at once: as an in-joke, as a commentary on the nature of 1960s art and as an accurate representation of the studio's purpose: to manufacture both era-defining artworks and celebrities—or, in Warhol's term, "superstars." Through the doors of the Factory came the famous, the would-be famous, fellow Pop artists, street hustlers, drag queens and socialites, all drawn by the flame of his renown.

In 1968 Warhol was riding high, for his life and work were devoted to surfing the waves of contemporary culture, and in no year were those waves larger or more unpredictable. Like the writer Ken Kesey, who told his chronicler Tom Wolfe that he'd rather be a lightning rod than a seismograph, Warhol was devoted to novelty: new faces, new looks, new sounds, the next trend.

The onetime advertising artist, who was born to Ruthenian immigrants as Andy Warhola in 1928 and was raised in Pittsburgh, found fame and notoriety early in the 1960s by painting Campbell's soup cans and sculpting Brillo boxes and calling them art. Today Warhol is viewed as a master of Pop art whose works sell for millions, and as an eerily acute prophet of the modern media age, where YouTube can make a "star" of anyone. But in 1968 he was more widely regarded as an outré pop prince who cultivated the famous (Mick Jagger, Bob Dylan) and rode herd over a gaggle of camera-struck wannabe celebrities whose sexuality was fascinatingly indeterminate and thus deliciously scandalous.

TIME, whose pronouncements in 1968 were an accurate barometer of conservative American opinion, described Warhol as one who "celebrated every form of licentiousness ... the blond guru of a nightmare world, photographing depravity and calling it truth." Perhaps a bit closer to the mark was one of Warhol's posse, Ingrid Superstar, who told TIME, "He likes to sit behind his sunglasses and observe the world."

On June 3, 1968, the real world came crashing into Warhol's plastic cosmos in the form of Valerie Solanas, a mentally disturbed Factory hanger-on who had appeared in Warhol's film *I, a Man.* Solanas had just founded a proto-feminist, one-woman, acronym-driven orga-nization called the Society for Cutting Up Men. Claiming to be searching for a script she had left with Warhol, she entered the Factory and shot the artist in the chest with a .32-cal. pistol. Warhol was rushed to a hospital, and he came very close to death. Solanas was convicted, served three years in prison and spent several years in mental hospitals before her death in 1988.

Warhol was gravely wounded, and the Factory scene would never again be so welcoming. As TIME's longtime art critic Robert Hughes wrote after Warhol's 1987 death, "Neither his health nor his talent would fully recover. There had been one Warhol before the shooting; another would emerge after it. The former had been the onlooker, both fascinated and wounded by media culture and its power to dictate desire and nostalgia. But this intensity began to leak out of his work after the shooting ... by the end of the '70s it was gone."

Solanas shot Warhol three days before Robert Kennedy died, and coverage of the incident was overshadowed by the nation's grief over R.F.K.'s assassination. But the attempted murder of a major American artist in his studio is another reminder that no domain was safe from the vicious currents of this remarkable year. ∎

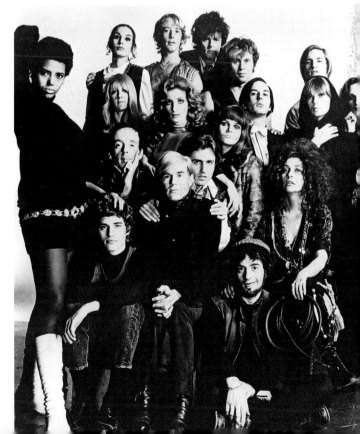

Factory hands *At right, Warhol and "superstars" pose for the celebrated photographer Philippe Halsman in 1968, before the shooting. Behind Warhol is longtime associate Gerard Malanga*

2001—or 1968? *Most of Kubrick's film may be set in 2001, but its visual motifs were drawn from the Pop Art and psychedelic styles of the 1960s*

Spaced Out

Stanley Kubrick's enigmatic visual masterpiece, *2001: A Space Odyssey*, is the film that launched a thousand trips

ALMOST 40 YEARS AFTER DIRECTOR Stanley Kubrick's exhilarating, bewildering movie, *2001: A Space Odyssey*, was released, TIME was still asking the same questions in a 2007 review of a new DVD version that audiences puzzled over in 1968: "What's happening at the beginning? What goes on at the end?" And, of course, there are still plenty of people wondering about what goes on in between. But on some points, almost all viewers of the film have agreed: *2001* is a monumentally audacious piece of filmmaking, a milestone in Kubrick's career and one of the great visual achievements in the history of the cinema.

Consider the sheer temporal range of the film: it begins with a sequence of simians at "The Dawn of Man," segues into a science-fiction tale set in 2001 and ends with a hallucinatory peek into the future of mankind. About that segue: it occurs after a simian who has learned to use a bone as a tool—thanks to the effects of a weird black monolith—throws the bone into the air, only to have it metamorphose into a space station. Arthur C. Clarke, the Briton who wrote the novel on which the film is based and worked with Kubrick in creating the movie, called that indelible scene "a 3 million-year jump cut." The bone's transformation is intended to imply that a spaceship is no more than a highly evolved tool; the ending of the film is intended to show the next stage in mankind's evolution, beyond the tool age.

Or something like that. But whatever message you take from *2001*, few will forget its most interesting character: that failed tool Hal the computer, who goes nuts and wages war upon the astronauts he (or it) was built to support. And as for the psychedelic journey at its end: TIME's 1968 review still rings true, saying it provides "some of the most dazzling visual happenings and technical achievements in the history of the motion picture."

Big wheel *The special effects used by Kubrick, left, in 2001 were primitive by 2008 standards yet highly effective. Above, some of the space-station scenes were shot on a specially built rotating set*

Indeed, *2001* is a triumph of purely visual moviemaking: the first line of real dialogue comes 40 minutes into the film. Small wonder it remains a cinema landmark, warts and all; and small wonder *Star Wars* guru George Lucas rhapsodizes on the 2007 DVD version, "To see somebody actually do it, to make a visual film, was hugely inspirational to me." As another informed movie lover, Steven Spielberg, told TIME in 1999, the year of Kubrick's death: when you saw one of his movies, "you committed yourself to its being part of your life." ∎

Mr. In-Between

What's that you say, Mrs. Robinson? A funny film about a nebbishy college kid is the biggest box-office hit of 1968

JOSEPH E. LEVINE

MIKE NICHOLS
LAWRENCE TURMAN

This
is
Benjamin.

He's
a little
worried
about
his
future.

THE GRADUATE

ANNE BANCROFT ... DUSTIN HOFFMAN · KATHARINE ROSS
CALDER WILLINGHAM ... BUCK HENRY PAUL SIMON
SIMON ... GARFUNKEL LAWRENCE TURMAN
MIKE NICHOLS TECHNICOLOR® PANAVISION® United Artists

ACCENTUATE THE POSITIVE," THE pop standard by Johnny Mercer and Harold Arlen advises. "Eliminate the negative/ Latch on to the affirmative/ Don't mess with Mister In-Between." Sound advice, but Hollywood successfully ignored it in the No. 1 box-office hit of 1968, *The Graduate*. Director Mike Nichols' study of a boy-man adrift in the dizzying gap between college and adulthood was a seismograph that charted many of the shock waves that rattled the late 1960s: the yawning distances between parents and their children, the vogue for sexual experimentation and, memorably, American kids' growing disaffection with the culture of affluence and consumerism that

had defined the 1950s and early '60s. (The film managed to distill an entire generation's scorn for adulthood's suspiciously synthetic values into, yes, one word.)

The film, based on Charles Webb's smart 1962 novel, was enormously aided by its soundtrack. Nichols, still establishing himself as an incisive, alert filmmaker after a successful career in stand-up comedy with partner Elaine May, had fallen for the music of the popular folk-rock duo Simon and Garfunkel. Paul Simon's memorable song *Mrs. Robinson* (adapted at Nichols' request from a tune Simon had originally written about Eleanor Roosevelt) was a No. 1 hit that managed to encapsulate the sense of bright young people adrift in their own nation in two memorable lines: "Where have you gone, Joe DiMaggio?/ A nation turns its lonely eyes to you."

There were no heroes in the land occupied by Benjamin Braddock, Nichols' Mr. In-Between—especially when he looked in the mirror. As portrayed by a Hollywood unknown, Dustin Hoffman, Braddock was the embodiment of a fish out of water, and Nichols cleverly turned the old cliché on its head, putting Hoffman in scuba gear and dispatching him to the bottom of a swimming pool, the image of a man utterly out of his element. The boyish Hoffman was 29 when he played the role of Braddock, who is supposed to be 21 in the film; Anne Bancroft, as the family friend who successfully seduces the callow Braddock, was 35.

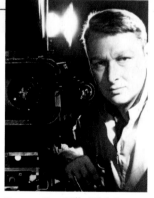

Oscar calling *Mike Nichols, then 36, won the Oscar for Best Director for* The Graduate. *Hoffman, Bancroft and Katharine Ross, a newcomer to the screen who played Bancroft's daughter and Hoffman's eventual love interest, were nominated but did not win*

Yes, America loved *The Graduate*. Sadly, TIME didn't. The magazine's original review was both brief and dismissive. While others hailed the film for its fresh, funny depiction of alienated college kids, TIME's reviewer didn't seem to get the point: "Most of the film has an alarmingly derivative style, and much of it is secondhand...Director Nichols, perhaps affected by his stage experience, has given much of the film the closed-in air of a studio set." Maybe—or maybe Nichols was using visual metaphors to suggest his antihero's feelings of isolation and suffocation. In a 2007 review of a new DVD release of the film, TIME made its amends, calling the film a "spot-on romantic satire [that nails] America's social and sexual shiftlessness." That's more like it. Forty years on, there's one word for *The Graduate:* fantastic. ■

Star tracks *Warren Beatty, Robert Redford and Charles Grodin were considered for the role of Benjamin Braddock, played by Dustin Hoffman. Marilyn Monroe was at one time intended to play Anne Bancroft's role as Mrs. Robinson; Doris Day was also considered for the part.*

Below, Hoffman and Ross flaunt convention near the end of the film. The movie opened late in 1967 to make its stars eligible for an Oscar and went on to dominate the box office in 1968

Guess Who's Coming to Dinner

Released very late in 1967 in hopes of reaping Oscars for its cast, Stanley Kramer's high-minded study of racism in Middle America became the No. 2 box-office hit of 1968, behind The Graduate. *The film can seem dated and preachy to modern viewers;* TIME *critic Richard Corliss said of Kramer's work in 1997, "[The films] evoke a dutiful do-gooderism: school lessons, church sermons, a stern talk from Dad."*

Even so, in the charged racial atmosphere of 1968, the movie's success was a tribute to the courage of the executives who funded it and of director Kramer and stars Sidney Poitier, Spencer Tracy (in his last film role) and Katharine Hepburn—who indeed walked away with an Oscar for Best Supporting Actress.

Screen Scene, 1968

Zombies with an attitude, urban witches and chatty chimps: the fall-off from the heights of *2001* and *The Graduate* was mighty steep in Hollywood's year

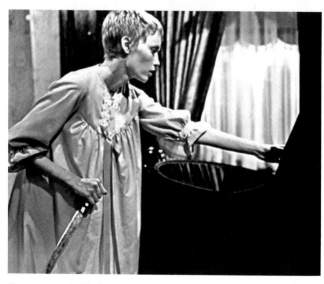

Rosemary's Baby

In the year that brought the surprisingly successful low-budget chiller Night of the Living Dead, *Hollywood fired back with one of its more intelligent horror stories. Rosemary's Baby was the first Hollywood film directed by the French-born Polish auteur Roman Polanski. Star Mia Farrow was a tabloid sensation at the time; only 22 during filming, she was served divorce papers on the set by husband Frank Sinatra, 52.*

Night of the Living Dead

This is it, horror-movie fans: the original, authentic, low-budget, make-you-laugh-while-it-scares you-to-death Ur–indie screamer that launched a thousand quips, four sequels and two remakes. Director George Romero, then 28 and working on TV commercials in Pittsburgh, made the film for only $114,000.

The story of flesh-eating zombies was set in a small town to keep costs low; filming took place in Evans City, Pa., 30 miles north of Pittsburgh; "blood" was Bosco chocolate syrup. Depicting alienated citizens in a disintegrating America, it captured the spirit of the time. Mainstream critics denounced it, but it made millions.

THE EVERETT COLLECTION

PHOTOS12—POLARIS

Barbarella

Before becoming a much-reviled activist against the Vietnam War, Jane Fonda, 30 in 1968, was a Hollywood bombshell whose husband, French director Roger Vadim, cast her as the title vixen in this sci-fi spoof. It flopped.

Funny Girl

Barbra Streisand, 26 in 1968, successfully adapted her hilarious 1964 Broadway turn as vaudeville star Fanny Brice into a box-office hit. Another musical, Oliver!, won the Best Picture Oscar for 1968.

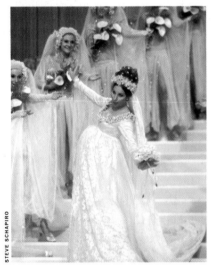

STEVE SCHAPIRO

Planet of the Apes

It's usually a bad sign when the most memorable aspect of a film is its makeup. But as TIME's *1968 review said, "The best thing about the film results from Producer Arthur P. Jacobs' decision to allocate $1,000,000 for masks and costumes." And its convincing representation of talking simians helped make* Planet of the Apes *one of the biggest hits of the year.*

Based on the novel by Pierre Boulle, the tall tale boasted a true star, Charlton Heston, as the hero, and featured a terrific surprise ending that left audiences gasping. It success launched an enduring franchise that evolved into four sequels, two different TV series and a successful 2001 remake.

KOBAL COLLECTION

Prague Spring: Czechmate!

For one brief, intoxicating moment, Czechoslovaks savor the taste of freedom. Then the empire strikes back

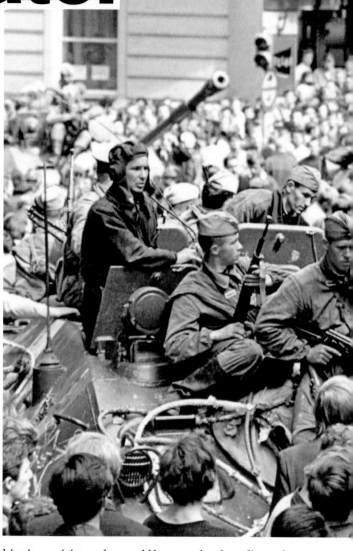

SUDDENLY," A SURPRISED TIME CORRESPONDENT reported in the magazine's March 15, 1968, edition, "Czechs in Prague and other cities have been snatching up newspapers as if they were priceless manuscripts. The normally routine and propagandistic *Rude Pravo* is usually sold out by midmorning; people regularly besiege kiosks for the livelier afternoon papers ... Cafés are packed as customers argue over their foamy beer. The cause of the excitement is the transformation that is occurring in Czechoslovakia under Alexander Dubcek, 46, who only in January ousted Antonin Novotny as boss of the country's Communist Party. Last week Czechoslovakia's 14,300,000 people were reading news that was as unfamiliar as it was welcome."

Czechs and Slovaks, today residents of the Czech Republic and Slovakia but then united in Czechoslovakia, recall with pride the liberalizing movement led by Dubcek, known to history as the "Prague Spring." And what a springtime it was, coming after the long winters of icy repression that had afflicted the nation since it had been swallowed up by the U.S.S.R. after World War II.

The saga began after the moderate Dubcek, a Slovak, managed to unseat the hard-liner Novotny from his post atop Czechoslovakia's Presidium, the ruling party's inner sanctum—even though Soviet leader Leonid Brezhnev made a special trip to Prague to try to prop up support for his gauleiter. An emboldened Dubcek soon began removing almost every restraint on the press and other media. He banished party censors from the Central Publications Administration, which oversaw the printing of everything from books to streetcar tickets. He even allowed TV newsmen into—of all places—a meeting of the Presidium.

With the floodgates open, long-dammed tides began flowing. Newspapers splashed examples of past brutality in their pages. The judiciary began reviewing all cases heard in the 1950s in an effort to right injustices, and a special commission began rehabilitating thousands of victims of the Stalinist trials of that era. Magazines, TV and radio exploded in an orgy of free expression: works by dissident playwright Vaclav Havel were staged; the

hippie musicians who would become the absurdist rock band the Plastic People of the Universe began jamming.

As the reforming impulse took hold, trade unions agitated for an end to party interference, and officials in the Justice Ministry began demanding genuine legal safeguards for the people. The new head of the nation's Writers Union, Edward Goldstucker, declared, "Let us combine two things that belong together: freedom and socialism." Dubcek had expressed the same ideal more memorably in January 1968, when he stated that his goal was to create "socialism with a human face."

Like many other observers around the world, TIME

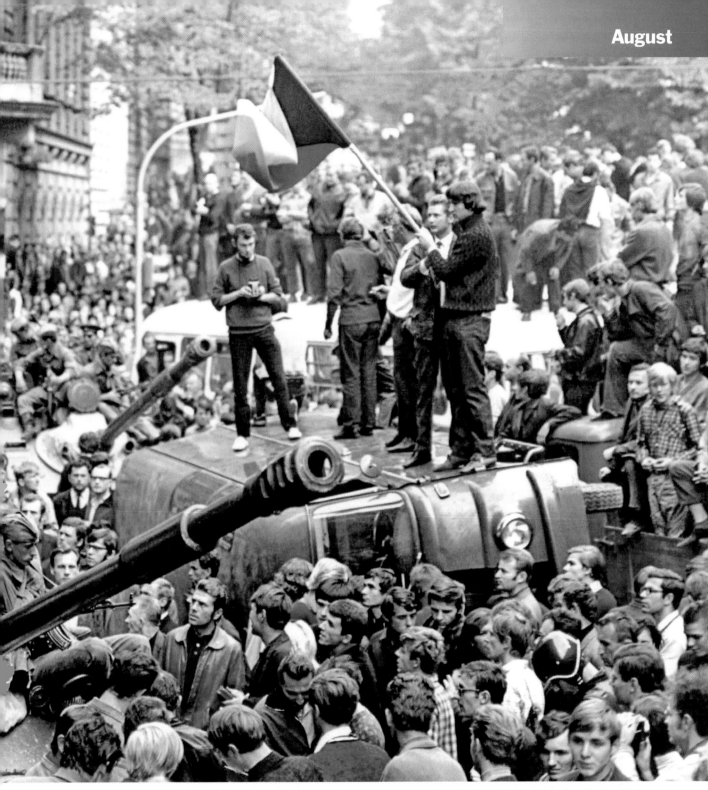

was not immune to Prague's spring fever. "One of the most hopeful signs for the ultimate success of their revolution is the amount of participation by the people," the magazine enthused in April. "Because it offers a socialist form of democracy so far unequaled anywhere in the communist world, Czechoslovakia's revolution may have a far more lasting impact on communism than either [Yugoslav leader] Tito's breakaway from the Kremlin or the Hungarian Revolution of 1956."

Or not. Certain figures in the Kremlin did not share either TIME's buoyancy, Goldstucker's view of socialism or Dubcek's preferences in Marxist physiognomy. The

Now what? *In the early days of the invasion of Czechoslovakia by Soviet and Warsaw Pact forces, young Russian soldiers faced hostile yet peaceful crowds, like this one in Prague on Aug. 21*

U.S.S.R. had dominated Czech affairs since Soviet tanks first rolled into the streets to "liberate" Prague in the spring of 1945—even as a U.S. Army under General George S. Patton was nearby, immobilized by an agreement over spheres of influence made by Allied powers. In 1948 the Soviets seized full control of Czechoslovakia's government; 20 years later they had no interest in yielding it.

On Aug. 20, the Kremlin clamped down—hard. Moving with stunning speed and surprise, some 200,000 sol-

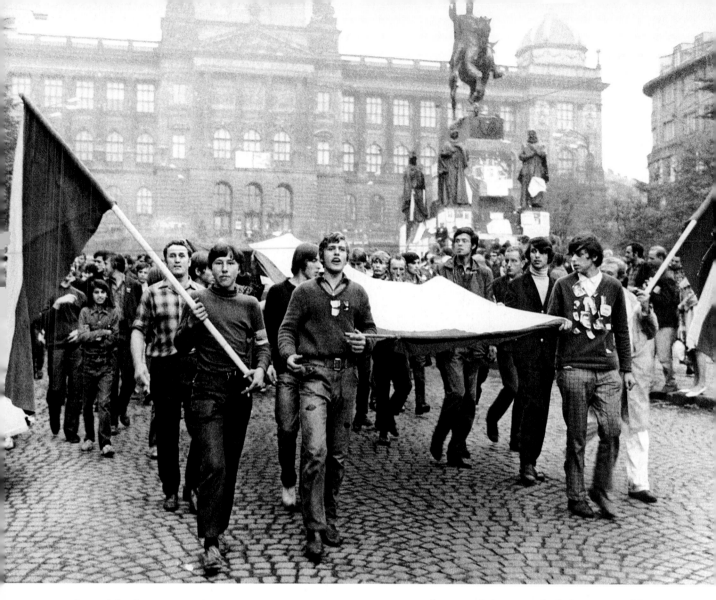

diers of the five Warsaw Pact countries punched across the Czechoslovak border just before midnight to snuff out Dubcek's experiment in humanizing communism. Russian and East German units smashed southward from East Germany. Forces thrusting from Ukraine rolled across from the east. Some 250 Soviet T-54 tanks raced from Hungary into the Slovak capital of Bratislava. They hit the city at an awesome tank speed of 35 m.p.h., their smoking treads churning up the asphalt as they knocked down lampposts, street signs, even automobiles that stood in their way.

MOST CZECHOSLOVAKS DIDN'T COME FACE TO FACE with the reality of the invasion until the next morning, and by then tanks were lumbering through the streets of Prague and the entire country lay in the vise of Soviet power. Everywhere, paratroops in purple berets and full battle dress stood guard alongside tanks, automatic rifles cradled in their arms. In swiftness of execution, the invasion had been a model military operation. But the occupation was soon to prove quite another matter in ways the Soviets had not foreseen. The Czechoslovaks, as the invaders discovered to their surprise, were not impressed. Instead, crowds surged around the alien tanks and their sentries and vir-

Banner year *The statue of King Wenceslas looks out upon a false dawn of freedom, as students in Prague protest the Soviet-led invasion on Aug. 28, a week after tanks rolled into the capital*

tually smothered them with falsely fraternal attentions.

As the tanks moved through Prague's Wenceslas Square, youths marched to their front and rear, shouting in chorus, "Long live Dubcek! Russians go home!" The statue of King Wenceslas was covered with boys waving the red-white-and-blue Czechoslovak flag. Atop the beloved King's head, they erected posters proclaiming U.S.S.R., GO HOME: WE ARE A FREE NATION.

Whenever the tanks stopped, the interrogations began—surely some of history's most curious confrontations between conqueror and conquered. Hounded by questions, many of the Russians—some of whom were youths no older than 18—looked nervous and stared blankly into the distance to avoid further embarrassment. A few told crowds in the street that they were in Czechoslovakia to protect the people from "counter-revolution" or the "reactionaries" in West Germany. But many had little notion of their mission and were apologetic. "We are only following orders," a youthful paratrooper said to an irate questioner in Prague.

Then the Czechoslovaks' mood began to change. Mobs of youths mounted squat tanks, forcing their crews

88

to disappear inside the hatch. Like elephant trunks swatting at flies, the tanks' gun turrets swung around eerily in an effort to knock off the screaming, chanting youngsters, who also bombarded the tanks with bricks, painted their flanks with swastikas and dumped garbage on their hot engine covers to create a stench. Daring youths in Prague and Bratislava even charged the tanks and set a few afire with flaming pieces of carpet and bottles of gasoline. One tank retaliated by blasting away at the façade of the National Museum in Prague.

Across the country, black flags of mourning appeared on buildings, statues and monuments. The struggle grew more coordinated—and cunning—as the Czechoslovaks mobilized all their resources to baffle, stymie and frustrate the occupiers. The campaign was directed and inspired by radio stations that continued to operate secretly throughout the country, reportedly employing transmitters provided by the Czechoslovak army, after the Russians had shut down the regular government transmitters. Czechoslovaks began moving road signs and town markers in order to misdirect Soviet troops. They also switched number and name signs on houses and apartments so that Soviet security police could not find liberal Czechoslovaks whom they sought to arrest.

The resistance continued for weeks, but however noble, it could not prevail. By October the full apparatus of repression was back in place. Dubcek had been flown to Moscow under arrest and was intimidated; the Presidium had been realigned, with the liberals cast out and replaced by Soviet-friendly ministers. By November, TIME reported that Czechoslovaks were settling into a mood of resignation, withdrawing back into their private lives, abandoning politics once more to the politicians. Hungarian, Polish, Bulgarian and East German troops were beginning to withdraw, but some 75,000 Soviet troops remained in the country, stationed along a central line that virtually cut the nation in half. Sixty massive artillery guns still surrounded Prague, now a bull's-eye.

And yet … as in so many of the great pitched battles of 1968, the end of the story would not be written for years. In 1969 Dubcek was handed a new post: ambassador to Turkey. In 1970 he was expelled from the Communist Party; he was later relegated to the national Forestry Service. But beneath the rigidly placid surface of his nation, a strong underground movement of samizdat publications and rock music flourished, cresting in the Charter 77 movement of 1977, led by playwright Havel, which again challenged Moscow's grip over Prague.

In November 1989, Czechoslovaks rose up against their Soviet masters in the great, nonviolent "velvet revolution"; at its high point, Dubcek joined Havel on a balcony overlooking Prague's Wenceslas Square, and the two received the rapturous plaudits of their countrymen. Dubcek was elected speaker of the nation's new Assembly and served in that body until his death after a car crash in 1992. He had helped Czechs and Slovaks restore their human faces. And he had helped prove the theorem that brought down the Soviet Empire: once acquired, the taste for freedom is difficult to suppress. ∎

A World in Turmoil

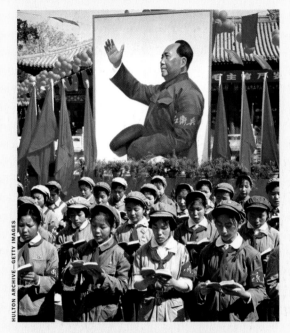

In China, Mao Breeds Mass Madness

In 1968 would-be revolutionaries around the world looked to Beijing for direction. This misplaced inspiration was one of the great ironies in 20th century politics, for the nation ruled by communist icon Mao Zedong was one of the most rigidly regimented societies in human history. Eighteen months into his repressive 1960s reign of terror, the Great Cultural Revolution, Mao's cult of personality, as embodied by the zealous, brain-washed Red Guards, above, and the ubiquitous Little Red Book of the Chairman's socialist axioms, was at high tide. Meanwhile freedom—and food—were in very short supply.

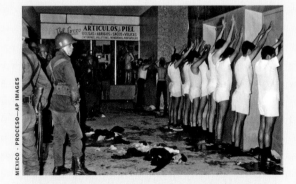

In Mexico, a Brutal Battle in the Streets

As in many other nations, students in Mexico rose up to demand academic reforms and more freedom in 1968. Their protests crystallized in opposition to the government of President Gustavo Díaz Ordaz. After a week of riots and skirmishes, federal troops opened fire on student protesters in Mexico City, above, on the night of Oct. 2, only 10 days before the Olympic Games opened in the capital. Authorities successfully hushed up for decades the extent of the violence that ensued, but it is now believed that at least 200 students were killed and some 1,000 injured.

POLARIS

Saddam Hussein, Iraqi General

"COUP-RIDDEN IRAQ SELDOM OVERTHROWS ITS LEADERS GENTLY," TIME TOLD readers in July 1968. "In 1958, Iraqis gunned down King Feisal II and dismembered Premier Nuri-al-Said's corpse. When they deposed Soldier-President Abdul Karim Kassem in 1963, the rebels tommy-gunned him, dragged his body to a television studio, then switched on the cameras to show the public the gruesome spectacle. Last week there was another coup in Iraq, but this time it was relatively civilized." The agents of change had rung up President Abdul Rahman Aref at 3 a.m. and informed him, "Tanks are now proceeding toward the palace." Within two hours the President was onboard an Iraqi airliner, and a nine-man, all-military "revolutionary Command Council" was in charge in Baghdad.

The leaders of the coup represented the right-leaning but revolutionary Baath Party; they had not tasted power since they had been booted out of the government in 1963. Only the leader of the new group in power, ex-Premier Ahmed Hassan al-Bakr, was mentioned in TIME's article, but one of Iraq's new rulers was a man imprisoned under the prior regime, General Saddam Hussein, who soon became al-Bakr's deputy. Saddam would meet the fate TIME predicted in 1968 almost 40 years later: an execution that was far from gentle, captured on a cellphone. ∎

In charge *Saddam, above, became the most powerful leader of Iraq's ruling council soon after the Baath Party coup of 1968*

Outlaw *Arafat, top right, was unknown to most Americans before 1968, but his notoriety soon increased*

Beacon TIME *noted in 1968 that Solzhenitsyn was not a political activist; rather, he was an aloof figure who let his works speak for him*

Yasser Arafat, Palestinian Guerrilla

READERS OF TIME FOUND AN UNFAMILIAR FACE staring at them from the cover of the Dec. 13, 1968, issue: a Palestinian warrior. "Arabs have come to idolize Mohammed ("Yasser") Arafat, a leader of El Fatah fedayeen who has emerged as the most visible spokesman for the commandos," TIME explained. "An intense, secretive and determined Palestinian, he is enthusiastically portrayed by the admiring Arab press as a latter-day Saladin, with the Israelis supplanting the Crusaders as the hated—and feared—foe."

Then as now, the Middle East was a cauldron of friction. The year before, Israel had emerged victorious from the Six-Day War, seizing control of vast tracts of land from Egypt, Syria and Jordan and creating hundreds of thousands of new Palestinian refugees. Now, TIME reported, a new wave of guerrilla leaders, personified by Arafat, 39, was emerging in the inflamed Arab world. As for El Fatah: "[Its] methods are brutal and indiscriminate, random terrorism for terrorism's sake without any military value."

TIME's Edward Hughes met with Arafat at his base in Amman, Jordan, and reported, "When a guerrilla comes in to report a successful raid, Arafat's eyes, bulging almost to the panes of the dark glasses he wears day and night, dance with delight. He speaks softly and turns aside all questions about himself: 'Please, no personality cult. I am only a soldier. Our leader is Palestine. Our road is the road of death and sacrifice to win back our homeland. If we cannot do it, our children will, and if they cannot do it, their children will.'" ■

Aleksandr Solzhenitsyn, Russian Writer

FIVE WEEKS AFTER THE SOVIET UNION SENT TANKS AND TROOPS TO crush the spirit of rebellious Czechs and Slovaks, TIME's cover featured one of the U.S.S.R.'s most prominent dissidents, Aleksandr Solzhenitsyn, then 49. "To his friends," TIME noted, "he is a vigorous, burly, bearded man with a booming voice—possessed equally by his love for Russia and his passion for freedom. To the Stalinists, his enemies, he is the arch-accuser, the self-appointed prosecutor, blackening Russia's name abroad. His works blaze with the indignation of a man who knows his enemy: he spent 11 years in prison, slave-labor camps and [internal] exile."

The year 1968 marked the second coming of the writer: his novel *A Day in the Life of Ivan Denisovich* had created an uproar when it was published in Russia during a brief 1962 thaw, at the express order of Nikita Khrushchev. Now, two works that had long circulated in the U.S.S.R. in samizdat form were about to be published in the West: *The First Circle* and *Cancer Ward*. Indeed, the two novels propelled the author to worldwide fame—and to further notoriety in the U.S.S.R., whose leaders would send the dissident writer into exile in 1974. ■

Showdown in The Windy City

With the whole world watching, Chicago police bust the heads of protesters at the Democratic National Convention

AMERICANS KNOW AND LOVE CHICAGO AS THE Windy City, the Second City and the City of Big Shoulders. But in 1968, above all else, Americans knew Chicago as the satrapy of Mayor Richard J. Daley. For 13 years, this archetype of the big-city boss had ruled his province like a Chinese warlord. The irascible mayor, then 66, had on the whole been a creative autocrat, lacing his megalopolis with freeways and pulling in millions in federal spending. In a city with as robust a tradition of political corruption as New York City or Boston, he had been a model of personal honesty. Yet like any other expert monarch, he knew where and how to tolerate corruption within his realm.

After starting out as a secretary to the city council at 25, Daley had scrambled upward through the Democratic Party ranks, and his understanding of his city's muscles and nerves was deeply intuitive. But by 1968 it was growing archaic, as he continued to rule in the outmoded paternalistic style of a benevolent Irish despot of the wards. As Americans formed into battle lines in 1968, it was clear where Daley stood: as the personification of everything the nation's young protesters despised.

Because of his clout in his party, Daley had secured a plum for his city: it would host the 1968 Democratic National Convention. But the price tag was high, for the party was in turmoil in 1968, traumatized by the Vietnam War and the rising tide of protest against it. The year brought a cascade of falling dominoes: Senator Eugene McCarthy revolted against Democratic President Lyndon Johnson; then L.B.J. declared he would not stand for re-election; then Senator Robert Kennedy threw his hat in the ring, only to be gunned down. By Aug. 26, when the convention began, it had become a magnet for dissent and turmoil, a target for agitated protesters, a proxy for all the divisions in the not-so-united States.

The demonstrators who descended on Chicago were (to use a phrase just coming into vogue in 1968) a mixed bag: New Left students, pacifists, assorted peace groups, socialists and—most baffling to the Chicago authorities—the Yippies. These prankster anarchists, led by Jerry Rubin and Abbie Hoffman, delighted in spoofing "the Man." Their Youth International Party was pure put-on, right down to their supposed candidate for the Democratic nomination, a pig christened "Pigasus."

The spoof boomeranged: Daley and the Chicago newspapers took the Yippies' tall tales at face value, repeating their threats to burn Chicago down by flooding the sewers with gasoline or to dump LSD in the city's water supply or to stage a swim-in that would end with the shocking sight of 10,000 nude bodies floating in Lake Michigan. Also widely accepted was the boast that 100,000 to 200,000 demonstrators would descend on Chicago. (Later reports confirmed that only about 5,000 protesters came from out of town.)

To face this harmless, if bizarre, menagerie, Daley turned Chicago into a bristling armed camp, with a posse more than 24,000 strong: 12,000 policemen, 6,000 Illinois National Guardsmen and, standing by at suburban naval posts, 6,000 U.S. Army troops equipped with rifles, flamethrowers and bazookas. The convention hall, International Amphitheatre, was protected by barbed wire and packed with cops and security agents. Only weeks after Russian tanks rolled into Czechoslo-

To the barricades! *While a motley crew of protesters gathered in Chicago's streets, Mayor Richard J. Daley, left, kept an iron grip on the city from inside the convention hall*

vakia, the protesters knew what to do. WELCOME TO PRAGUE, said their signs.

As the youngsters began arriving in the city, the mood grew increasingly tense: demonstrators taunted the police and in some cases deliberately disobeyed reasonable orders. Most of the provocations were verbal—screams of "Pig!" and much fouler epithets, words that were never voiced in public in the U.S. at the time. Police are seldom shocked by four-letter words. But they were outraged to see obscenities printed on placards and to hear them shouted by apparently well-educated, middle-class college women. The barrage of epithets helped convince some policemen that their foes were scarcely human—and they began to shed their own humanity.

THE TEMPERATURE BEGAN RUNNING HIGH IN THE streets around the convention hall and in Lincoln and Grant parks, where many protesters were camping, as demonstrators hurled bricks, bottles and nail-studded golf balls at the police lines. During the first three days of the week, the cops generally reacted with tear gas and occasional beatings. But on Wednesday night, Aug. 29, as delegates gathered to nominate their candidate, the police broke down and gave vent to a cathartic bloodletting. Outraged when the protesters lowered a U.S. flag during a rally in Grant Park beside Lake Michigan, the cops hurled tear gas into the crowd. The demonstrators, bent on parading to the convention

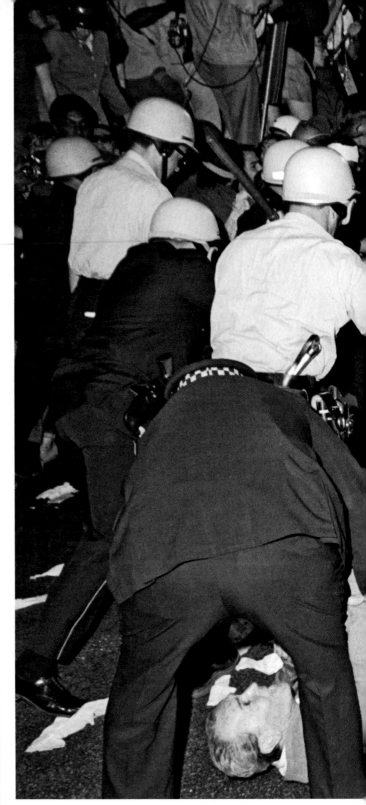

In Defense of the Authorities

TIME *asked Richard Schultz, a prosecutor at the 1969 trial of seven protesters charged with inciting the riots in Chicago, to recall the mood of 1968.*

What's hard to remember today is that we took the threat of overthrowing the government seriously—this was a credible threat. These people had come to Chicago hoping to ignite a revolution in the streets. They were trying to show that the government was so illegitimate that it had to use heavily armed National Guard forces to protect delegates from protesters— that men with guns had to protect politicians from children. These kids would stand in line, throw bags of urine at the cops, chant and taunt them. Their leaders' thought was to get thousands of children into the parks, demanding to be heard by an illegitimate government. And then to provoke the the police into beating the children. And for all of this to happen on national TV, that could foment the revolution.

They were tapping into a very real division in the United States: many people despised the government because they or their children had to go and fight in a war they didn't believe in. The leaders of the protests were devoting all their energy to overthrowing our government, but they had no plan for what to do once they had taken power.

In a sense, the bad guys won in Chicago: the perception was created that the government was inflexible and illegitimate, like a dictatorship.

site (Daley had refused a permit for their march), regrouped in front of the Conrad Hilton Hotel, where they were surrounded by phalanxes of cops. Police then warned the demonstrators to clear the streets and waited for five minutes for several busloads of reinforcements to arrive. Then the order was given.

Suddenly the cops stormed the protesters, flailing blindly into the crowd of some 3,000, then ranged onto the sidewalks to attack onlookers. In a pincer movement, they trapped some 150 people against the wall of the hotel. A window of the Hilton's Haymarket lounge gave

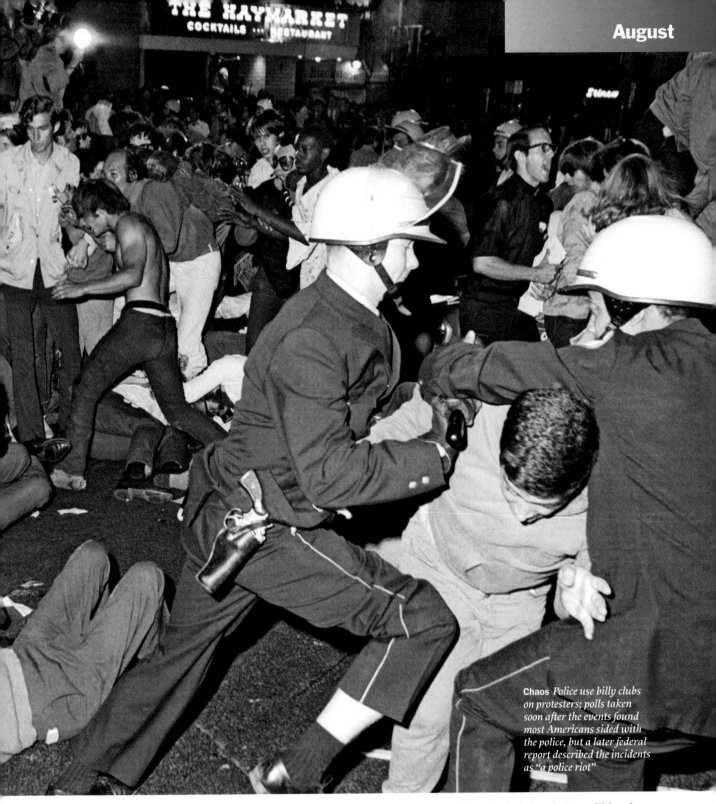

Chaos *Police use billy clubs on protesters; polls taken soon after the events found most Americans sided with the police, but a later federal report described the incidents as "a police riot"*

way, and about 10 of the targets spilled into the club after the shards of glass. A squad of police pursued them inside and beat them. Two waitresses inside took one look and capsized in a dead faint. Bloodied men and women tried to make their way into the hotel lobby. Within minutes, the breakdown of police discipline was complete. As his policemen went out of control, the deputy superintendent in charge had to pull berserk officers off battered and bruised demonstrators, shouting at them, "Stop, damn it, stop!"

The onslaught ended half an hour later, with about 200 arrested and hundreds injured; incredibly, there were no fatalities. The confrontation raged through the streets for hours, as the media-savvy demonstrators chanted, "The whole world is watching!"

And it was. Newspapers and TV commentators from Moscow to Tokyo reacted with revulsion to the violence. Under fire, Daley uttered a memorable gaffe. "The policeman isn't there to create disorder," he explained, "the policeman is there to preserve disorder." Yet polls soon reported that a majority of Americans believed that, given the provocations they encountered, Chica-

go's police had struck a notable blow for law and order.

Three months later, a well-documented report titled *Rights in Conflict*, ordered up by President Johnson, offered a balanced view of one of the most serious civil disruptions in U.S. history. The report stressed the provocations suffered by the police and recorded some examples of restraint on their part. But its conclusion minced no words, calling the mayhem in the streets "a police riot." It seconded TIME's original report of the events, which said, "With billy clubs, tear gas and Mace, the ... cops violated the civil rights of countless innocent citizens and contravened every accepted code of professional police discipline ... [they] savagely attacked hippies, Yippies, New Leftists, revolutionaries, dissident Democrats, newsmen, photographers, passersby, clergymen ... *Playboy's* Hugh Hefner took a whack on the backside. The police even victimized a member of the British Parliament, Mrs. Anne Kerr ... who was

Maced outside the Conrad Hilton and hustled off to the lockup." The federal report supported the accounts by numerous journalists who testified that the cops deliberately slugged them and wrecked their equipment in an effort to thwart coverage of their brutality.

TO THE DEMOCRATS' DISMAY, THE CHAOS OUTSIDE the convention center completely overshadowed the news from within, as Vice President Hubert Humphrey was chosen as the party's nominee for the presidency. Delegates who had arrived in Chicago already deeply divided watched in horror as what previously had been a bitter but rational argument about the Vietnam War was translated, traumatically, into street battles between protesters and police. The entire event was tarred, first by Mayor Daley's obsessive security measures, which surrounded a major function of U.S. democracy with the air of a police state—and then by

Donkey serenade *Emotions ran high in the convention hall. Clockwise from top left: actor Paul Newman and playwright Arthur Miller react; delegates cheer Humphrey; the Vice President and running mate Senator Muskie; McCarthy supporters; an angry California delegate shows his credentials*

bad news. In the olden days they used to put him to death. I don't think they'll go quite that far in Chicago."

South Dakota Senator George McGovern, a late entry, hoped a deadlocked convention might turn to him. But his backing from some supporters of the late Robert F. Kennedy didn't amount to much in terms of delegate strength. The candidacy of Georgia's rabidly segregationist Governor Lestor Maddox was a stunt that only highlighted the party's increasingly slim hold on its once strong Southern constituency.

In a sign of the party's internal divisions, the seating of a record 1,000 delegates from 14 states was challenged on grounds ranging from racial discrimination to improper selection procedures, but most of the challenges were overturned. Though the presumptive Mississippi delegation was left unseated on the ground of racial bias and was replaced by a half-white, half-black group, the decision wasn't a McCarthy victory, as Humphrey also supported the insurgents.

On the issue that towered above all others, the war in Vietnam, delegates engaged in a spirited debate that ended with the approval of a relatively soft plank that called for an immediate bombing halt (which L.B.J. opposed), a drawdown in offensive operations by the U.S. and a phased withdrawal of all foreign troops—but made no mention of the contentious proposal to set up a coalition government in South Vietnam. Party doves' hopes to adopt a stronger antiwar measure were dashed in the wake of Russia's thrust into Czechoslovakia earlier in August. Said Rhode Island's Senator Claiborne Pell: "The triumph of the hawks of the Kremlin has strengthened the hawks in Chicago." A Louis Harris poll showed that Americans opposed the doves' support of a unilateral bombing halt 61% to 24%, and of a coalition government in South Vietnam, 52% to 27%.

With the nomination in hand, Humphrey desperately appealed for party unity, and his selection of Maine Senator Edmund Muskie as his running mate was well received. But a Gallup poll taken just after the convention bore dismal tidings. Where Richard Nixon had led Humphrey a scant 2% before his nomination as the GOP candidate in Miami earlier in August, after the cataclysm in Chicago he opened up a huge 16% lead, boasting 45% to Humphrey's 29%.

Just before the showdown in Chicago, McCarthy aide Richard Goodwin told Time, "This is the convention of the lemmings. Everybody is swimming out to sea, screaming at each other—and Richard Nixon is sitting on the bank laughing." Ten days later, Mayor Daley, Chicago's cops and the protesters had firmly linked the Democratic Party to the prospect of anarchy in America's streets. Nixon and the GOP were licking their chops: they had been served up a three-word theme that would carry them to victory in the fall—law and order. ∎

the paroxysms of street violence that, indeed, the whole world had witnessed.

Humphrey had stumbled in recent weeks, contradicting himself in his seeming eagerness to please all comers, and doubts about him were multiplying. Rumors circulated that if a deadlock developed, delegates would draft Senator Edward Kennedy as a proxy for his late brother. Others speculated that desperate delegates would turn to the man who had renounced the office, Johnson. The fact that L.B.J. was busily demeaning Humphrey to party leaders only fed such musings.

But if Humphrey was weak, his opponents were even weaker. Vietnam War critic Senator Eugene McCarthy arrived with far fewer delegates than Humphrey; his strategy was to force floor fights to stir up his followers and win more votes through challenging state delegations. But the gloomy Senator was not optimistic, allowing, "I'm like the messenger who comes bearing the

Abbie Hoffman and Jerry Rubin, Yippies

WHAT THE HECK IS A YIPPIE? THE TERM BAFFLED MANY AMERICANS IN 1968, AS IT WAS INTENDED to. But from the vantage point of 2008, it's not that hard to arrive at a definition: a Yippie was a hippie who had been mugged by politics. The description fit millions of young Americans who had been happy smoking pot and listening to *Sgt. Pepper* in 1967 but who followed new pursuits in 1968: smoking pot and marching against the war in Vietnam. Leading the parade were two of the era's most notorious pied pipers, Abbie Hoffman and Jerry Rubin, founders of the Youth International Party (emphasis on the last word). The Yippie duo were exemplars of a type not common in U.S. culture until the 1960s: the agent provocateur. Hoffman, 31 in '68, was a self-described "Jewish Road Warrior" and Brandeis University alumnus. Rubin, 30 in '68, was a University of Cincinnati graduate who later studied at the University of California, Berkeley. TIME called them "minions of the absurd whose ... antics at least leavened the grim seriousness of the New Leftists with much-needed humor."

For the Yippies, the main opportunity to act out in 1968 was the Democratic National Convention in August, and indeed they practiced their "politics of ecstasy" with brio in Chicago. Hoffman cadged dinner from his four police tails, passed out phone numbers of city officials for telephonic harassment and was ultimately arrested for wearing a four-letter word on his forehead. Rubin had even more fun. To protect himself from police strong-arm tactics, he hired a sledge-fisted Chicagoan known as "Big Bob Lavin," whose beard and bellicosity were matched by his ability to throw bottles at the cops. Big Bob was gassed by the police and clubbed into submission—carrying with him into jail Rubin's tactical diary. Only then was it revealed that Big Bob was really undercover cop Robert Pierson, 35. Said an unfazed Rubin: "Well, at least he was a good bodyguard." Hoffman died in 1989, Rubin in 1994. ∎

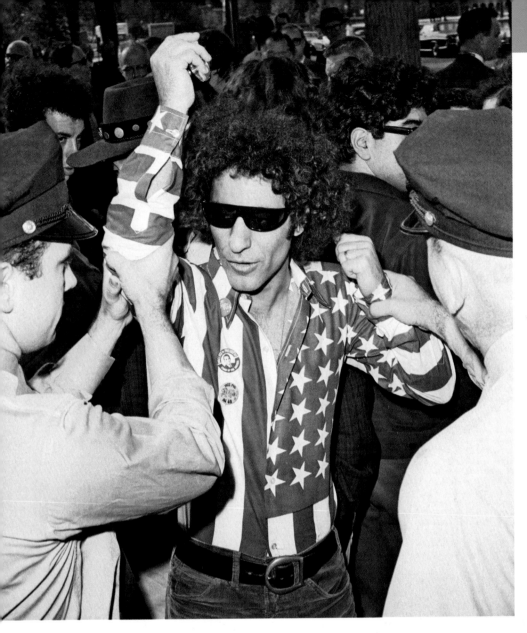

Theater of the absurd At far left, Jerry Rubin was ejected from an October 1968 hearing of the House Committee on Un-American Activities on the Chicago riots for his satirical get-up (the gun is plastic, but the bandolier held live bullets). The outfit drew the response Rubin desired from a woman outside the Capitol.

At near left, Hoffman is arrested upon trying to interrupt the same hearing

Act II *After rising to fame as a proponent of New Left policies in the '60s, Hayden, below, has continued to work for change within the political system; he identifies himself today as a Progressive Democrat. He is shown testifying before a House committee in 1968*

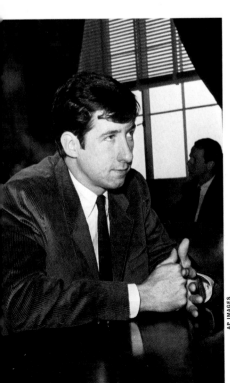

Tom Hayden, Activist

TOM HAYDEN WAS BRANDED WITH JERRY RUBIN AND ABBIE HOFFMAN AS ONE of the "Chicago 7," who were tried in 1969 for inciting riots at the Democratic Convention. But as Hayden told TIME late in 2007, "They [the government] came up with a composite of the movement—one black Panther, two Yippies, two SDS types, one graduate student, one old-line communist. They fabricated this network by bringing us together—they invented us. It was the same problem they had with Vietnam: they thought North Vietnam was a puppet whose strings were pulled by Beijing and Moscow. It never occurred to them that this was a legitimate nationalist, anticolonial movement."

Hayden, 28 in '68, was a serious student of politics, an admirer of R.F.K.'s whose New Left agenda was no put-on. Recalling that era for this book, Hayden said, "Our strategy in the early 1960s was to win—to be the radical wing of a left-wing coalition that elected a President and a congressional majority. That dream died with Kennedy and King. What came next was a hardening effect. We decided that if we couldn't be part of the mainstream, we were still going to take political action outside the mainstream—in the streets. [After Mayor Daley refused to issue permits for protest marches], I thought that the only thing that would be worse would be to retreat and go home. I felt we had a moral permit to march." ∎

Medal Madness

In a year of riots and rebellion, even the Olympic Games become a tumultuous arena of dissent, violence and discord

THE LATIN MOTTO OF THE OLYMPIC GAMES IS *CITIUS*, *Altius, Fortius:* "Faster, Higher, Stronger." But as TIME pointed out in its review of the Games of the XIX Olympiad, held in Mexico City in October, a more fitting motto for the 1968 Games might have been "Angrier, Nastier, Uglier." Like most other social institutions in this chaotic year, the Olympics seemed infected by rancor in 1968, memorable as much for their politics and protests as for pole vaults and pageantry.

The infection struck before the Games began, when Mexican college students joined their counterparts around the globe in marching for academic reforms. Tensions mounted, until police and students clashed in a major riot on Oct. 2, in which hundreds of students were slain *(see page 83)*. Mexican authorities managed to successfully hush up the deadliness of that incident, but they couldn't stop TV cameras from beaming the moment that became the iconic symbol of the Games: U.S. sprinters Tommie Smith and John Carlos converting their medal ceremony into a political protest by holding their clenched fists aloft in a Black Power salute. The act was so provocative that it dominated the remainder of the Games, overshadowing the athletic events.

For the record, the U.S. team had a field day south of the border, winning 45 gold medals and 107 overall, far ahead of the U.S.S.R., which took 29 gold and 91 overall medals. *"The Star-Spangled Banner* was played so often that it began to sound like *The Stars and Stripes Forever,"* TIME said. Over time, the memories of Mexico City have expanded to embrace the remarkable feats of two other U.S. athletes, long jumper Bob Beamon and high jumper Dick Fosbury. ∎

Grab air! *Some credit Mexico City's altitude; others simply marvel at Bob Beamon's 1968 long jump, left, still the Olympic record, at 29 ft. 2 in. Fellow gold medalist Dick Fosbury revolutionized his event, the high jump, by soaring over the bar head and back first*

Show of hands *When U.S. sprinters Tommie Smith, center, and John Carlos raised their fists in a Black Power salute after placing first and third in the 200-m event, they were reviled by many—including* TIME, *which called the protest "a public display of petulance." A few other U.S. athletes cheered; many more objected. "I came here to win a gold medal—not to talk about Black Power," said Ohio's Willie Davenport, after winning the 110-m high hurdles. The two men were expelled from the Games by the head of the International Olympic Committee, the crusty American Avery Brundage. In later years the men's protest came to be perceived by many as an honorable political statement; a statue of their deed was erected by their alma mater, San Jose State University, in 2005. Often forgotten is the fact that the second-place finisher, Australia's Peter Norman, joined them in wearing a human-rights medal on his chest. When he died in 2006, Smith and Carlos were pallbearers at his funeral.*

Sports Greats Of '68

In a year of turmoil, Arthur Ashe, Peggy Fleming and other stars offer visions of grace and mastery. And don't forget about O.J.!

Before the Fall

The saga of footballer O.J. Simpson may have turned into one of the great tragedies of modern sport, but the running back's fall from grace was far in the future when he took his last bow as a college star at the University of Southern California, after running for 128 yds. and two touchdowns in the 1968 Rose Bowl.

Here's what TIME had to say back then: "Heisman Trophy winner Simpson [is] everybody's All-Everything. The pros liken his bulling power, his marvelous moves and his explosive speed to a cross between Jim Brown and Gale Sayers. [A scout] called him 'the greatest college runner in 10-20-50 years.'"

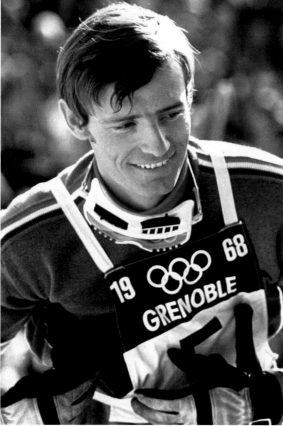

Grenoble in Four Words: Jean-Claude and Peggy

The Summer Olympics in Mexico City may have been a fiasco, but the Winter Games, held in Grenoble, France, in February, offered chills and thrills galore. For Americans, the thrills were generated primarily by figure skater Peggy Fleming, described by a perhaps smitten TIME *correspondent as "a raven-haired Colorado College coed." The first great U.S. star in women's skating in years, Fleming ignited a passion for her sport among her countrymen that has yet to subside. After racking up a strong lead of 77.2 points over her closest competitor in the compulsory competition, Fleming might have taken the safe route. No chance. "I am competing against myself," she told* TIME. *"I'll skate as well as I can." Dressed in a chartreuse outfit sewn by her mother, and skating to the strains of Tchaikovsky's* Pathétique, *she soared to a clear victory in her final performance.*

While visions of chartreuse danced in male spectators' heads, women around the world were falling for the dashing male star of the Games, the host nation's Jean-Claude Killy, who shushed his way to Olympic immortality by winning the gold medal in three Alpine skiing events, the slalom, giant slalom and downhill.

Academic of the Baseline

He resembled a professor, and he once said, "For every hour spent on the playing field, two should be spent with a book." But Arthur Ashe was a gifted tennis player who won the inaugural U.S. Open in 1968. When South Africa's apartheid government denied him a visa later in the year, effectively banning him from that nation's Open, American fans crossed racial divides to support his crusade to boycott the event.

A Brash Young Golfer Makes His Mark

The game of golf found one of its most colorful stars in 1968, when Lee Trevino, 28, won his first major championship, the U.S. Open, at Oak Hill Country Club in Rochester, N.Y. Born in Dallas to parents of Mexican descent, Trevino was a rags-to-riches kid whose loquacious, upbeat personality soon had fans referring to him as the "Merry Mex." "The only time I stop yakking," Trevino told TIME, *"is when I'm asleep."*

Pitchers' Duels

Baseball fans call it the Year of the Pitcher, for good reason: Denny McLain, Bob Gibson and Mickey Lolich made the '68 season sizzle, and their World Series was a real fall classic

SIZING UP THE STATE OF THE NATIONAL PASTIME JUST before July 4, 1968, TIME noted an old baseball bromide, which holds that the team leading its league on Independence Day will win the pennant. At the time, the reigning world champion St. Louis Cardinals were enjoying a steady six-game lead in the National League, while in the American, the Detroit Tigers boasted an eight-game bulge.

The Tigers' story was compelling, for Detroit had suffered harrowing race riots in the summer of 1967. Now baseball was doing what it does best: uniting Michiganders of all stripes behind a winning team. Moreover, the Tigers hadn't won a pennant in 22 years, and their success was a huge surprise, given that their team batting average was .227 and their dugout was filled with sore arms and legs.

One Tiger's arm wasn't sore. Pitcher Denny McLain, 24, was dazzling; by July 4 his record was 14-2. But McLain was a sorehead, a tough customer with a surly temper, who happened to be enjoying one of the greatest years in baseball history. By September he was on the cover of TIME; by season's end his record would be 31-6, making

him the first pitcher to win 30 games in a season since Cardinals legend Dizzy Dean had done so in 1934. No pitcher has done so since.

McLain's heroics put the focus on pitching's new dominance in the game, thanks to a 1963 rules change that expanded the strike zone, favoring pitcher over batter. The trend reached its peak in 1968, to fans' dismay. The Cardinals' intimidating right-hander Bob Gibson, 32, would notch 22 victories that year, including 13 shutouts; his earned-run average of 1.12 is the lowest in National League history. At season's end, the game's overlords stepped in, restoring the smaller strike zone and reducing the height of the pitcher's mound.

But that was 1969. When the '68 World Series opened, with—sure enough—the Cards and Tigers facing each other in St. Louis, fans were dying to watch Gibson and McLain duke it out. Going into the game, McLain oozed confidence. "I want to humiliate the Cardinals," said McLain. "If that's the way he feels, he'll get his chance," retorted Gibson. Humiliation ensued, but it was Gibson who would administer the lesson, with a virtuoso performance unmatched in the 65 preceding Series.

For McLain, the contest was over quickly; unusually erratic, he walked three batters, gave up three hits and three runs and retired to the showers after five innings. Meanwhile, Gibson shrewdly mixed up his pitches, alternating sliders and slow curves with his humming fastball. By the end of the eighth inning, 14 Tigers had gone down on strikes. When Gibson took the mound in the ninth, only one strikeout stood between him and Sandy Koufax's World Series record. Gibson got that, and more. Eleven-time All-Star Al Kaline merely waved at a fastball. Norm Cash missed a slider by a mile. With a final flourish, Gibson slipped another slider past Willie Horton and stalked off the field with a five-hit 4-0 victory and a new Series mark of 17 strikeouts—another record not equaled since.

The tide turned sharply in the next three games. Mickey Lolich, the Tiger's portly No. 2 pitcher, threw nine strikeouts, and the Tigers won Game 2, 13-6. St. Louis countered with a 13-4 blowout in Game 3. Gibson and McLain dueled once again in the fourth game, and after the Cards' brilliant outfielder Lou Brock welcomed McLain with a lead-off homer, St. Louis won 10-1. The world champions now had the upper hand. The Tigers were down, three games to one, and Gibson had beaten McLain twice. Relaxed and confident, Gibson was ready to pitch again, if necessary, in the best-of-seven Series.

By the middle of Game 5, the Tigers looked like certain losers. Lolich, their only Series winner, was laboring on the short end of a 3-2 score; he seemed ready to take the long walk to the clubhouse when he got an unexpected reprieve from Brock, the National League's best baserunner. Heading for home with a sure run, Brock unaccountably failed to slide, came in standing up, crashed into catcher Bill Freehan and was easily tagged out. The rally was over. Two innings later, Detroit scored three runs. Final score: Tigers 5, Cards 3.

Back to St. Louis went the Series. At last McLain had his stuff; he held the Cards to nine hits and one run while the Tigers pummeled seven St. Louis pitchers for 13 runs. Suddenly, it was Game 7—Gibson vs. Lolich (pitching on two days' rest), winner take all. Once more Lolich was good, but Gibson was great. He struck out seven of the first 23 men he faced, allowed only three hits and no runs. Then Lolich was given another gift, this time by St. Louis' Curt Flood, one of the game's best outfielders. In the top of the seventh, with two Tigers on base, Detroit's Jim Northrup hit a deep but routine line drive to center field. Flood lost the ball against the white-shirted crowd, found it, then stumbled and watched it sail over his head for a triple. Two runs scored, and the Tigers went on to win 4-1, as Lolich served the Cardinals nothing but junk for the last three innings.

In the Year of the Pitcher, Lolich was chosen as the World Series MVP: his record of pitching and winning three complete Series games remains unequaled 40 years later. No one approved more heartily than Mickey himself: "Everybody mentions heroes on the team, and Lolich has always been second or third best. Well, today was my day, and I'm glad it came." ∎

How They Wound Up

Bob Gibson

The rules may have favored pitchers in 1968, but Bob Gibson would have been a dominating hurler in any era. A Vince Lombardi kind of athlete, Glbson was a man filled with pride, a scowling, intense competitor who lived for victory and whose mean brushback pitch ensured few batters dared to crowd home plate. He was also a fine hand with a bat (his batting average in 1970 was .303) and a sterling base runner: in the era before pitchers were coddled, the Cards sometimes used Gibson as a pinch runner. In 1999 *Sporting News* ranked Gibson, 72 in 2008, as No. 31 on their list of the game's 100 greatest players.

Denny McLain

After his 1968 heroics, life has been tough for the one-time star. The man known for his large ego and fierce temper was always attracted to life's dark side. He became involved with professional gamblers and was suspended from the game for three months in the 1970 season, which he ended with a record of three wins and five losses. The story gets worse: after leaving baseball in 1972, he served time in prison for crimes that included drug trafficking, embezzlement and racketeering. McLain, 63 in 2008, released an autobiography in 2007. Its title: *I Told You I Wasn't Perfect.*

Mickey Lolich

The World Series MVP in 1968 finally saw his record of winning three games in the fall classic equaled by future Hall of Famer Randy Johnson in 2001—but even Johnson didn't pitch and win three complete games, as Lolich did in '68. Often forgotten is another interesting fact: Lolich gave himself a boost in Game 2, when he hit the first (and only) home run of his career. Lolich, shown above leaping into the arms of catcher Bill Freehan after the Tigers won the Series, ranks third among left-handers in career strikeouts, with 2,832. After retiring from the game in 1976 and skipping the 1977 season, he pitched for the San Diego Padres in the 1978 and '79 seasons. Sixty-seven in 2008, he stays in shape by serving as a coach at a Tigers fantasy camp.

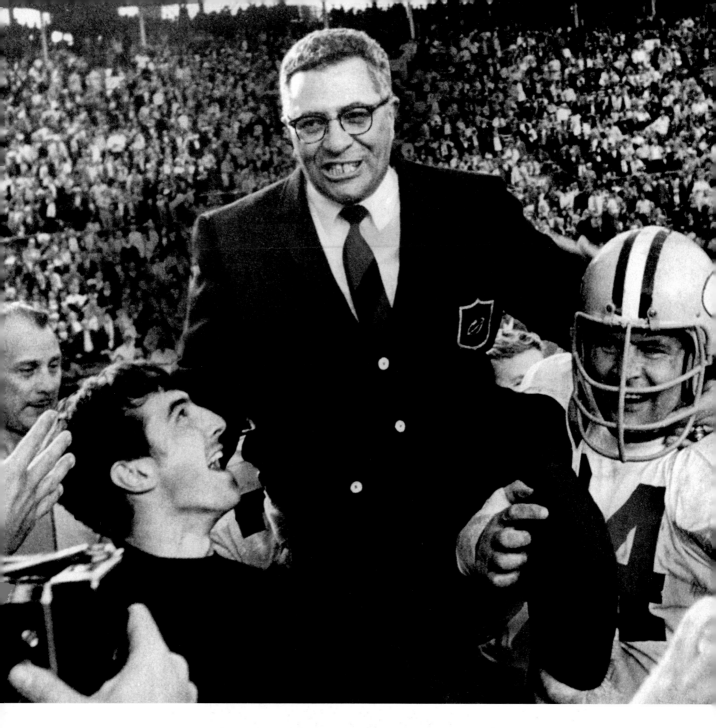

Vince Lombardi, Football Coach

YOU'RE LOOKING AT HISTORY, SPORTS FANS: THE NFL'S MOST REVERED COACH, VINCE LOMBARDI, enjoys his last hurrah as leader of the Green Bay Packers on Jan. 14, 1968. Lombardi's Packers had just whipped the overmatched American Football League (AFL) champion Oakland Raiders, 33-14, to win Super Bowl II. A year earlier, the Packers had won the first showdown between the NFL and the AFL, beating the Kansas City Chiefs, 35-10. Lombardi had appeared on the cover of TIME in 1962, three years after the Packers hired the Brooklyn-born former Fordham University fullback for his first head-coaching job. A cross between General Patton and a good Italian mama, Lombardi was a raging, weeping leader of men who took a gang of has-beens and molded them into superstars, seemingly through sheer force of will. As for strategy: "We always hit them at their strongest point," he told TIME.

Lombardi, then 54, surprised fans by retiring to become Green Bay's general manager only a few weeks later. But after one season he agreed to coach the Washington Redskins, saying he missed the rapport he shared with players. He led Washington for only a year before the cancer that would kill him in 1970 was diagnosed. Lionized in 1968 by those who despised the mores of the youthful counterculture, he was revered as a man's man, an inspiring leader who preached pride and mutual esteem, though he never permitted intimacy. "He treats us all the same," said Packers tackle Henry Jordan. "Like dogs."

Muhammad Ali, Boxer

WHAT'S IN A NAME? IN 1968 AMERICANS WERE SO BITTERLY DIVIDED BY the war in Vietnam and their battles over cultural values that the name you used to refer to the ex–heavyweight champion of the world was an instant indicator of your worldview. If you called the 26-year-old boxer Cassius Clay, the name he was given at birth, you were likely a pro-war, conservative American. If you called him Muhammad Ali, the name he adopted when he joined the Nation of Islam in 1965, you were likely an antiwar liberal. (As for TIME, it charted the changing tides of 1968: early in the year it referred to the boxer as "dethroned champ Cassius Clay"; by mid-year, he was "Muhammad Ali, alias Cassius Clay"; by year's end the same man was, simply, "Muhammad Ali.")

What turned a heavyweight boxer into a weathervane for political breezes? In 1966 Ali had thrice refused to step forward and be drafted into the U.S. Army. In response, he was stripped of his crown and convicted of a felony; his case would go to the Supreme Court. His action resounded along the nation's fault lines: those on the right vilified Ali as a draft-dodging traitor, while those on the left cheered him as a victim of conscience. Those on the center—well, there wasn't much of a center in 1968. But whatever side they were on, many Americans repeated Ali's typically colorful comment on his opposition to the conflict: "I ain't got no quarrel with them Viet Cong … they never called me n____."

Love him or hate him, 1968 was one of the years Ali spent in the wilderness—years that, in a less charged era, he might have spent displaying his immense powers in the ring and delighting Americans with his hammy antics. Instead, Ali spent his days making the rounds of antiwar rallies and attending Nation of Islam functions; his first child, daughter Maryum, was born in June. Yet even in tough times, the irrepressible Ali couldn't contain his gift of gab. He treated college anti-war audiences to his latest bit of doggerel, a wishful forecast of his return to the ring to challenge the man who had assumed his crown, Joe Frazier:

> *The referee wears a worried frown*
> *Cause he can't start counting 'til*
> *Frazier comes down.*
> *Who would have thought when they came to the fight*
> *They'd witness the flight*
> *Of the first colored satellite?*

Calling an audible *After resigning as coach of the Packers in 1968, Lombardi took a cameo role in the film* Paper Lion. *The script called for him to turn down writer George Plimpton's request to try out for the Packers with a curt "No." But Lombardi ad-libbed: "Have you tried the AFL?"*

On the outs *Dressed in the suit-and-tie uniform of the Black Muslims, Ali accepts the homage of a fan at an anti-war rally in San Francisco*

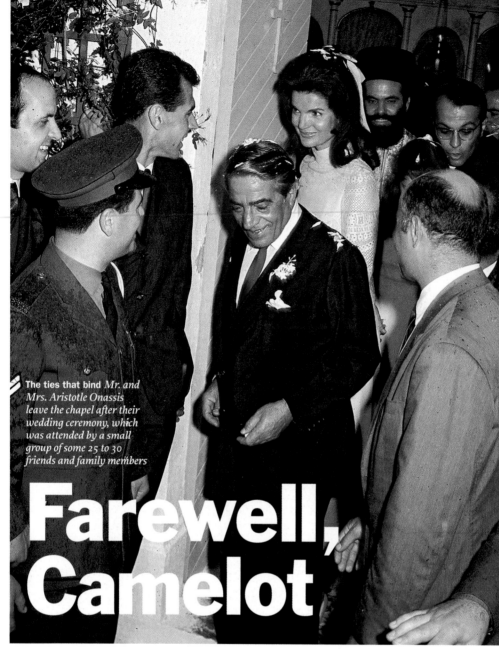

The ties that bind *Mr. and Mrs. Aristotle Onassis leave the chapel after their wedding ceremony, which was attended by a small group of some 25 to 30 friends and family members*

Farewell, Camelot

An American icon abdicates her throne: Jackie Kennedy, widow of an idolized President, marries a foreign tycoon

THE GROOM WAS ONE OF THE WORLD'S RICHEST men, a Greek shipping magnate whose private yacht, private island and very public liaison with a woman not his wife, opera diva Maria Callas, had made him famous. The bride was one of the world's most admired women, a symbol of taste, elegance and glamour, and for five years now the widow of a U.S. President whose brief term in office she had helped romanticize, indelibly, as "Camelot."

Considering the groom's wealth and the bride's fame, their wedding on Oct. 20, 1968, in the tiny, neoclassic Chapel of Panayitsa (the Little Virgin) in a cypress grove above the harbor of the Onassis-owned isle of Skorpios, was almost self-consciously modest. Rain, considered a blessing by the Greeks, descended like a gray benedic-

tion across the island. In the tiny chapel, Jacqueline Bouvier Kennedy, 39, stood quietly—almost in a daze—in her beige chiffon-and-lace dress, with Aristotle Onassis, 62, in his dark blue business suit. The bride's two children, John, 7, and Caroline, 10, each carrying a single tall white candle, flanked them. As Archimandrite Polykarpos Athanassion intoned the solemn Greek of the nuptial liturgy, Jackie and Ari exchanged rings and wreaths of lemon blossoms, and drank wine from a single chalice. Then the priest led them round a table three times in the ritual dance of Isaiah.

It was a quiet affair, but news of the marriage struck Americans and the rest of the world with the force of a bombshell. Reaction ranged from dismay to a kind of shocked ribaldry. JACKIE, HOW COULD YOU? read a head-

line in Stockholm's *Expressen*. Said a former Kennedy aide: "She's gone from Prince Charming to Caliban."

To Americans living through the most uncivil year in recent memory, the unlikely marriage was of a piece with the other grim headlines of 1968. It was not enough, it seemed, for two contemporary heroes, Martin Luther King Jr. and Robert F. Kennedy, to be murdered in cold blood; now even the cherished myths of an idealized dead President and his New Frontier had been shattered. "It's the end of Camelot" was a common reaction.

Even before the assassination of her husband in 1963, Jackie Kennedy's beauty and style had captivated the world. In the days after his death, millions grieved for the widow whose poise and lonely courage during his funeral helped carry the U.S. through an ordeal. Jackie had taken on a mythic quality in the American mind. Now, with little notice, she seemed brusquely to abdicate the throne that Americans had made for her—and not for love, it seemed, but for money.

TIME readers vented their dismay in letters to the magazine. "I am unhappy. My goddess has feet of clay" was one of the more sedate missives. "We've lost a national shrine," read another. A third addressed the charges that so irritated many Americans: "Papa Onassis has added another jewel to his collection, a jewel that one would have thought was not for sale at any price." Only one writer displayed a sense of humor: "It must be love. Surely, Jackie didn't trade the proud name of John Fitzgerald Kennedy for a mess of yachtage! Did she?"

A German paper's headline read, AMERICA HAS LOST A SAINT. But gradually, both Americans and Europeans began to realize that the saint, or heroine, had been of their own making. In the next few years Jackie would acquire a new persona, as the jet-setting Manhattanite "Jackie O." The surprising union—during which the couple were noted to spend little time together—would be brief: Onassis died in 1975. Most of his immense fortune went to his daughter Christina, 18. After contesting the scant allowance she was owed under the terms of a prenuptial agreement, his widow received $26 million.

This skewed fairy tale has a happy ending. Aristotle Onassis' widow went on to make a triumph of her "third life," regaining the world's respect on her own terms, through her work as an editor, her crusade to preserve landmark buildings, her quiet charity and her ability to raise two remarkably poised and successful children amid a life lived in the public eye. At her death in 1994, the world mourned a woman of grace and strength, described by TIME as "America's First Lady." ■

The Man Who Married a Legend

When the idolized widow of an idolized President married a Greek shipping tycoon many years her senior, Americans needed a briefing on the bridegroom. TIME obliged, telling readers in its cover story on the marriage, "Aristotle Onassis is a man of considerable magnetism. Some of his friends profess to see him as part Alexander the Great (for whom he probably named his son), part a Hellenic Great Gatsby. He is iron-willed, infinitely considerate of his women, vain of his limitless ability to charm, entertain and protect those whom he likes or loves."

Born in Smyrna on Jan. 20, 1906, the son of a well-to-do tobacco dealer, Onassis witnessed as a youth the savage Turkish invasion of 1922, during which an uncle was lynched in the town square. His family fled to mainland Greece. At 17, Aristotle embarked for Argentina with $60 in his pocket, to seek his fortune.

After working in Buenos Aires as a telephone lineman at 25¢ an hour, he began importing Turkish and Bulgarian tobacco blends that became immensely popular in Latin America. Three years later, he had saved $20,000; by age 23, tobacco had made him a dollar millionaire. During the Depression he began buying merchant ships; when World War II broke out, Onassis owned many of the precious oil tankers in Allied waters.

His worth vastly enhanced by wartime earnings, Onassis in 1946 married the younger daughter of Stavros Livanos, then one of the most powerful of the Greek shipping magnates. Athina

Safe harbor *Jackie Kennedy and children John and Caroline walk near the Onassis yacht* Christina. *Following are Jackie's sister Lee Radziwell, left, and J.F.K.'s sister Pat Kennedy Lawford*

(Tina) Livanos was only 17 when she married the stocky (5 ft. 5 in.) Onassis; the couple had two children, Alexander and Christina, before Tina divorced the tycoon due to his much-publicized liaison with Greek opera diva Maria Callas, which lasted until only a few months before he began courting Jacqueline Kennedy.

By the late 1960s Onassis was one of the world's richest men, his status secured by his 325-ft. yacht, the *Christina*, and his private island, Skorpios. Though largely self-educated, Onassis was well-read in classical Greek history and spoke six languages: Greek, Turkish, English, Spanish, French, Italian. Shrewd, apolitical and a live-wire operator, he was a tough businessman as well as a charming socialite, a night person who caromed among his pieds-à-terre around the world: in Paris (on Avenue Foch), London (Claridge's Hotel), Montevideo, Athens and Manhattan (the Pierre Hotel). Onassis died in 1975, seven years after his unexpected marriage made him an international celebrity.

Pop
Goes
The
Tube

Television strains to keep up with the culture, breeding a rough mix of success stories, stereotypes and one all-too-frequent invitation: "sock it to me!"

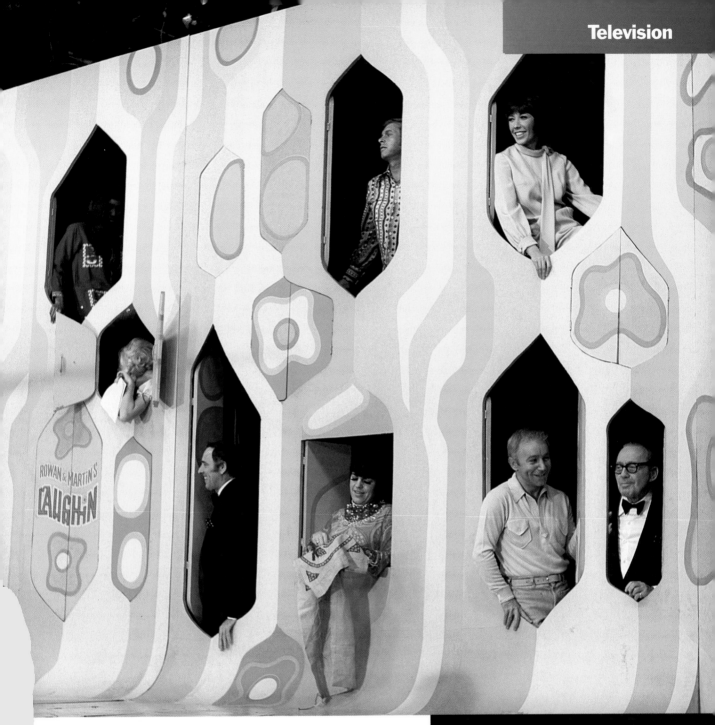

Rowan and Martin's Laugh-in

You had to be there—had to be a victim of television as it plodded through the 1950s and early '60s—to appreciate the impact created by the debut of Rowan and Martin's Laugh-In on TV viewers across the land on Jan. 22, 1968. The effect was electrifying, giddy, liberating: Can you really get away with this on network TV? Although the show's attempts to mimic pop culture were often dated ("Sock it to me!") and the jokes lame, that didn't matter. It was the sheer speed of the enterprise that stunned viewers, with some filmed snippets lasting as little as one-eighth of a second.

Veteran nightclub comics Dan Rowan, left, and Dick Martin gathered a big cast, including Goldie Hawn, top left, and Ruth Buzzi, right, and it seemed larger, as the comics quickly opened and closed the doors on the elaborate wall that was the show's centerpiece and signature, shooting off quips and catchphrases. Unexpected guests (Richard Nixon, Sammy Davis Jr., Marcel Marceau) kept it surprising. Within 10 months of its debut, TIME put the show on its cover, hailing its "artful spontaneity, a kind of controlled insanity, emerging from a cascade of crazy cartoon ideas …"

Elvis (The '68 Comeback Special)

Elvis in black leather: any questions? He had been rock 'n' roll's "it" boy of the 1950s, but by 1968, Elvis Presley was as hip as a hula-hoop. Thanks to his Svengali, "Colonel" Tom Parker, he was reduced to lip-synching banal songs written by factory hacks in Hollywood B-movies. (In May 1968, jazz guitarist Wes Montgomery told TIME he would never play with a string section: "Man, to me that would be as bad as doing Elvis Presley tunes.") But in December 1968, Elvis took a major career risk: as a Christmas TV special loomed, the singer defied Parker's suggestion that he perform only Yuletide tunes, starved himself to fit into his old leathers, stripped down his backing group to his original sidemen, belted out his old hits with renewed vigor to a live audience—it was his first live show in seven years—and revived his career with a legendary performance.

The Mod Squad

It's possible that the single best thing about this ABC series was its title—although its promotion line runs a close second: "One White, One Black, One Blonde." Michael Cole, Peggy Lipton and Clarence Williams III were the hip, young crime-busting cops who seized the weekly chance to don undercover duds and start jellin' with the felons. Did we mention they were young and hip?

The Prisoner

Trippy! This British import, which ran for only 16 episodes as a summer replacement series on CBS, is one of TV's all-time cult classics. Patrick McGoohan, right (and left), starred as a captive/member of a shadowy cabal with numerals for names (McGoohan was No. 6) in an undisclosed location … well, you get the picture. We can't prove it, but we suspect David Lynch, Tim Burton and other future fabulists were tuning in.

60 Minutes

The CBS series TIME hailed as one of TV's 100 best shows debuted with a familiar cast in place: producer Don Hewitt, journalists Mike Wallace, left, Harry Reasoner, right, and others. It has been much imitated and has had a few slip-ups, but, said TIME in 2007, "it sticks to the ideal that a camera could be a crowbar to pry out truths."

The Andy Griffith Show

Lest we forget: not all Americans ogled The Mod Squad in 1968. On thousands of Main Streets across the land, enough folks turned into the down-home antics on The Andy Griffith Show to make it the year's No. 1 series. The show, featuring Griffith as the sheriff of fictional Mayberry and the nerdy Don Knotts as his bug-eyed backup, remains in syndication.

The Smothers Brothers

TIME'S TELEVISION LISTINGS FOR SEPT. 27, 1968, PROMISED, "HARRY BELAFONTE and Cass Elliott join Tom and Dick in their first show of the new season." Well, sort of. The tape Tom and Dick Smothers delivered to CBS for the season premiere of *The Smothers Brothers Comedy Hour* included a 7-min. segment of Belafonte singing *Don't Stop the Carnival* as he stood in front of footage of street violence at the Chicago Democratic Convention a month earlier. But the segment was cut by network censors before the show aired. Network scissors also snipped out two more minutes in which the brothers parodied their direct competitors for viewers on Sunday nights. CBS's heavy-handed tactics were only the latest salvo in a running war that would end with the show's cancellation in April 1969.

CBS executives believed they were taking a risk in even airing a show created by the two brothers, whose folk-singing/comedy act was controversial for its edginess at a time when political satire was seldom featured in mainstream U.S. media. At its premiere in February 1967, CBS slotted the show as a sacrificial lamb against a ratings powerhouse, NBC's *Bonanza*. Yet the *Comedy Hour* got strong ratings, especially among the young viewers advertisers crave. Within two months, it was in the Top 20. Young, then unknown writers like Steve Martin and Rob Reiner crafted a smart, topical show that took on subjects like racism, religion and Vietnam. The result was an oasis of challenging fare amid network TV's vast 1960s wasteland— but one that proved too challenging for CBS. The last show created for the series in 1969 never aired: it lampooned the powerful chairman of the Senate Subcommittee on Communications, Rhode Island's John Pastore, who had recently convened hearings on the "questionable moral content" of popular TV shows. ■

Twofer *Tom Smothers, then 31, left, played the "dumb blond" in the team's comedy act, while Dick, 29, was his facile straight man. In fact, Tom was a smart, opinionated entertainer who was a leader in arguing that the show must retain its freedom to attack sacred cows, whether on Capitol Hill or in executive suites. After the show's cancellation, a CBS official told* TIME, *"Tom had been sticking his finger in the network's eye, and something had to be done"*

Goldie Hawn

WHEN SHE MADE HER FIRST APPEARANCE IN THE PAGES OF *TIME*, IN A COVER story on the 1968 TV sensation *Rowan & Martin's Laugh-In*, Goldie Hawn didn't even rate a name-check. "Periodically," the magazine noted, "a bikini-clad girl is shown dancing the boogaloo; then the camera moves in to reveal that the girl is painted head to feet with silly graffiti." The painted lady in question was Hawn, whose Twiggyesque frame made for a billboard with little room for excess verbiage; thanks to her girlish demeanor and stick figure, what might have been a leering set piece on the show had its fangs pulled. The comic, 22 in 1968, managed to incorporate a distinctly '60s wrinkle into her update of the standard baffled blond: she came across as a waifish flower child who just might have been too high to keep track of the show's antics. Indeed, it took Hawn a few years to shake off her persona from the show and to reveal herself to be an actor with smarts and wit. ■

Gaffes TIME *called Hawn* Laugh-In's *"resident dumdum who takes all the verbal pratfalls ... At first, her fluffs were a case of misreading the cue cards. Now they are part of the act"*

NBCU PHOTO BANK

America's Choice:

Richard Nixon is elected President and fosters a major
political realignment that continues to shape U.S. politics

THE GREATEST PRESIDENTS," TIME WROTE EARLY IN
1968 of its recently anointed Person of the Year
1967, Lyndon Johnson, "are those who emerged
during periods of severe strain, domestic or for-
eign. Johnson still has a chance to stand among them."
Yet even in the first weeks of the 1968 presidential elec-
tion year, that prospect seemed increasingly remote, as
Johnson's popularity continued its steep decline. Now,
like lions circling a wounded antelope, aspirants in
both major parties, along with a third-party Southern
maverick, began positioning themselves to succeed L.B.J.

For Republicans, Michigan Governor George Romney

(father of 2008 Republican contender Mitt Romney) was
an early front runner. His chances fizzled, however,
when he spoke out against the war in Vietnam and made
an ill-considered remark about having been "brain-
washed" by military officials on a visit there. After he
withdrew from the race in February, three major GOP
contenders remained in the race: Vice President Richard
Nixon, New York Governor Nelson Rockefeller and a rel-
ative newcomer, California Governor Ronald Reagan.

Nixon's resurrection from his defeats in the 1960 pres-
idential race and the 1962 California gubernatorial con-
test was a historic act of political reinvention. By the

The Happy Warrior *Some Americans ridiculed candidate Hubert Humphrey's "pleased-as-punch" demeanor, but his good cheer was not feigned; it was difficult for him to operate in attack mode. Here he is campaigning in Iowa. At left, a relaxed and newly approachable Richard Nixon chews the fat with young constituents*

STAN WAYMAN—TIME LIFE PICTURES

Law, Order, Nixon

first weeks of 1968, he had been raising money and rebuilding his party base for two years by campaigning for Republicans in local races around the nation. Nixon took dead aim at the party center and held it. Rockefeller, in contrast, had a vast personal fortune and a reputation for statesmanship but was hesitant and coy: he entered the race early on, then withdrew, only to jump back into the contest in June.

The Democrats reaped the whirlwind of Johnson's unpopular war in Vietnam at the end of March, when the President stunned Americans with his announcement he would not run for re-election. Suddenly, the world changed: every Republican candidate had to plan an entirely new campaign, against a Democrat whose name they would not know for months. "We had a pi-

geon," said one Republican, "and he flew the coop." The Democratic race was now wide open. Vice President Hubert Humphrey declared his candidacy in the last week of April, but until late in the campaign the Vice President would be hog-tied, struggling to balance loyalty to the domineering Johnson with the need to declare his independence from L.B.J. and his unpopular policies.

For politicians of both parties, the race was transformed yet again by the tragic assassinations of Martin Luther King and Robert Kennedy. The first stoked racial unrest in dozens of cities, bringing to the fore the "law and order" issue that was becoming one of the campaign's most resonant themes. The latter steered the Democrats toward Humphrey—a gift to Republicans who knew the Vice President was yoked to Johnson's policies.

117

Victory times two *Nixon rallies a crowd in Santa Barbara, Calif. His famous double-victory salute was oddly evocative of the peace symbol flashed by antiwar demonstrators, a point he delighted in. "It drives them crazy," he once said*

With Nixon emerging as the clear front runner among Republicans, the moderate Rockefeller was forced into an unlikely alliance with a long-shot candidate, Reagan, who was emerging as the standard bearer for the GOP's growing conservative wing. The two Governors hoped to prevent a Nixon victory on the first ballot at the G.O.P.'s August convention in Miami Beach. But when neither man was willing to throw his support behind the other, Nixon won the nomination on the first ballot.

The Republican candidate startled everyone with his choice of the obscure Governor of Maryland, Spiro Agnew, for his running mate, calling him an "underrated man." But Agnew soon proved useful, when he accused Humphrey (by now the presumptive Democratic nominee) of being "squishy soft" on communism. Agnew's angry polemics against hippies and street criminals quickly earned him a reputation as Nixon's attack dog.

A few weeks after the GOP convention was gaveled to a close, the Democrats gathered in Chicago. In a meltdown TIME called "the Convention of the Lemmings," Humphrey was nominated on the first ballot, while the party's hopes for unity were shredded by the bloody clashes between police and protesters outside the convention hall. The riots served the law-and-order issue to the Republicans on a platter: Humphrey said to his aides after the convention, "I'm dead." As a Maryland Republican told TIME, "Nixon and Agnew are riding the right issue—trouble in the streets. It outruns everything, especially with women voters. They're scared to death to walk down the street any more."

Because Humphrey was so closely identified with the war in Vietnam, the second major issue of the election was also swinging in favor of the GOP, especially after the Nixon camp suggested he had a secret plan to end the war. Though he provided no details, the mere hope of such a possibility trumped the alternative—four more years of the quagmire—in the minds of voters.

By mid-September a nationwide survey by TIME correspondents gave the Humphrey camp ample justification for pessimism. Nixon was projected to capture 34 states with 328 electoral votes (270 were needed to win). Humphrey was deemed likely to win only 10 states, plus the District of Columbia, for 121 votes. Four Deep South states, with 39 electoral votes, were anticipated to support the banner carrier of racial segregation, Alabama Governor George Wallace, while two others, Michigan and Pennsylvania, were rated toss-ups.

THROUGHOUT THE CAMPAIGN A MORE POWERFUL, indeed seismic, shift in U.S. politics was taking shape: Nixon and his advisers had settled on a strategy of courting the South and West as the new Republican base. This was a radical innovation: the "Solid South" had consistently voted for Democrats in the century following the Civil War, so great was the lingering resentment of the Republican Party's role in that conflict and its ugly aftermath, Reconstruction. Indeed, TIME noted that Nixon had chosen Agnew "in large part because he was acceptable to South Carolina's Strom Thurmond and others in the party's Southern wing."

Now the moment was right for Nixon's "Southern strategy": the Johnson Administration's public support for Dr. King's crusade for racial equality, its passage of several historic civil rights bills and its introduction of

Dying breed *Nelson Rockefeller was one of the last GOP candidates to run as a moderate rather than as a conservative*

a host of liberal Great Society programs had deeply alienated millions of white "Dixiecrats." Nixon's pursuit of Southern votes was important for another reason: every ballot cast for spoiler Wallace was a potential GOP vote squandered.

During the fall, Nixon positioned himself as the moderate alternative to the extremes offered by both Wallace and the Democrats—and even poked fun at himself by going on *Rowan and Martin's Laugh-In* to declare: "Sock it to me!" His appeals to the "silent center" were directed at the "forgotten Americans, the nonshouters, the nondemonstrators." (He would not use the phrase that came to be associated with this strategy, the "silent majority," until 1969.) Nixon called his Main Street constituency "good people. They're decent people. They work and they save and they pay their taxes and they care." One Southern woman who supported Nixon described herself to TIME as one of the people "who are sick and tired of their money going out of their pockets to keep people sitting in front of TV sets all day."

In mid-October, however, another surprising event occurred: Humphrey began to hit his stride. On Sept. 30

he had finally broken with L.B.J. and called for a unilateral bombing halt in Vietnam. Now, branding Nixon "Richard the Silent" for his refusal to debate him, the exuberant campaigner known as the Happy Warrior went to war, vowing "to put a blow torch to his political tail and run him out into the open." One week before the election, TIME's poll reduced Nixon's projected total of electoral votes from 328 to 278, while the list of states too close to call had doubled, to eight. Then, on the weekend before the election, Johnson announced a halt to the bombing of North Vietnam and indicated that an end to the war could follow shortly. Within 48 hours, polls nationwide narrowed to a statistical dead heat.

The voting was so close on Election Day that the results were not final until the following morning: Richard Nixon had been elected the 37th President by a margin of fewer than 500,000 popular votes out of more than 73 million cast. Yet however narrow, his victory marked one of the most profound political realignments in U.S. history. The "Southern strategy" would become a critical component in the Republicans' victory in six of the following nine presidential elections. As TIME observed a few weeks before Americans went to the polls in 1968, "For the Democrats, it has become obvious that they are left with the problem of marking out new constituencies. After nearly 40 years, the coalition assembled by Franklin Roosevelt is in the final throes of disintegration, a process that was slowed down but not halted by Lyndon Johnson's 1964 victory." Forty years later, the Democrats' search for that new coalition continues. ■

The South Rises Again

Whatever else might be said about George Wallace and his third-party presidential bid in 1968, the Alabama Governor delivered on one campaign promise before getting his first vote: "We're going to shake the eyeteeth of the liberals of both national parties," he pledged. By liberal, he meant anyone left of the far, far right. Indeed, Wallace's campaign and his appeal were based largely on his antipathy to "them"—that is, anybody who was not "us." While Wallace stoutly denied that he was a racist, "they" was shorthand for America's newly outspoken blacks and their supporters. "They" embraced Supreme Court Justices and bureaucrats in Washington, professors in colleges and journalists everywhere, whom Wallace often referred to as "sissy-britches intellectual morons." As one Wallace supporter in Los Angeles told TIME in October, "The punks, the queers, the demonstrators and the hippies—we're going to put them on a barge and ship 'em off to China. Or better yet, sink it."

Through much of the year, Wallace soared on gusts of middle-class discontent. His response when he ran into hostile crowds was an

ironic form of gratitude: "They got me a million votes," he'd reflect. In the end, however, there were not enough millions of votes to support Wallace's vision of America's future. He received 13% of the ballots cast, giving him slightly more than a million votes, the largest third-party showing since 1924. But his appeal was strictly regional: he carried Louisiana, Mississippi, Alabama, Arkansas and Georgia.

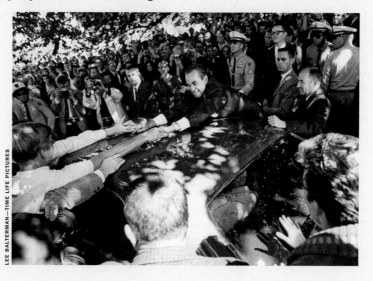

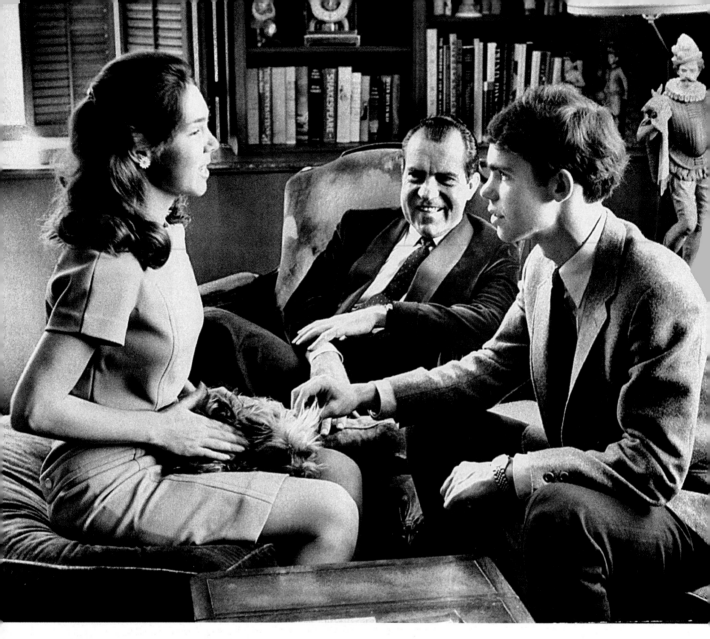

Julie Nixon and David Eisenhower, Newlyweds

DAVID EISENHOWER, GRANDSON OF AMERICA'S 34TH PRESIDENT AND SON-IN-LAW TO ITS 37TH, recalls the year 1968 as much for personal as for political reasons. Then a junior at Amherst College, he had been dating his future wife, Julie Nixon (a student at nearby Smith College), for two years as her father prepared to run for the White House. While his grandfather maintained what the younger Eisenhower remembers as "Olympian neutrality" (Dwight Eisenhower never endorsed his Vice President's '68 candidacy), the young man traveled with the Nixon campaign. In September TIME called David and Julie, who announced their engagement late in 1967, "the most engaging performers in the campaign road show" and reported that candidate Nixon liked to boast, "I always campaign better with an Eisenhower," before introducing his daughter's fiancé.

The young Eisenhower understood that the nation's divisions in 1968 made for poisonous politics. "Everyone knew the Nixon White House wasn't going to end up basking in goodwill," he reflects. "We knew that with the Indochina war. It was painful, but that came with the territory." Even so, he maintains that Nixon's "first Administration was one of the greatest in American history. He had a keen intelligence and extraordinary strategic vision." He recalls 1968 as "an eventful year, but it was not fundamentally chaotic, at least not in the way it's remembered now ... Americans understood the dilemma, and they voted on it. It was a rational outcome to an irrational year."

Six weeks after the election, the Rev. Norman Vincent Peale presided at David and Julie's wedding. Afterward, they hoped to be inconspicuous as they drove cross country for a honeymoon. "We rented the plainest, most average-looking blue sedan we could find," David, a historian and his grandfather's biographer, recalls with a laugh. "But it didn't do us any good. Our Secret Service detail followed us all the way across the country in a white Lincoln Continental convertible." ∎

Young love *David Eisenhower and Julie Nixon were both 20 when they married on Dec. 22, 1968. Today, David says he most admired his father-in-law for "his matter-of-factness, his frankness about being for yourself. His philosophy was that pursuing happiness contributes to the betterment of all. I accept that too"*

Ronald Reagan, Governor of California

RONALD REAGAN'S STAR WAS RISING IN 1968—ONLY NOT FAST ENOUGH. IN A YEAR when the Republican game plan was to capture the mainstream, his unapologetic brand of conservatism inspired true believers but made moderate Republicans who recalled Barry Goldwater's cataclysmic 1964 defeat wary. Even so, Reagan's ambition and appeal were undeniable—to everyone except the California Governor himself, who denied early in the year that he was a candidate. When he began campaigning in earnest in the spring, he spent only $13,500 on the Nebraska GOP primary (compared with Richard Nixon's $100,000) yet still captured 22% of the vote. Commenting on Reagan's telegenic appeal, TIME wrote in May that "he grins, laughs and frowns as the occasion dictates—but he always looks good," adding that "Reagan is not yet a serious danger to Nixon, but he might be if he can prove himself in the May 28 Oregon primary." It was not to be: Reagan's lackluster finish in that contest all but doomed his candidacy.

After briefly allying himself with New York's moderate Republican Governor, Nelson Rockefeller, in a "Stop Nixon" movement (Reagan hoped to be the compromise candidate if the convention deadlocked), the former movie star admitted defeat. But his signature issues—welfare abuse, Big Government, crime, getting tough on domestic dissent and tougher on adversaries abroad—proved surprisingly resonant at a time when moderates held sway. A Reagan aide promised TIME after the Oregon primary, "The country may want a Neville Chamberlain [right now], but sooner or later, Winston Churchill is going to be President." For Reagan, 57 in '68, "later" meant cooling his heels for 12 more years. ∎

Work in progress
John Chancellor of NBC News interviews Reagan at the Republican National Convention in Miami Beach in August

Role call *In a photo shot in the Abbey Road studio during the White Album sessions, the Beatles' personas are clear: Paul hams it up and John fools with a parrot, while George and Ringo stay in the background*

The Fab Four Bite the Apple

From India to Yoko, the Beatles weather a hectic year,
but they have *Hey, Jude* and *The White Album* to show for it

EVEN WHEN REGARDED IN A REAR-VIEW MIRROR, the career of the Beatles seems to take place at an accelerated pace. It's still difficult to imagine that in little more than three years, the mop-topped popsters who thrilled American kids in their U.S. debut on Ed Sullivan's TV show in 1964 transformed themselves into the mustachioed, psychedelic shamans on the cover of the album *Sgt. Pepper's Lonely Hearts Club Band*. In that short period of time, "I want to hold your hand" had become "I'd love to turn you on," and the group's music had undergone a similar transformation, as the Beatles rejected the lure of rehashing their early hits, stopped doing their grueling live tours and retreated into the studio to become sonic pioneers, opening up new realms for pop music to explore.

By 1968 the Beatles exerted enormous cultural influence around the globe: millions of students, teenyboppers, artists, hippies and musicians took their marching orders from John Lennon, Paul McCartney, George Harrison and Ringo Starr. Following the release of such groundbreaking albums as *Rubber Soul* (1965), *Revolver* (1966) and *Sgt. Pepper*, the onetime Fab Four were now widely recognized not only as brilliant musicians and songwriters but also as avatars of the wave of youth culture that was reshaping societies around the globe. And they *were* young, astonishingly young: Lennon and Starr turned 28 in 1968, McCartney 26, Harrison 25.

Somehow the Beatles managed to anticipate, embody and refract seemingly every cultural trend that was coming down the pike in those hectic days. And sure enough, the group, like the rest of the world, weathered a series of shocks in the course of the restless year 1968. The resulting personal and creative fissures led directly to their breakup only two years later.

The roots of the Beatles' turbulent 1968 can be traced back to Aug. 27, 1967, the day their longtime manager Brian Epstein died at only 32. It was Epstein who had shepherded the boys from local renown at Liverpool's Cavern Club to worldwide fame. Along the way he had cleaned up the Beatles' act, turning them from leather-jacketed teenage rebels with little stage presence into polished, suit-wearing, showmen who ended live gigs by bowing in unison. But Epstein had acquired a debilitating amphetamine habit over the years of the Beatles' rise, and his early death was a result of his drug abuse.

Though he was not much older than the Beatles, Epstein had served as a father figure for the group, as well as their shield from the dealmaking, royalty brokering and bean counting that are the pistons and gears of pop-music's starmaking machinery. Now, with his restraining, professional influence missing, the Beatles had no compass to provide direction, no one with the authority to override their more outlandish schemes. Surrounded by yes men, they needed, above all, a "no" man.

The first bitter fruits of the vacuum left in Epstein's wake came on Dec. 26, 1967, when BBC-TV screened the Beatles' made-for-TV film, *Magical Mystery Tour*. Like *Sgt. Pepper*, the film was the brainchild of Paul McCartney, who was constantly seeking new guises for the Fab Four–era Beatles, whom the group had symbolically buried on the cover of *Sgt. Pepper*. The film, which chronicled the adventures of the group and a few mates on a stoned-out, burlesque bus tour of Britain's byroads, had been shot in a couple of weeks in September 1967. Unscripted and essentially undirected, the film was a mess, an unpolished product that the sophisticated Epstein would never have released. The reaction of the British public was scathing—so much so that McCartney felt obliged to offer a public apology for the work.

With that fiasco behind them, the Beatles turned to another misadventure: their journey to Asia to study with Indian guru the Maharishi Mahesh Yogi. This 51-year-old savant was the founder and P.T. Barnum of the practice he called Transcendental Meditation. Harrison, a lifelong spiritual seeker, had been captivated when he first heard the Maharishi speak in London in August 1967, and the other Beatles quickly signed on for this promising new adventure. This was the all-for-one sort

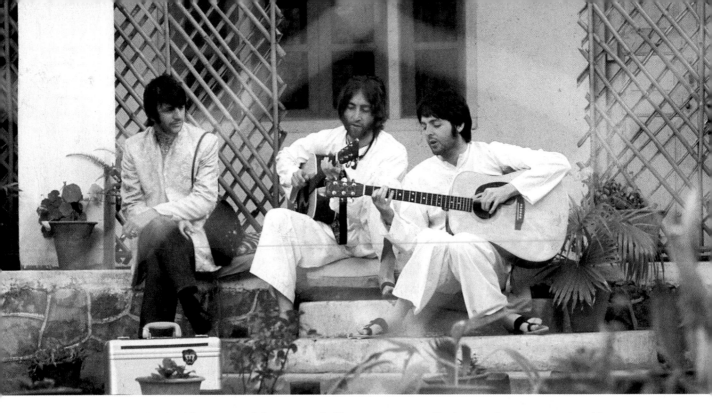

of groupthink that had been one of the group's hall-marks; it would vanish by the end of 1968.

In February, the four men and their entourage of wives, girlfriends and associates flew to India to undergo an extensive course in TM at the Maharishi's ashram in Rishikesh. The journey proved unfulfilling: Lennon, McCartney and Starr were simply not cut out for the spiritual life, and after hearing apparently false allegations that the Maharishi was enjoying physical favors from some of the young women in the ashram, they hurriedly decamped for home. But the sojourn did produce one happy by-product: quickly bored by TM, Lennon and McCartney found themselves with plenty of time to write songs. One memorable Lennon tune invited fellow TM student Mia Farrow's sister Prudence to "come out and play." Another tune, whose title was changed from *Maharishi* to *Sexy Sadie*, lampooned a seducer who "made a fool of everyone."

Back in England, the Beatles ran smack into reality: it was time to record a new album, and with Epstein missing, their business affairs were in chaos. Before leaving

Ashram jam *Meditation proved not so transcendental for Lennon and McCartney, who found better ways to spend time in India*

for Asia, they had taken their first step toward running their own affairs, forming Apple Corps Ltd., which they envisioned as a multimedia conglomerate that would not only produce their music but also extend nourishing tentacles into the worlds of art, fashion and design. It was to be an exercise in "Western communism," the group insisted—a prophecy that fulfilled itself when the startup company's first project, the Apple boutique in London, closed its doors after only six months of operation because of excessive shoplifting.

The Beatles quickly learned what many other rock stars have discovered: musical genius seldom walks hand in hand with business acumen. By 1969, Apple's business affairs would be an albatross, draining the group's creative energy, fostering personal friction and leaving McCartney to grouse (if lyrically): "You never give me your money/ You only give me your funny paper/ And in the middle of negotiations/ You break down."

Come Together—or Not

The Beatles began 1968 at a low point in their career. The huge success of their June 1967 album *Sgt. Pepper's Lonely Hearts Club Band* was followed by the Christmastime BBC-TV special of their drug-fueled bus ride through backroads Britain, *Magical Mystery Tour*, which was amateurish and widely derided. 1968 would be crowded with highs and lows, from their journey to India and the founding of Apple to the new liaison between John and Yoko and the recording of the *White Album*.

FEBRUARY *The Beatles and their entourage fly to India to study Transcendental Meditation with the Maharishi Mahesh Yogi, seen with George Harrison, above. The Beatles met the Maharishi (91 in 2008) in 1967. Harrison was drawn to Indian culture by his sitar mentor, Ravi Shankar.*

JUNE *John and Paul pay a brief visit to America to promote their new record label and business venture, Apple. They hire a Chinese junk and sail around the Statue of Liberty and appear on the* Tonight Show *(where they do not perform). But Apple would soon become a burden.*

JULY *The animated film* Yellow Submarine *opens in Britain. The band had little to do with it, but it captured the group's good vibes and was a commercial and critical success.*

FORTUNATELY FOR THE BEATLES, THE MAKING OF A new album took them back to the one safe haven they still shared: the EMI studio on Abbey Road, long their fortress of solitude. Here, also, was their second father figure, the very much alive producer George Martin, 42, whose fostering hand had helped them realize even their most far-fetched sonic fantasies.

But now, for the first time, further disruption in the group's private lives began to interfere with their studio work. Back in 1962, Lennon had married his Liverpool sweetheart Cynthia Powell, after she became pregnant. But she was not well suited to be the partner of the restless intellectual and artistic rebel, and the marriage was failing. When Lennon met Japanese conceptual artist Yoko Ono, then 33, at a London gallery showing her work in November 1966, their attraction had been immediate. In the spring of 1968 the two embarked on a torrid affair, bonding as lovers and fellow experimental artists. By the summer, Lennon had moved out of the mansion he shared with Cynthia in suburban London and was living with Yoko in a small flat in the city.

Lennon's passion for Ono was outsized, over the top. He insisted that Ono, as an artist, belonged with the Beatles in the studio. Suddenly, the most famous boys' club on the planet was harboring an outsider. The intrusion accelerated a development that was probably inevitable as the Beatles matured: the group's new recordings seemed less a product of collaboration and more a reflection of each man's personal style.

Now, for the first time in the Beatles' career, the recording sessions became a chore rather than a labor of love. Tempers flared and arguments erupted; at one point, mild-mannered Ringo actually left the sessions (and England) in disgust; when he agreed to return, he found his drum kit surrounded with flowers of apology. When Lennon and McCartney merely dallied with Harrison's song *While My Guitar Gently Weeps*, George resorted to inviting his pal Eric Clapton into the studio to play lead guitar—and managed to get their full attention.

The Beatles had so many strong new songs that they were released as a double album late in November. Titled simply *The Beatles*, its pure-white cover quickly led to its being dubbed *The White Album*. And while its songs may have been recorded amid creative pain, the pleasures of such numbers as *Back in the U.S.S.R., Blackbird, Happiness Is a Warm Gun, Birthday* and many others are abundant. Sadly, the Beatles as a group never rediscovered the harmony that was shattered in 1968; they would split up in the spring of 1970. Happily, their music endures. No doubt there will come a time when *The White Album* seems quaintly antique, a curio of a distant era rather than a collection of songs that still has the capacity to surprise, to challenge and to please. But as of 2008, that time had not arrived. ■

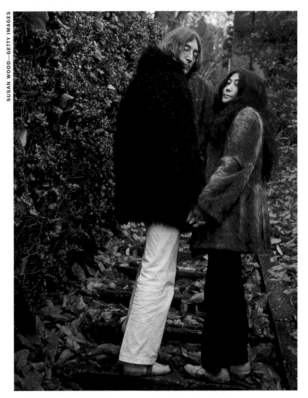

SUSAN WOOD—GETTY IMAGES

Don't look back *Lennon, increasingly unhappy as a member of the Beatles, found in new partner Yoko Ono an escape from a pair of old ones—his first wife Cynthia and musical mate McCartney*

AUGUST *The first Apple single is released. McCartney's 7-min. ballad* Hey, Jude, *with its sing-along coda, is the No. 1 single of 1968 worldwide. The flip side: Lennon's* Revolution.

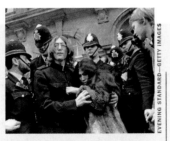

EVENING STANDARD—GETTY IMAGES

OCTOBER *Lennon and Ono are busted for marijuana possession at a Montagu Square flat in London owned by Ringo Starr, where they had been living. By now the Beatles, once the toast of the British press, had become tabloid fodder; Lennon was particularly ridiculed for his increasingly avant-garde leanings.*

NOVEMBER The White Album *is released.* TIME's *review notes that for the first time, the songs sound less like a group effort and more the product of their individual writers.*

The BEATLES

NO CREDIT

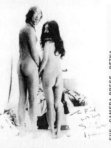

SUS—CAMERA PRESS—RETNA

NOVEMBER
Apple releases Two Virgins, *recorded by Lennon and Ono on the first night they spent together. The music is experimental electronic noodling, and the cover art—pictures of the two naked—is calculated to defy cultural norms (and attract publicity).*

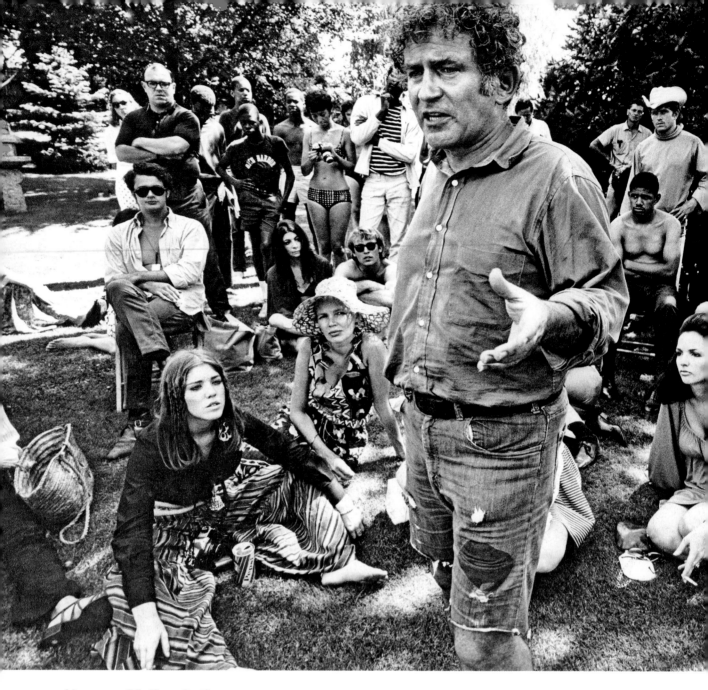

Norman Mailer, Author

WHERE WAS NORMAN MAILER IN 1968? WHERE ELSE?—THIS STORM CHASER OF A WRITER WAS right at the center of the year's whirling vortexes. The novelist, 45 that year, had abandoned fiction to chronicle the rush of events of the 1960s; his hot-off-the-griddle book on his participation in the 1967 march on the Pentagon, *The Armies of the Night*, was a major critical success and won the National Book Award. Now, he told TIME in October 1968, his attendance at the year's national political conventions had fostered some of his very best writing, and the magazine agreed. Forsaking his usual compulsive self-analysis, Mailer re-created in the November issue of *Harper's* magazine the events, personalities and mood of the year's two political musters. His "informal history," a classic work of New Journalism, was published late in the year as *Miami and the Siege of Chicago*.

"His reporting is, as always, intensely personal as it probes the darker, unexplored passageways of American political life," TIME noted. "But Mailer—Eastern Seaboard exotic, alienated artist, New York practitioner of improvisational cinema—is strangely in touch with heartland America this election year." Indeed, Mailer's account of the Democratic Convention found him not only railing at the Chicago cops, as readers would expect, but also at the candidates, his account seething with contempt for conventional liberalism. Most surprising of all, Mailer, who in his classic 1957 essay *The White Negro* had declared his unbounded admiration for African-American culture, now boldly declared he "was getting tired of Negroes and their rights." Maybe so—but Mailer typically had it both ways, also telling TIME that if he did vote in 1968, it would be for Black Panther leader Eldridge Cleaver. ■

126

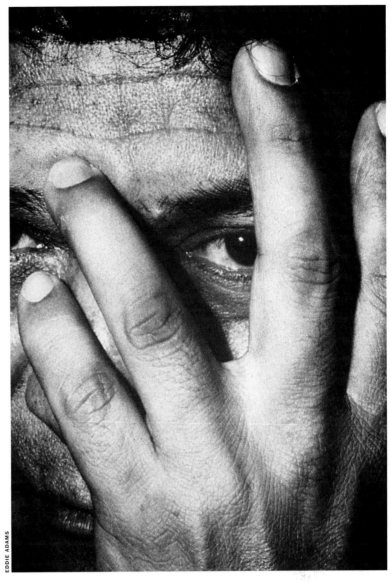

EDDIE ADAMS

Carlos Castaneda, Sorcerer's Apprentice

EMERGING AGAINST THE BACKDROP OF THE 1960s FASCINATION WITH the power of psychotropic drugs, Carlos Castaneda's book *The Teachings of Don Juan: A Yaqui Way of Knowledge,* created a sensation upon its publication in the spring of 1968. The book is a first-person account of Castaneda's apprenticeship with Don Juan, an adept of the ritual sorcery practiced by Central American Indians, which involves the use of native plants such as peyote to create altered states of consciousness. Brimming with colorful details of native religious practices and gripping in its depiction of chilling encounters with demonic forces, the book is a unique amalgam of anthropology, natural history and psychedelic philosophizing. It reads with the power of a novel—which is precisely what critics in later years have charged it to be.

Indeed, it's difficult to arrive at the facts surrounding both Castaneda and his numerous works. The Peruvian-born writer, who died in 1998, deliberately cloaked his life and his books in a veil of obscurity. At the height of his fame, in 1973, TIME put Castaneda on its cover, quoting one admirer of his works as saying Don Juan's Boswell was either a great anthropologist or a great novelist. But "heads or tails, Carlos wins." ∎

Two cents' worth *Mailer, above, assumes his standard operating position—at the center of attention—as he holds forth at a social gathering in 1968*

Mystery man *When* TIME *put Castaneda on its cover in 1973, it noted that it could not prove that his purported teacher, Don Juan, was real. The writer, however, "is alive and well in Los Angeles, a loquacious, nut-brown anthropologist, surrounded by such concrete proofs of existence as a Volkswagen minibus, a Master Charge card, an apartment in West-wood and a beach house"*

Destination: Hell

North Korea seizes a U.S. spy ship and holds 82 sailors as hostages—and there's not much Uncle Sam can do about it

Captured *This North Korean photo shows the crew being taken captive on Jan. 23, 1968. Below, the U.S.S.* Pueblo *in 1967*

THE FIRST MISSION OF THE U.S.S. *PUEBLO*, A WORLD War II U.S. military freighter converted in 1967 for service as an intelligence vessel, did not go well. Assigned to snoop on military radio traffic in the waters off North Korea, near the U.S.S.R.'s Pacific fleet headquarters at Vladivostok, the ship was approached on Jan. 23 by a Soviet-built North Korean torpedo boat. Using international signal flags, the PT boat asked *Pueblo's* nationality. When she identified herself as American, the Korean boat signaled, "Heave to, or I will open fire." *Pueblo* replied, "I am in international waters." An hour later, three more North Korean vessels came slashing in from the southwest. "Follow in my wake," signaled one of the small vessels. "I have a pilot aboard." The Korean boats took up positions on *Pueblo's* bow, beam and quarter. Two MiG jets screamed in and began circling off the American vessel's starboard bow.

Even so, the *Pueblo's* skipper, Commander Lloyd M. Bucher, 40, kept his cool. It was only when one of the

North Korean vessels rigged fenders (rubber tubes) to cushion impact and began backing toward *Pueblo's* bow that Bucher realized what was happening: in the bow of the craft stood an armed boarding party. "These guys are serious," Bucher told his home port, U.S. Navy headquarters in Yokosuka, Japan. "They mean business."

As the lightly armed *Pueblo* took evasive action, the North Korean gunboats fired repeatedly across her bow, killing crewman Duane Hodges, while eight jet fighters buzzed the vessel. At 1:45 p.m., *Pueblo* radioed Yokosuka that the North Koreans had boarded his ship. At 2:32 p.m. the *Pueblo* sent its last message. Engines were

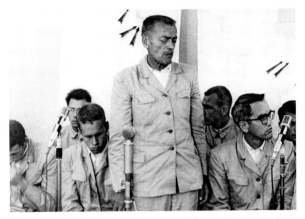

Hostages *U.S.S.* Pueblo *Commander Bucher and crew members are put on display by the North Korean government*

"all stop," Bucher reported; he was "going off the air."

Thus began an 11-month ordeal in which the 82 surviving members of *Pueblo* were jailed, tortured, starved and humiliated, while Washington pondered and rejected plans for a military rescue, then tried to negotiate their release. As diplomats wrangled, the crew suffered. Bucher was beaten repeatedly and ordered to sign a "confession." He refused, until the North Koreans made clear they would begin shooting his crew, one by one, while he watched if he did not comply. ("Twice," recalls sailor Richard Rogala, "they told me they were going to shoot me in the morning.")

Realizing that his captors included not one fluent English speaker, Bucher wrote a sneering apology that ended with the words, "We not only want to paean the North Korean government, but to paean the North Korean people as well." After the North Koreans broadcast his confession and discovered the hidden pun, more beatings followed. Rogala says that "the confessions and propaganda broadcasts seemed to be the most important thing to them. They spent much less time ques-

tioning us about our mission or anything classified. And though they beat us during those interrogations, they were much less intense than the sessions meant to get us to say what they wanted. The real violence was over whether we would say what they wanted us to say."

In midsummer, the crew's captors tried for another propaganda win by giving the men a few days of decent rations, then allowing them to shave and shower before being photographed. The sailors all gave the camera what they called "a Hawaiian good luck sign"—a raised middle finger. When the North Koreans learned they had been made fools of once more, the torture reached a new level of ferocity: several crew members were beaten with sticks, even stabbed with bayonets, for 39 straight hours, and suffered multiple broken bones.

Finally, a few days before Christmas, the North Koreans agreed to release the men in exchange for a signed confession and apology—with no hidden messages—from a senior U.S. official. The deal allowed the U.S. representative to convey verbally that the document he was signing was false and meaningless, but not to reflect this in the text. Minutes after U.S. Army Major General Gilbert H. Woodward signed the statement on Dec. 23, the crew crossed the Bridge of No Return that separates North and South Korea.

Americans cheered the news: after a grim year, the release of the crew coincided with the Apollo 8 voyage to the moon. Yet the U.S. government was not pleased: the Navy briefly considered court-martialing the *Pueblo's* senior officers but decided to put the matter behind it. Official ambivalence about honoring the men who suffered so severely for their country lasted for decades: the crew did not receive the POW medals accorded thousands of other prisoners of war until 1990. In 2008 the *Pueblo* is still moored in Pyongyang harbor, where it serves as an anti-American tourist attraction. The vessel remains the only U.S. Navy ship still listed as being on active duty that is in possession of a foreign power. ∎

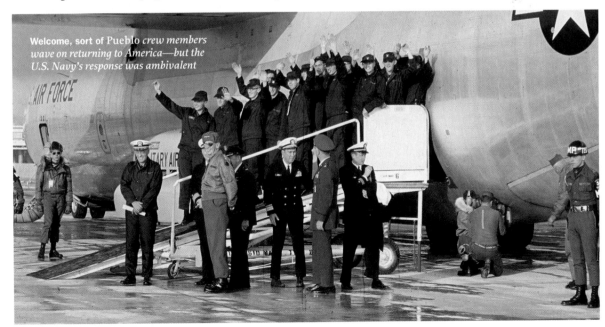

Welcome, sort of Pueblo *crew members wave on returning to America—but the U.S. Navy's response was ambivalent*

At Year's End, New

Ready for its close-up *This photograph of the nearly full moon was taken by Bill Anders just after the lunar module completed its 10th orbit and the three astronauts began the voyage home*

Perspectives

Ending a dismal year on a welcome high note, three NASA astronauts achieve a milestone in space on Christmas Eve

WAS THERE EVER A YEAR MORE IN NEED OF A concluding grace note than 1968? On their TV screens, Americans had watched in dismay as their power-loving President fled from power, as Viet Cong guerrillas prowled the grounds of the U.S. embassy in Saigon, as two national leaders were murdered, as cops and protesters battled in the nation's streets, as Soviet tank treads crushed the hopes of freedom in Prague. Looking back on 1968 in its annual Person of the Year issue, TIME observed at the end of those perilous 12 months, "Seldom had the nation been confronted with such a congeries of doubts and discontents ... While U.S. prestige declined abroad, the nation's own self-confidence sank to a nadir at which it became a familiar litany that American society was afflicted with some profound malaise of spirit and will."

How fitting, then, that in the last weeks of the year the national mood followed the nation's eyes and began looking up—very high up, in fact, to the new frontier that the late President John F. Kennedy had promised Americans in the first buoyant days of the 1960s. For at the end of this bleak year, the National Aeronautics and Space Agency (NASA) provided exactly what the world needed, a new perspective on its problems, even if the impulse driving the diversion was both Earthbound and political: the still white-hot space race between cold war rivals the U.S. and the U.S.S.R.

Early in 1968 the CIA began hearing whispers that the Soviet Union was planning an imminent manned trip around the moon, which would place it far ahead of the U.S. in the propaganda war based on the exploration of space. Indeed, the U.S. program had lost its swagger. In the 23 months since the Apollo 1 fire killed three astronauts on a Cape Kennedy launchpad on Jan. 27, 1967, NASA had managed only one manned flight—Apollo 7 in October 1968, a snug, low-Earth-orbit mission. Apollo 8 was slated to venture farther, out to a much higher orbit that would allow the crew to practice making a high-

speed re-entry. But with the CIA's suspicions in mind, NASA decided to roll the dice and send astronauts Frank Borman, Jim Lovell and Bill Anders out farther still—all the way to the moon for a 10-orbit tour.

The flight began flawlessly. On Dec. 21, at Pad 39A at Cape Kennedy, Fla., the three men lay strapped in the 11-ft. command module that was perched atop a 363-ft. Saturn 5 rocket. With a deafening bellow, the rocket inched upward on a rising pillar of smoke and flame, then spurted off into Earth orbit. During its second turn around the planet, it accelerated from 17,400 m.p.h. to 24,200 m.p.h., enough to escape Earth's gravitational embrace and send Apollo 8 on the road to the moon.

Almost 69 hours after liftoff, the three astronauts made their historic rendezvous with planet Earth's great satellite. Below them, less than 70 miles away, lay a desolate, pock-marked landscape. In the black sky above hung a half-disk—Earth—its blue and brown surface mottled by large patches of white. Thus, incredibly, they were there, precisely where the mission planners had predicted, finally living the dreams of untold generations of their ancestors. Now, in orbit around the moon and 230,000 miles farther away from home than any humans had ever before traveled, the Apollo 8 astronauts conveyed impressions of their pioneering adventure in a series of six live telecasts that gave Earthbound viewers an unforgettable astronaut's-eye view of the moon, seasoned with a poetic touch.

"The moon is essentially gray, no color," Lovell reported. "Looks like plaster of Paris, or sort of a grayish deep sand. We can see quite a bit of detail. The Sea of Fertility doesn't stand out as well here as it does on Earth. There's not as much contrast between that and the surrounding craters. The craters are all rounded off. The round ones look like they've been hit by meteorites or projectiles of some sort."

From their descriptions, it was obvious that the Apollo crew had diligently learned its lunar lessons. The as-

NASA

tronauts casually called out names of lunar craters and other landmarks as if they were old friends. Messier. Pickering. The Pyrenees Mountains. The craters of Colombo and Gutenberg. The long parallel cracks or faults of Gaudibert.

By Apollo's sixth revolution of the moon, the program had taken its toll on the crew. "I'm going to scrub all the other experiments," Borman announced, "we're getting too tired." Ten minutes later, he reported that Lovell was already asleep and snoring. "Yeah," replied the Houston communicator, "we can hear him down here." Later, when Borman inquired about the weather in Houston, a communicator reported that there was "a beautiful moon out there tonight." Replied Borman: "Now, we were just saying that there's a beautiful Earth out there."

On Christmas Eve, during their ninth revolution of the moon, the astronauts presented their best description of the lunar surface in the longest and most impressive of the mission's six telecasts. "This is Apollo 8 coming to you live from the moon," reported Borman, focusing the TV camera on the moonscape drifting by. "The moon is a different thing to each of us," said Borman. "My own impression is that it's a vast, lonely, forbidding-type existence—great expanse of nothing that looks rather like clouds and clouds of pumice stone. It

Dress rehearsal *The three Apollo 8 astronauts train for the mission before the launch. From left: lunar module pilot Anders, command module pilot Lovell and mission commander Borman*

certainly would not appear to be a very inviting place to live or work."

NOW APOLLO WAS NEARING THE TERMINATOR, THE line that divides the lunar day and night, which showed as a sharply defined front of darkness on the moonscape traveling from the left of the television screen. To conclude their Christmas Eve telecast before the view below was blotted out, the astronauts took turns solemnly reading the first 10 verses of the Book of Genesis: "In the beginning, God created the heaven and earth … And God said, Let there be light: and there was light … And God made two great lights; the greater light to rule the day, and the lesser light to rule the night; he made the stars also." Accompanying the views of the primordial lunar landscape below, their rendition was impressive and moving: when TIME created a list of the highlights of the space age 39 years later, in 2007, it recalled that indelible moment and noted, "If you didn't go misty at that, your heart wasn't beating."

As Apollo began its 10th revolution, tension rose again both aboard the spacecraft and in Houston. Dur-

ing their final pass behind the moon, the three astronauts were scheduled to restart the module's engine, this time to increase their velocity from 3,625 m.p.h. to 5,980 m.p.h., enough to propel them out of lunar orbit and back toward Earth. Failure of the engine to fire would leave them stranded in lunar orbit.

This time, there were no final bon voyages, no quips and no sentiment. "All systems are go, Apollo 8," the controller reported. From Borman came back only a terse "Roger." As the spacecraft passed into radio silence, the Houston communicator reported, "Flight controllers here in mission control, as with the rest of the world, are waiting." Although it was now more than half an hour into Christmas Day in Houston, the controllers avoided any exchange of greetings, awaiting word that Apollo 8 was safely on its way home. That word came 37 minutes later in a transmission by Lovell as Apollo re-emerged. "Please be informed," he said, "that there is a Santa Claus."

After the astronauts landed safely on Dec. 27, Borman told a press conference that the most memorable part of the mission for him was not the orbit of the moon but rather when the heat of re-entry into Earth's atmosphere ionized the air around Apollo: "The whole spacecraft was bathed in light that made you feel like you were inside a neon tube."

That experience was a good preparation for the weeks in the limelight that followed the astronaut's touchdown. In history's long view, the successful moon landing of Apollo 11, which followed the Apollo 8 flight by only seven months, has overshadowed the historic nature of the Christmas 1968 flight. But at the time Anders, Borman and Lovell were lionized, whisked along a heroes' route that took them to the White House, an appearance before Congress, a ticker-tape parade in Manhattan and a reception at the United Nations. Lovell was correct in saying there was a Santa Claus in 1968, for these three men had given their countrymen a gift that was sorely needed: the sense that America could still do something right—and could still produce heroes. ■

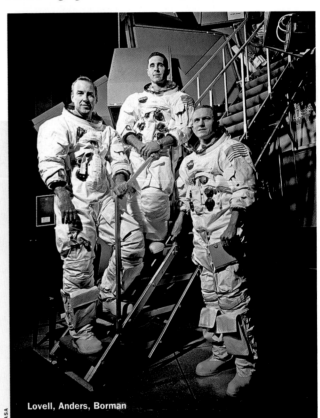

Lovell, Anders, Borman

Three for the Moon

The three astronauts who were named Persons of the Year 1968 by TIME are among the most memorable of America's first generation of astronauts. Frank Borman, 40 in 1968, was a lay reader of his Episcopal Church congregation; it was his inspiration to read from the Book of Genesis on Christmas Eve. It was also mission commander Borman who played the Grinch, forbidding Lovell and Anders to sample the 1-oz. bottles of brandy that fellow astronaut Deke Slayton had smuggled aboard the orbiter for a Christmas toast. But no one doubted Borman's courage: in his days as a U.S. Air Force pilot, when the engine of his F-104 blew up in flight at twice the speed of sound, rather than bailing out, Borman stayed in the plane, got the engine started again and coaxed enough thrust to make a safe landing. After leaving NASA, Borman became the CEO of Eastern Air Lines. As of early 2008, he was living in Las Cruces, N.M., and enjoying his hobby: flying vintage aircraft.

At 35 in 1968, Bill Anders was the youngest of the three Apollo 8 astronauts. He made the most of his only spaceflight: Anders served as commander of the lunar module, and he took the photo of Earthrise as seen from the moon that has become one of the iconic images of the space age. The former U.S. Air Force fighter pilot is an expert in nuclear power; after leaving NASA, he joined the Atomic Energy Commission and spent his professional career in the field of nuclear energy and defense; he retired as CEO of defense contractor General Dynamics in 1993. Like Borman, he continues to fly vintage aircraft and is the founder and executive director of the Heritage Flight Museum in Bellingham, Wash.

No one could imagine that Jim Lovell, 40 in 1968, could possibly trump his Apollo 8 flight, but today he is perhaps better known for a mission that failed. In 1970 Lovell was the commander of the Apollo 13 mission when an explosion in the service module en route to the moon came close to killing Lovell and fellow astronauts Fred Haise and Jack Swigert. "Houston, we've had a problem," Lovell famously radioed to NASA, and over the next four days, the Apollo 13 crew improvised a daring emergency strategy that brought them home safely—an electrifying saga that was told by Lovell in his 1994 book *Lost Moon: The Perilous Voyage of Apollo 13,* written in collaboration with TIME correspondent Jeffrey Kluger. The book became the basis for the 1995 hit film *Apollo 13,* in which actor Tom Hanks plays Lovell. The former U.S. Navy pilot retired from NASA in 1973 and worked in the communications industry until the 1990s; he holds the unique distinction of being the only human to have orbited the moon twice but never walked on its surface.

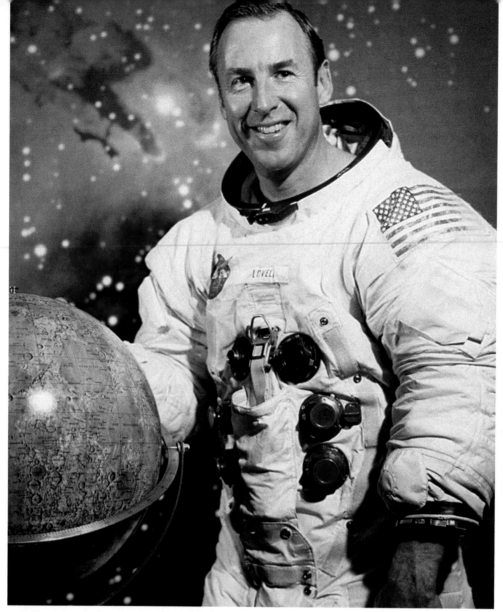

Move over, Marco
*Reviewing the hit
1995 film* Apollo 13,
TIME *critic Richard
Corliss called Lovell,
80 in 2008, "history's
greatest traveler,
with almost 7
million miles on his
Gemini and Apollo
odometers"*

Transformed *Anders,
right, 74 in 2008,
told* TIME *in 1972
that seeing the Earth
from the moon
prompted "feelings
about humanity and
human needs that
I never had before"*

Jim Lovell, Command Module Pilot

WE NEVER SAW THE MOON ON THE WAY OUT," APOLLO 8 ASTRONAUT JIM LOVELL RECALLED for TIME in 2008, "because of the direction of the spacecraft. We just saw the Earth getting smaller and smaller, which was very sobering in terms of understanding how far away we were." When the men reached lunar orbit, they fired rockets to slow the spacecraft down and reorient it to face the moon's surface. "I had seen the pictures, but my God, there we were, for real. It was all shades of gray: dark and light grays, dark black areas. It was beautiful in a sort of horrible way, craters and mountains everywhere." When Apollo 8 then passed around the far side of the moon, he remembers, "the side that always faces away from Earth and had never been seen by human beings. We were like three school kids looking in a candy-store window."

The astronauts were so preoccupied with the lunar surface that they initially overlooked an even more spectacular sight. "Anders was busy taking pictures of craters, so he didn't even notice the sudden burst of color along the lunar horizon," says Lovell. "It was the Earth coming up over the moon's surface. I was so dumbfounded at the beauty of the sight, I called to Anders to photograph what we were seeing." Living up to the nickname "No Nonsense," which Lovell and Anders had given their mission commander, "Frank Borman protested, saying it wasn't on the flight plan. But before long, all three of us were snapping pictures, absolutely in awe." Lovell has never lost the vivid impression created by the planet's size at that distance. "You put your hand up to the window, and you could put the Earth behind your thumb. It gives you a humble feeling, that everything you've ever known is behind your thumb." Today, Lovell says, "all three of us can look at the moon and say, 'We were there.'" After completing his Apollo 8 mission and surviving a potentially fatal close call on Apollo 13, Lovell says, "I used to carry my grandson around the yard and point to the moon and tell him, 'Buddy, you might not be here if I hadn't come back.'" ■

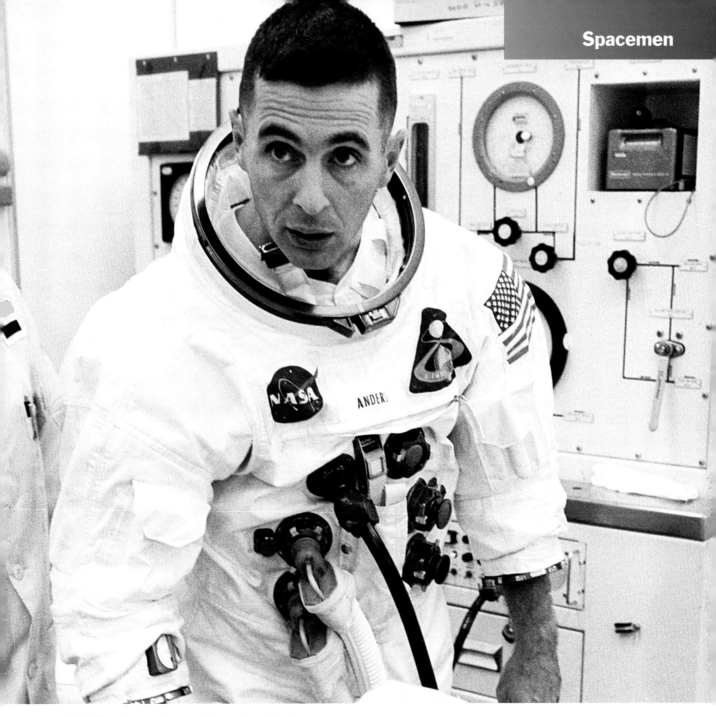

Bill Anders, Lunar Module Pilot

Y OU KNEW YOU WERE ON SOMETHING DIFFERENT," BILL ANDERS REMEMBERS THINKING AS APOLLO 8 LIFTED off on Dec. 21, 1968. "Maybe on a one-way trip." Still, he had a military man's perspective on the risks. "It was safer than being shot at in Vietnam over a patch of jungle," he told TIME in 2008. "We were all fighter pilots. We had all done more dangerous things." Anders recalls being struck by the irony that, "after spending all of that time and money to get to the moon, the most impressive sight was our own Earth in the vast blackness of space. It was the only color we could see in the universe, and it was a gorgeous, moving sight." His impression was that "instead of some infinite mass of granite for us to kick around, beat up and pollute, it looked, appropriately enough, just like a Christmas-tree ornament hanging there: very delicate, very finite and very fragile." While the men were reading from the Book of Genesis, he remembers thinking, "We're a very tiny part of a very immense thing, and if there is a God, he's much less Earth-centric than most religions would imply. And he must be awfully fed up with us killing each other."

Anders claims to have only one regret about the Apollo 8 mission, explaining that the crew "picked three nice, not-too-big craters to name after ourselves" but were later overruled by astronomers. "They named three other craters after us, except that on our flight, this was the only piece of the moon we couldn't see. It was totally black." Asked to reflect on Apollo 8's legacy, he says, "We're all humans and we're certainly the only humans in the universe. We better start learning to stick together, rather than throwing bombs at each other." ■